WITHDRAWN

HIGH STRUNG

HIGH STRUNG

BJORN BORG, JOHN McENROE, AND THE
UNTOLD STORY OF TENNIS'S FIERCEST RIVALRY

Stephen Tignor

HARPER

An Imprint of HarperCollins*Publishers*
www.harpercollins.com

HarperCollins books may be purchased for educational, business, or sales promotional use. For information, please write: Special Markets Department, HarperCollins Publishers, 10 East 53rd Street, New York, NY 10022.

FIRST EDITION

Library of Congress Cataloging-in-Publication Data

Tignor, Stephen.
 High strung: Bjorn Borg, John McEnroe, and the untold story of tennis's fiercest rivalry / Stephen Tignor. 1st ed.
 p. cm.
 Summary: "Using as its primary lens the fabled 1981 U.S. Open match between Bjorn Borg and John McEnroe, as well as the watershed tournament at large, High Strung orbits around the four greatest, enigmatic talents of that age and argues that with their collective, athletic denouements came the end of the golden era of tennis"— Provided by publisher.
 ISBN 978-0-06-200984-5
 1. Borg, Bjorn, 1956– 2. McEnroe, John, 1959– 3. Tennis players—United States—Biography. 4. Tennis players—Sweden—Biography. 5. U.S. Open (Tennis tournament) (1981) 6. Sports rivalries. I. Title.
GV994.A1T47 2011
796.3420922—dc22
 [B] 2011013011

 11 12 13 14 15 OV/RRD 10 9 8 7 6 5 4 3 2 1

To the memory of my grandparents and first tennis teachers,

William and Anne P. Hamilton

CONTENTS

HIGH STRUNG

THE ANGEL AND
THE BRAT

"It's what I live with, you know, that I lose someday."
—BJORN BORG

In the minds of most tennis fans, when Bjorn Borg took his first rolling, measured strides onto Centre Court for the 1980 Wimbledon final, he might have been stepping down from the clouds. The myth of the divine Swede had been growing in London since 1973, when he'd made his debut as a 17-year-old. That year, Borg's wavy blond hair and shy, smooth-cheeked smile earned him the nickname Teen Angel. They also earned him the attention of hordes of shrieking, hopping, giggling, weeping, and uncontrollably aggressive English schoolgirls. After his first match, 300 of them attacked Borg and dragged him to the ground. Thus began a phenomenon previously unseen on the lawns of the All England Club, one that would take a variety of forms over the ensuing years: the "Borgasm." (Asked later if he'd been scared by the experience, Borg replied with the equanimity that would become his trademark: "Well, yes, I was a little scared, as I lay there in the dust on the street with girls all over me. But it was fun, too.")

The following year, Wimbledon officials put out the word to 60 neighboring schools: Keep the girls under control. They couldn't do it, and neither could the police. "The Viking God was mobbed," one club member reported in 1974, "and in the scuffle a policeman's helmet was knocked off and an officer knocked to the ground."

As the decade progressed and Borg evolved from a young heart-throb to a grizzled world champion, his myth and his nickname evolved with him. By 1980 he had been rechristened the Angelic Assassin. A silent man with a headband for a halo, Borg was re-nowned for his icy precision and improbable, back-from-the-brink victories. He was, by all appearances, invincible in the paramount test of tennis nerve, the five-set match. He had won 10 straight dating back to 1976. With his seemingly inhuman consistency and his impenetrable reserve on court, there was an air of mystery, of the uncanny, surrounding everything Borg did. Urban legends sprouted around him. His heart rate was 35 (it was between 50 and 60). He slept 10 hours a night in freezing cold hotel rooms (he did). His racquets were strung so tightly they popped in his hotel room while he was sleeping (they did). He had ice in his veins (probably not true). Fellow player Ilie Nastase referred to him as "the Martian."

The mythmaking was understandable because Borg was one of those rare athletes who changed the nature of his sport single-handedly—or, in his case, double-handedly. For 30 years the ac-cepted style of play in men's tennis had been to follow the serve forward, to attack, to pressure the opponent and create winning angles by hitting your shots from as close to the net as possible. It was known as the Big Game, and it seemed to be the final word in strategy. But Borg, legendary from a young age for his stub-bornness, turned the textbook—and the sport's geometry—upside down. Believing that the Big Game was as much about machismo as it was tactics, he stayed back, and won by outlasting his oppo-nents. He hit his forehand with an extreme grip that had rarely

been seen before, and he popularized the two-handed backhand, an equally rare shot before him, but one that would become virtually universal after him.

Borg's style elevated physicality and athleticism to a higher degree of importance in tennis. He kept his weight at 160 at all times and didn't worry much about his technique; what he cared about most was arriving at the ball in time to hit it—and then never missing it. He was also a minimalist when it came to tactics. Asked how he approached an important point, Borg said he "made sure I got the ball over the net." His game was taxing on mind and body, yet by the end of the 1970s his approach had wiped away three decades of the Big Game and established itself as the new orthodoxy.

No one could argue with its success: Borg entered the 1980 Wimbledon final having won four straight titles there, a record unmatched by any man in the 20th century. He was at the peak of his powers. A June 1980 *Time* cover story on Borg, which began by asking, "Is he the greatest of all time?," called him an "incredible tennis machine, an inexorable force that is one part speed, one part topspin, and two parts iron will." His victories weren't merely inevitable. They seemed to be ordained from above.

So it might have come as a disappointment to many to find out that the Angelic Assassin, rather than descending from Valhalla, or Mars, or Big Ben's tower, had ridden in for the final that day from a local Holiday Inn. Located next to the grass court club where he practiced in the Hampstead section of London, the hotel was where Borg always stayed during the tournament. It took 45 minutes by car to get to the All England Club, and Borg had made the trip the same way for the better part of four years. He rode up front in the passenger seat. His fiancée, Mariana Simionescu, a Romanian tennis pro two years his senior who trimmed his hair and cooked his meals, sat in the back. Lennart Bergelin, his 55-year-old coach, who also served as his secretary, masseur, racquet keeper, and second father, was at the wheel. This three-person cocoon—"home"

to Borg—had been threading its peaceful way through the tennis world undisturbed since 1976.

The car was always a Saab, which was one of Borg's sponsors, and Bergelin always drove, for the same reason that he answered Borg's phone calls and kept his 50 racquets precisely tuned at all times: so his player wouldn't waste a moment of concentration on anything other than batting a tennis ball over a net. The route Bergelin took through London's leafy suburbs never varied. It wasn't necessarily the shortest path, but it minimized the chance that Borg would be confronted with something "new" along the way.

Superstition is a guiding faith among professional tennis players. They'll do whatever it takes not to step on a line as they walk around the court. In the midst of a winning streak, they've been known to eat nothing but McDonald's or wear the same pair of shorts for 10 days running. But it was more than just an occupational hazard for Bjorn Borg; the trait ran in his family. His parents, Rune and Margarethe, first saw their son win at the All England Club in 1977. The last digit of that year was taken as a sign. From then on, they would attend Wimbledon only in odd-numbered years, while traveling to the French Open, which Borg would eventually win six times, in even-numbered years. As of 1980, their record was unblemished, though there had been more than a few close calls.

In the 1979 Wimbledon final, Borg played an intense five-set match with Roscoe Tanner, an American whose erratic, go-for-broke style and machine-gun lefty serve always rattled him. Margarethe ate candy throughout the match, for luck, as she did during many of her son's matches. After more than three hours, Borg served for the title at 5-4 in the fifth set. He went up 40-0, triple match point. His mother thought she was safe at last, so she spit the well-chewed candy on the floor of the player's guest box. Borg proceeded to lose the next three points. Margarethe picked up the candy and popped it back in her mouth. Borg won the next two points and the match.

The addition of Bergelin to the Borg team didn't help. If anything, he outdid the family when it came to superstitions. In 1975 he coached the Swedish Davis Cup team to its first title. Throughout the season, Bergelin refused to take off his lucky long underwear, which was festooned with cartoon tigers. He kept it on despite 100-degree temperatures over a weekend in Spain. When the team won, Bergelin pulled down his pants and danced on a table in his long johns.

Rune and Margarethe's only child turned the family predilection into a way of life at Wimbledon. Each year, Borg put away whatever Fila outfit he'd been dressed in that season and pulled out the skintight green-pinstriped shirt he'd worn on his way to his first title there, in 1976. Each year he asked for the same chair he used the year before. On court, he demanded exactly two towels. Borg also brought the "playoff beard" to tennis. He stopped shaving once certain tournaments, including Wimbledon, began. By the end of the fortnight, a dark, scraggly patch of hair would be spread across the bottom of his face. (On occasion, the beard would be accompanied by a breakout of pimples on his chin that would also vanish once the tournament was over. But this rare outward sign of anxiety from Borg was not, as far as anyone knows, part of his system of superstitions.)

Simionescu believed that her fiancé's habits were an elaborate "search for order" and a "source of energy and concentration." But on the day of the 1980 Wimbledon final, Borg's routine was altered just slightly. Sitting next to Mariana in the backseat of the Saab was a gregarious English friend named Tommie who ran a restaurant at the club where Borg practiced. He had been invited to sit with Bergelin and Simionescu in the player's box that day. Unable to contain his excitement about traveling to the final with the champion, he cheerfully predicted a win for Borg. Bergelin flashed Mariana a sharp look in the rearview mirror. She told Tommie to keep quiet. Borg sat placidly in the front seat, his blond hair curling

at his shoulders, as the car traced its familiar course through the narrowing lanes of suburban London. He had won 34 straight matches at Wimbledon. He didn't need to hear talk of a 35th.

While his run to the final that year had been relatively routine—none of his traditional Houdini acts had been required—Borg knew better than to tempt fate. In the first round he had drawn an Egyptian, Ismail El Shafei. During a game of cards at the hotel, Simionescu innocently assured him that it was an "easy match." Borg did the equivalent of hitting the roof for him: He stood up and walked silently out of the room. An hour later he was reading the paper. Out of nowhere, he put it down and said, "I just want to remind you, Mariana, there's no such thing as an easy match. A player who thinks like that might as well give up, and I have no intention of doing that."

As a tennis player, Borg knew that nothing was ordained.

While the Viking God's trips around the city had been soothing and predictable, those of his opponent in the final, John McEnroe, had become a source of rising agitation. The 21-year-old New Yorker could never get away from himself in London. More accurately, he couldn't get away from the obnoxious cartoon alter ego the city's tabloids had saddled him with: Superbrat. Headline writers used it as if it were his real name: "Disgrace of Superbrat!"; "Superbrat Out in the Cold—and He Blames the British Weather!" Something about John McEnroe inspired the London tabloids. While he wouldn't become the all-time Wimbledon champion, no tennis player could touch him when it came to nicknames: At various times he was McBrat, McNasty, McTantrum, the Mouth That Roared, the Merchant of Menace, and, this author's personal favorite, the Incredible Sulk.

The words and the images followed him everywhere. McEnroe often shared a taxi with his friend and doubles partner Peter

Fleming. On those rides, a song by the Police that had been released two years earlier, "I Can't Stand Losing You," was in suspiciously heavy rotation on the radio. Over a hammering New Wave beat, the lead singer, Sting, robotically repeated the phrase *I can't . . . I can't . . . I can't stand losing, I can't . . . I can't . . . I can't stand losing* dozens of times. When the song finally ended, the DJ's next words had come to seem inevitable: "Sounds like a song for Superbrat!"

That's how it had been for McEnroe at Wimbledon ever since, fueled on pizza grease and candy bars, he'd made his debut run to the semifinals as an 18-year-old qualifier three years earlier. He had skipped his high school graduation to play the French Open and Wimbledon; his headmaster at the Trinity School in Manhattan had called the trip McEnroe's "Senior Year Project." McEnroe's parents thought that simply entering the event would be a great learning experience for Johnny, something akin to the recent excursion he had made to Washington, D.C., with his fellow seniors. A few weeks later McEnroe was world famous and threatening to win the sport's biggest tournament. In the words of *Tennis* magazine, McEnroe "wandered through the draw like a child half-stumbling toward the throne room in a strange, Labyrinthine castle."

But while his success may have seemed unlikely to others, the high-schooler was hardly awed by his august surroundings and the men who walked through them. "I remember seeing him in the locker room before one of his matches," Fleming says, "and he was talking about his opponent: 'If I lose to this guy, I'm quitting tennis!' The guy was a pretty good pro, too. John had that confidence even then."

McEnroe was the most exciting newcomer to Wimbledon since Borg. Together they introduced the seemingly unchanging lawns to two major elements of '60s youth culture. Borg, the tournament's one-man version of the Beatles in 1973, had brought the sex. McEnroe, the punkish invader of 1977, delivered the rebellion. It hardly mattered that Borg was more Shaun Cassidy than Mick Jagger, or that McEnroe bore a closer resemblance to Danny Bonaduce from

The Partridge Family than he did any of the Mohawked rockers parading around London at the time. Borg and McEnroe were still radical characters for the All England Lawn Tennis and Croquet Club.

The year that McEnroe made his Wimbledon debut also marked Queen Elizabeth II's Silver Jubilee, a celebration that inspired the country's most notorious punk band, the Sex Pistols, fronted by singer Johnny Rotten, to record a scabrous anti-tribute, "God Save the Queen." ("She ain't no human being" was one of the more polite lines that followed.) On June 7, the day of the Jubilee holiday, the band members were arrested after trying to play the song from a boat on the Thames. Two weeks later, the middle-class tennis fans of Great Britain were treated to their first glimpses of John McEnroe. They saw a freckle-faced, wild-haired American staring desperately at his Wilson wood racquet. They saw a teenager in full meltdown pounding the grass with his fists after he fell while losing a point. "McEnroe's determination in both triumph and defeat," Pete Axthelm wrote presciently in *Newsweek* after the tournament, "took the form of a constant flushed and frantic expression that threatened to break into tears at any time—and left some observers wondering sadly if John had any idea of what a wonderful, exultant thing he was doing." In a matter of days, McEnroe's expressions had redefined what determination and disgust could look like on a tennis court.

Rather than shrieking English schoolgirls, McEnroe was greeted by outrage. Wimbledon's normally well-mannered fans didn't know what to make of this no-name kid—with, as McEnroe put it, "chubby cheeks, thick thighs, and Snickers bars in my equipment bag"—who had the temerity to confront the sleepy retirees that the tournament then employed as linesmen. When McEnroe lost a second-set tiebreaker in his 1977 quarterfinal against Phil Dent, he put his racquet under his foot and began pushing down on it. It appeared that he was going to break it in half. Booing commenced. To McEnroe's amusement, kicking the frame across the grass only raised the decibel level.

Never mind that he was a lawyer's son from a comfortable Queens, New York, neighborhood. Never mind that he was a devotee of dinosaur rockers Led Zeppelin, the band that the punks loathed more than any other. Tennis had its own Johnny Rotten. McEnroe had skipped his high school graduation only to graduate into an unexpected and unwelcome new public image. The Trinity kid who was notorious for crying after his losses in the juniors— "Here come the floods," his opponents would say after they beat him—would be transformed into a poster boy for everything that was wrong with Western society. "The worst advertisement for our system of values since Al Capone," the *New York Times* scolded. By the middle of the 1980s, University of Pennsylvania sociologist E. Digby Baltzell—he had popularized the term *WASP* two decades before—would be inspired to write a book about the role of tennis in 20th-century life. One of its working titles: *John McEnroe and the Decline of Civilization*.

But McEnroe's behavior would hardly have registered if he hadn't also been blessed with a breathtakingly idiosyncratic talent for the sport. He wasn't yet a fully formed player in 1977; a multisport athlete who practiced tennis just twice a week in the winter, he wasn't even a *full-time* player at that point. McEnroe had only just begun to feel physically strong enough to play the serve-and-volley game that would become his signature. But his delicate and deceptive all-court style was something new in tennis, just as Borg's machinelike approach had been earlier in the decade.

It was equally counterintuitive. Borg had won by defending instead of attacking. McEnroe, in an era of elaborate ground-stroke swings inspired by the Swede, had been taught by his coach, Tony Palafox, a former Mexican Davis Cupper, to shorten his stroke— even, heresy of heresies, *to slow it down*. Palafox also emphasized using every part of the court and trying to think multiple shots ahead. He had been a touch artist as a player, and in McEnroe he found the perfect pupil.

"In a way I can't totally explain," McEnroe said of his first expe-

riences on a tennis court, "I could feel the ball through the strings. From the beginning, I was fascinated by all the ways you could hit a tennis ball—flat, topspin, slice."

More than that, he was blessed with an extreme sensitivity to everything around him. People watching McEnroe's matches got the sense that he wasn't just playing; he was conducting the events on the court. "One time I was in a crowd of people at the top of the steps at Queen's Club," says Richard Evans, a British tennis journalist and McEnroe's early biographer, "and I sneezed. John was on court. He stopped and stood up and said, 'Bless you, Richard.'"

At 18, McEnroe hadn't yet filled in his canvas, but the artist's line in his game was unmistakable. The high school soccer standout mixed lightning forays to the net with feathery, caressed drop shots and lobs, all with the insouciance of the born improviser. Like Borg, McEnroe stood the textbook on its head. He didn't bend his knees much, he didn't turn and get his weight into the ball, he didn't switch his grip for different shots, and he barely took a backswing. And unlike every other tennis player in the world, he never got a tan or added any muscle. (McEnroe always lamented the fact that he couldn't build anything approaching the "Popeye" arm that his hero, Rod Laver, developed from years of swinging a heavy wooden racquet.)

By relying on physical superiority and relentless accuracy, Borg carried the game to one extreme. New, heavier balls had been introduced to the sport in the late 1960s, which slowed the pace of play and made his style more viable. From there, Borg set about making the game itself heavier. Points became wars of attrition, and the spin he put on the ball made it weigh more heavily on his opponents' racquets. "It was all *boom, boom, boom*," said Cliff Richey, an American of the previous generation, after he lost to a teenage Borg at the French Open in the early 1970s.

McEnroe carried the game to the other extreme. His easy movement lightened tennis up again. Rather than endurance, he relied on the feel and creativity in his hand and wrist. "His touch is un-

believable," said Mary Carillo of her hometown friend and mixed doubles partner that year. "He really plays with his hand." After studying McEnroe's strokes, instructor Vic Braden said that his "biomechanics are so perfect it's like magic."

If this magician's style wasn't as revolutionary as Borg's, that's because it was even harder to copy. While the Swede held the racquet differently and used new tactics, McEnroe's uniqueness was more fundamental: the ball came off his strings in a way that it didn't for anyone else. Compared to him, other pros hit *at* the ball. McEnroe let his racquet guide it where he wanted. Borg emphasized repetition; each of McEnroe's shots seemed to come with its own unique curl. The man who stopped his run in the Wimbledon semifinals in 1977, Jimmy Connors, summed up the general, slightly bewildered opinion of the teenager: "This kid is tricky to play."

It was in the locker room before the match, though, that Connors paid his younger opponent the ultimate compliment. At 25, "Jimbo" was America's number one player and resident left-handed bad boy, the brat before Superbrat. When McEnroe tried to introduce himself before their semifinal, Connors turned his back. McEnroe, unable to so much as lift his head and look at his opponent, asked himself, "Do I even belong here with this guy?" He didn't have to wait long to hear his own answer. "Don't want to win," McEnroe thought as the match began. "Can't handle it." It was a champion's mind game by Connors, and it was the beginning of years of animosity between the two biggest American tennis stars of their generation. When Connors strutted to the net for the handshake after his four-set win, McEnroe again did his best not to meet his eyes. It looked like the floods might come if he did.

Over the next two years, McEnroe fulfilled his potential everywhere except Wimbledon. He beat Borg and Connors. He reached number two in the world. He won the U.S. Open. McEnroe realized that his net-rushing style was made for Centre Court's slick grass, but he lost early in 1978 and '79, to lesser players. The expectations and the scrutiny had gotten to him.

Now, in 1980, after two relatively calm weeks on the court, McEnroe found himself right where he had left off in 1977: in a sometimes hostile, sometimes brilliant semifinal with Connors. By this point, McEnroe had pushed Jimbo out of his traditional perch in the top two. The result, he admitted, was "some serious testiness."

Most of that testiness, however, came from McEnroe's side, and most of it was directed at a white-headed gentleman several decades his senior named Pat Smythe, who had the misfortune of being in the umpire's chair that day. Late in the first set, McEnroe, his electrified-looking hair ready to burst out of his headband at any moment, squinted upward, his face a picture of pained incomprehension. He bounced a ball on his racquet strings, giving his words a menacing backbeat.

"Can I have the referee, please?" McEnroe said, pointing to the back of the court.

The umpire leaned forward to hear. "No, no, no . . ."

"I'm not playin'," McEnroe interrupted. The hard edge of New York City had come to Centre Court. He sounded like a Queens lawyer pleading his own case. "It's my right to see the referee."

"No, no, no . . ."

"I'm not playin'. I want the referee."

Connors stood in annoyed disbelief at the other baseline, spinning his steel racquet on his index finger. Tongue literally lodged in his cheek, he climbed into the stands to share a laugh at his countryman with fans in the front rows. The familiar audience tumult that followed McEnroe everywhere now surrounded him again. This time it grew loud enough to force Smythe to rise up in his chair and bellow, with exasperated finality, "Mr. McEnroe, you are getting a public warning!" The crowd erupted in approval. Superbrat, muttering, head down, trudged back to the baseline. Two points later, he hit an ace to win the game. He pointed his racquet at Smythe: "How was that?" The match was 28 minutes old.

It was a sequence that would become familiar to all tennis fans: the sputtering disbelief, the righteous harangue, the crowd anger,

and then, when it was all over and it seemed impossible for McEnroe to have a shred of concentration left, the ace. Whereas Borg thrived by controlling everything within him and around him, by burying his emotions, McEnroe worked himself up and worked out the rising anxiety inside. He externalized everything he was going through, even putting his vulnerability on display for his opponent to see. Many players had shown anger or pumped themselves up on court, but McEnroe may have been the first to signal that he was choking. After a particularly bad or crucial miss, he would grab his throat, lean back, and open his mouth as if he couldn't breathe. The tantrums and self-dramatizations didn't always lead to his best tennis, but they didn't destroy him, either; the talent and the temper were, at some level, inseparable.

Also soon to be familiar to fans was the conversation that McEnroe and Connors had at the next changeover. Connors wagged his finger in McEnroe's face, called him a baby, and said, "You keep your mouth shut out here." McEnroe replied by telling Connors "what he could kiss." Still, it was an improvement on an exchange they had had two years earlier, at the U.S. Open. As McEnroe slumped on the sideline during a changeover in their quarterfinal match, Connors filled his mouth with water and spat it at McEnroe's feet as he walked back onto the court. Connors, after marking his territory, would win that round as well.

Playing against each other often brought out the worst in both men. Their matches weren't artistic creations, like those that Borg and McEnroe would stage over the next year. They were knife fights. Connors, the game's great counterpuncher, stood on top of the baseline and crowded McEnroe. And McEnroe's poetic flights around the net were countered by the "pounding prose," as one British writer put it, of Connors's relentless ground strokes. McEnroe had gone to an elite Manhattan prep school. Jimbo, the working-class kid from East St. Louis, reminded him that they had the same Irish blood in their veins. McEnroe may have wanted Borg, the gentleman and model citizen, as his older brother, but he was

stuck with the uncomfortably similar Connors. "It was lefty against lefty, Irish against Irish," Connors said. "It was always about more than tennis with us."

"Borg was the best rivalry," McEnroe said, "it was yin and yang. With Jimmy it was two bulls getting in the ring together."

The rest of this Wimbledon semifinal wasn't quite as dramatic. *Sports Illustrated*'s Frank Deford described it as "unpleasant and interminable . . . like watching grass die." When it was over, McEnroe, though drained from the struggle, had reversed the result from three years earlier. He was in the Wimbledon final. He had reached the tennis stratosphere. He had left Connors behind and was now ready to join Borg at the pinnacle. He believed, as he later said, that his "time had come," and that if he got out to an early lead, he could win easily. But there was a part of McEnroe that still felt like the disfavored son, the unwanted guest at the golden child's coronation.

The night before the final, Borg, sitting in his Holiday Inn suite, flicked his eyes up from the newspaper's Sports section to see McEnroe being interviewed on TV after his win over Connors. The champion listened silently as the New Yorker, with a blend of defiance and defensiveness, said, "I always wanted to meet Borg on grass, which is my favorite surface. I know the Wimbledon audience wants Borg to keep winning forever, but there's McEnroe in his way."

———————

The next day, the rookie finalist shuffled into the locker room at the All England Club alone. He wore white sweatpants, his red-white-and-blue U.S. Davis Cup jacket, and lugged an overstuffed Nike racquet bag. With his sloped shoulders, McEnroe might have been mistaken for a junior player. This was the venerable "A" locker room, where photos of past champions lined the wall and players still hung their clothes on old-fashioned hanging racks. (In the spirit of British class division, the room was reserved for the top players

in the world; everyone else was relegated to the "B" locker room.) The A room had long been Borg's lair. When McEnroe arrived, the four-time champion was already there with Bergelin, strolling around regally in his red-and-cream Fila warm-up jacket and autographing a tournament program for an official.

As Borg sauntered behind him, McEnroe put his bag down and pulled out one of his racquets, a wooden Wilson Pro Staff. He stood back and flipped it into his left hand, his playing hand. In that moment he was transformed. As with a painter with his brush, a swordsman with his rapier, something came to life in McEnroe when he held a tennis racquet. An inner grace and confidence were made visible. Superbrat, the surprisingly shy, high-strung kid with the puffy hair and freckles, the kid who wasn't sure anyone would want him around that day, had vanished. John McEnroe was ready to play his first Wimbledon final.

A few minutes later, at 2:00 PM on Saturday, July 5, 1980, pawing distractedly at his hair and strutting side to side in order to, in Mariana Simionescu's words, "show that he didn't care," McEnroe strode onto Centre Court a few steps ahead of his heaven-sent opponent.

There were boos.

BARBARIANS ON THE LAWNS

"We gave up the fun for the money."

—ARTHUR ASHE, ON TENNIS'S SHIFT FROM AMATEUR TO PROFESSIONAL

n many ways, the 1980 Wimbledon men's final is tennis's Wood-stock. Just as the sight of dazed hippies rolling in mud on an upstate New York farm has become shorthand for the "the '60s," the head-bands and short shorts that Borg and McEnroe wore that day have come to represent the much–mythologized tennis boom years of the 1970s. The preposterously small wooden racquets the two players carried, which would soon be swept away by a wave of bigger, more explosive, atomically manipulated frames, have become the vinyl records of the sporting world, hipsterish talismans from a seemingly simpler, more organic time. Borg and McEnroe would be the last men to win Wimbledon with wooden racquets.

The nostalgia for that day isn't misplaced. While participation in the sport had peaked a few years earlier, the 1980 final would be the high-water mark for tennis as a popular spectacle. It came at the end of a 12-year period in which the sport's players, fully professional-ized and allowed to accept prize money for the first time, leaped

the ivy-covered club walls that had held them for nearly a century and took their place in the Me Decade's celebrity parade. By the end of the 1970s, there were no bigger tennis celebrities than Borg and McEnroe. Their Wimbledon final would be the fulfillment of a decades-old dream: professional tennis played on the lawns, the sport's Mecca, viewed by millions around the world and contested for millions of dollars in prize money. Looked at three decades later, the match, instantly recognized as one of the sport's greatest, serves as a barometer of how far tennis had come in such a short time.

It wasn't *only* boos that greeted McEnroe as he did his shy swagger onto Centre Court. A restless anticipatory buzz echoed through the compact 15,000-seat, 58-year-old arena. The majority of the noise came from the standing-room-only aisles that stretched down both sidelines. Hundreds of youngish fans were jammed shoulder to shoulder—when they weren't falling into and over one another—for the duration of a match that would last nearly four hours. The crowd was drawn from a wider and scruffier spectrum of English society than was seen inside Centre Court before the democratization of tennis in the 1970s. Young men in Edwardian costumes and young women with hacked, punk-style haircuts whistled for McEnroe. Cigar-chomping middle-aged men clapped wildly for Borg. Torn T-shirts, rodeo hats, Rolling Stones lips logos, Fila windbreakers, bright yellow dresses, loud blue sweaters, forehead-spanning sunglasses, pink blouses, army jackets—the genteel sport, forever ridiculed as "lily-white," was witnessed by a colorful middle-class morass on this day. If Centre Court had been a theater, these would have been its groundlings. The standing room sections were the only ones left uncovered by the stadium's overhanging roof.

It would rarely be as rambunctious inside this arena again. After a series of riots at English sporting events in the middle of the decade, the All England Club would be forced to tear out the floorboards

and replace them with seats. In the ensuing years, minus a streaker or two, Wimbledon settled back down to something approaching its staid old self. Today, Centre Court no longer looks ready to burst at the seams on finals day.

That day in 1980, much had changed since the dawn of open professional tennis in 1968, but this was Wimbledon, so much more was familiar. That included the players' traditional bow to the Royal Box, where the Duke and Duchess of Kent sat front and center in their black sunglasses. As rich and famous and entitled as the pros had become during the 1970s, Wimbledon had never stopped reminding them that they were smaller than the game—or, in any case, smaller than Wimbledon. (The tournament's official name, as it appears in the program, is simply "The Lawn Tennis Championships"; "The" might was as well be italicized.) Borg and McEnroe pivoted together to face the royals and awkwardly bent forward. Ideally, they were supposed to do this in unison, but McEnroe brusquely barreled ahead—formal rites, not to mention subservience, weren't his cups of tea—and left the champion to follow a half-second later.

Tennis players would bungle those bows at Wimbledon for another quarter century before the practice was finally halted. But even in 1980 they seemed as quaint as the idea of a royal family itself. Like Wimbledon, which by then was the only significant tournament still held on the sport's first surface, grass, this mandatory genuflection was a literal nostalgic nod to a more glorious English past, as well as to one of the products of that past, lawn tennis, which originated during the prosperous Victorian 1860s and '70s, on the large estates that had begun to sprout up in the countryside during those years.

The new leisure class on those estates needed new amusements, and they got plenty of them. Polo and croquet were first played in England in the 1860s. The rules of soccer were codified in 1868. Badminton and rugby debuted in 1873. But croquet soon proved a bore, and the birdie kept flying away in the wind—what game was going to help eligible ladies meet eligible bachelors? Patented in 1874

by a cash-poor gentleman-at-arms and aristocratic hustler with so-
ciety connections named Major Walter Wingfield, the sport even-
tually called lawn tennis—the name told you that property would
be required—was the answer. Within a year, Wingfield's boxed sets
of racquets, balls, and nets would be purchased by the Prince of
Wales, the Princess of Prussia, Prince Louis of Hesse, eight dukes,
49 earls, and untold marquises and viscounts. At the same time,
lawn tennis spread through the "better military garrisons," as one
historian wrote, to the far-flung outposts of the empire.

But while it was played across the globe, tennis seldom reached
below the upper crust. Like court tennis, the royal sport from which
it was derived (and which was banned in France after the Revolu-
tion), lawn tennis would always be identified with the ruling class.
It was an athletic form of conspicuous consumption; only golf re-
quires more land per person. In the United States it was taken up as
a society fad in Newport, Rhode Island, the summer retreat where
the first U.S. Championships were held in 1881. In France it thrived
on the Riviera. The best player to come out of Germany in the first
half of the 20th century was a baron. In Russia it was played by the
nobility and quickly fizzled after the 1917 Revolution.

The culture of Victorian England would continue to guide this
elite diversion even as the British Empire ceded its global authority
to the United States. That culture was amateur, and the gentleman,
the top-hatted man of independent means, stood at its apex. In the
19th century, it was understood that a gentleman served, whether
he was in the halls of Parliament or on a tennis court, without pay.
Idealistic on the surface, the system was also a handy way of keeping
the wrong sort out: Who else could afford to spare the time needed
to serve in the House of Commons, or perfect his backhand, but a
gentleman?

It was a class division and a way of life that would survive in
tennis longer than anywhere else. While members of Parliament re-
ceived their first paychecks in 1911, the sport's best players wouldn't
be so lucky. In 1913 the gentlemanly officials who ran tennis came

together to found the game's first global ruling body, the International Lawn Tennis Federation. ("Lawn" was finally dropped in 1977, the same year, incidentally, that John McEnroe appeared at Wimbledon.) One of the purposes of the ILTF's formation was to ensure that tennis's important events remained unpaid.

Against all economic odds, the organization succeeded in its quixotic exclusionary quest for more than five decades. Until 1968, tennis remained a secret pastime, a tiny slice of the 19th century sealed off from the 20th century's exploding sports marketplace, a leisurely world of ocean liners, immaculate lawns, and quiet applause populated by well-heeled "tennis bums." In a reversal of merit that's flabbergasting to imagine today, the men who played the game for money—legendary names such as Rod Laver, Lew Hoad, Pancho Gonzalez, Jack Kramer, and Ken Rosewall—were kept out of Wimbledon and the other Grand Slams. In the eyes of the moneyed volunteers who clung to authority over tennis, the professionals were the sporting equivalent of tradesmen, a crasser rung of humanity.

Instead of bringing their talents to Centre Court, the pros traveled through a wilderness of one-night stands in small-town high school gyms. Their court was not an immaculate lawn but a piece of canvas they chucked in the back of a station wagon on their way from one burg to the next. Wimbledon and the amateur establishment acted as if they didn't exist. When Laver won the title there in 1962, he was presented with the club's mauve-and-green tie; like all Wimbledon champions, he had been made an honorary member. The following year, he turned professional, and the All England Club immediately rescinded his membership. Soon after, Laver received a letter from the club's committee requesting that he refrain from wearing its tie.

Bjorn Borg and John McEnroe, professional tennis players of a more welcoming era, stood up from their bows and turned toward their

chairs, which were placed on opposite sides of the umpire's stand. They removed their gaudy warm-up jackets. Underneath Borg's were his customary green Fila pinstripes. Throw in his red-and-yellow headband, wide black collar, and the dark green edges at the top of his socks, and this was as much color as a player had ever been allowed to wear at Wimbledon.

Color on tennis clothes was code for professionalism. The amateur uniform had been an unchanging all-white, a look that was derived from cricket. (After its invention, lawn tennis had been adopted by cricket clubs in England and on the East Coast of the United States.) White represented commercial purity; it also happened to be ideal for hiding the sweat of decorous ladies and gentlemen. The game's "color barrier" was finally, and ironically, broken at the U.S. Nationals in 1968 by Arthur Ashe, who briefly sported a yellow shirt on his way to becoming the first black man to win the title. But even through the 1970s, Wimbledon had held on to its "predominantly white" clothing rule. The custom extended to the balls they used. While the rest of the tennis world had switched to "optic yellow" in 1972—the better to see the ball on TV—Wimbledon stubbornly stuck with white until 1986.

Borg's outfit was tinted further by a set of small, square logo patches. In the bottom left corner of his shorts was a Fila patch; another was on the left side of his chest; and another on each of his shoulders. The Swede was paid handsomely to wear Fila, as he was to wear Diadora sneakers and to play with the orange-and-black Donnay Pro racquet that he now gently tapped against his hand, checking its string tension. While his headband was logo-less for this match, in the past Borg had made a significant amount of money for wearing a band with "TuBorg," the name of a Swedish beer, billboarded above his eyeballs. What beer, even a Swedish beer with the word *Borg* in it, had to do with his athletic accomplishments was left unsaid.

"He looked like one of those guys who used to walk around town with sandwich boards" was how former Wimbledon cham-

pion Jack Kramer, never exactly an admirer of Borg's, described him. In the slightly kinder words of *Time*, the Swede was a "child of the big bucks, media-blitz era of sport."

Borg, who turned pro three years into the Open era, was the first pure product of professionalism. He never had to labor in the one-night-stand wilderness the way Kramer and the other pioneering pros did. He dropped out of ninth grade and started raking it in soon after. The combination of his success and the utterly blank slate that he presented to the world made him the perfect vehicle for another pure product of the professional era, the corporate endorsement.

The stars aligned when one newcomer destined for tennis greatness, Borg, hooked up with another, Mark McCormack, founder of a company with a name that was almost Orwellian in its blandness: International Management Group, or IMG. (A few players eventually did coin a more descriptive meaning for those initials: "I Am Greedy.") It would be only a slight exaggeration to say that before 1968, tennis was run by the ITF; since then it has been run by IMG.

After signing Arnold Palmer as his first client, McCormack built his talent agency into a global empire that represented everyone from Tiger Woods and Kate Moss to Serena Williams and Pope John Paul II. In 1990, *Sports Illustrated* named McCormack the "most powerful man in sports," and with its purchase of the Nick Bollettieri Tennis Academy in Florida in 2001, IMG became the biggest developer of tennis talent in the world.

The firm got into the sport on the ground floor. In late 1967, Wimbledon signaled the end of what is now known as the "amateur era" when it announced that it would allow professionals to enter for the first time. The Open era—"open" to the pros—had begun. The gentlemen of the ILTF, now more commonly known as the "stubborn Old Goats" of tennis, had remained in power longer than they could reasonably have hoped, but they couldn't survive 1968, a year of cataclysm and revolution, when authority was challenged all

over the world, even on its tennis courts. That year, and in the decade that preceded it, old hierarchies and divisions—between black and white in the American South, between men and women, fine art and commercial art, rock and jazz and folk—had been dissolved. The staid old game of lawn tennis contributed one more: its tradesmen, its pros, could now mix with the gentlemen. They could wear the club tie.

More than one amateur official likened the move to opening the temple to the money changers. McCormack, a sandy-haired Yale Law graduate and low-key American workaholic, may have looked harmless enough, but he turned out to be just the figure the traditionalists feared, someone who would take their game from them and expose it to the energy and vulgarity of the marketplace. IMG wasted no time entering the temple. The firm began a relationship with Wimbledon in 1968. It was the opening shot in a war for the game.

At first, the shift from the amateur era to the Open era meant simply that tennis players would finally be paid for their efforts. But what it eventually signaled was the sport's transfer from the British Empire to the American Empire. In the 1970s, jurisdiction over tennis moved from the ILTF's gray-haired volunteers to a motley, contentious cast of U.S.-based agents, lawyers, Barnum-style promoters, and dilettante millionaires, all of whom had been barred from the lawns for nearly a century. The sport, which from a commercial standpoint had resided on such high, dry land for so long, would be swamped by a tidal wave of money. In its focus on the individual, tennis would even turn into a trendsetter. One of the sport's young go-getting agents in the 1970s was David Falk, who would go on to manage Michael Jordan and other NBA stars. There he would be accused of marketing team sport athletes "like tennis players," like, in other words, one-man brands.

In 1980, spectators in Centre Court were still getting used to seeing a new word that had made a sudden and surprising appearance on the scoreboard the year before. Just above the players' names was the distinctive crown logo of Rolex. It was put there

in large part by McCormack, who negotiated the rare sponsorship inside Centre Court in 1979. To get a logo there was a coup. Unlike all other tennis tournaments, where signage is plastered over every square inch of wall space, Wimbledon restricts sponsorships to manufacturers that provide a product to the event. Slazenger, which makes the balls, and Robinsons, which makes the barley water that the players try not to drink, are sponsors. Rolex makes the clocks. To the timepiece company, Wimbledon represented "timeless quality." With IMG in charge, the All England Club's disdain for commercialism was no longer a badge of honor. It was their strongest selling point.

IMG's relationship with Wimbledon conferred prestige, but its tennis meal ticket was Bjorn Borg. The combination of the company's thoroughness in finding new ways to make money out of the Swede, and his near-total willingness to go along with them, made him the richest athlete in the world by the end of the 1970s. In 1979, Borg endorsed 39 products worldwide, from Saabs to suntan lotions to chocolate bars to clogs to Vidal Sassoon jeans to a notebook, pencil, and eraser set; there was even rumor of Bjorn Borg bread. Not content with just one racquet or sneaker deal, he played in Tretorn shoes and swung a Bancroft racquet in the United States, then switched to Diadora and Donnay in Europe. Even Borg's superstitions were marketable. IMG convinced a razor company to pay for the honor of having Borg use one of its blades to shave off his lucky Wimbledon beard each year.

While Borg tapped his Donnays together, John McEnroe engaged in one of his own favorite nervous tics on the other side of the chair umpire. He sat down and relaced his blue Nikes, something he would do at least a dozen more times that afternoon.

Only a few years before, the American had been a Borg fan like anyone else. He had been thrilled to serve as his ball boy at the

1972 U.S. Open at Forest Hills. (McEnroe may have been an angry young man, but he was never a slacker. He won an award for his ball-fetching efforts that year. "Johnny worked so hard and looked so neat," his mother, Kay, said.)

The teenage acolyte was also an enthusiastic Borg consumer. "He had an aura even then," McEnroe said, "even when he was 16, 17, 18." After watching the ice-cool Swede, McEnroe claimed "he would do anything to get a Fila striped shirt." When McEnroe made his debut at Wimbledon, he did it in Borg's green Fila pinstripes. "There was a Beatle-like frenzy when he [Borg] was walking around outside the locker room," McEnroe recalls. "The guy seemed to have it all, and I wanted to be a part of it."

McEnroe, as polarizing as the Swede was inoffensive, would never match the breadth of Borg's endorsement power. But from an evolutionary standpoint, he was already a step ahead in the marketing race by 1980, and it was his controversial image that had put him there. At Wimbledon three years earlier, McEnroe had mismatched his Fila shirt and shorts with a set of Adidas sneakers and socks. The combination of his artful game, anguished face, and that ensemble was nothing if not eye-catching, and it caught the eye of a fellow American, Phil Knight, the 40-year-old chief executive of Nike.

Knight and Nike represented a new breed of sporting goods manufacturer. The Oregon-based company, founded in 1964, had a countercultural mind-set. Knight didn't want to associate Nike simply with winners; he wanted athletes who fit the company's image of defiant individuality, people who broke the rules and still won.

The company had, naturally, gravitated to Romanian wild man Ilie Nastase earlier in the decade. Then, in 1977, according to Nike chronicler Donald Katz, "Knight sat in the stands at Wimbledon and watched a florid-faced 18-year-old play tennis like even more of a maniac than Nastase." Knight realized that McEnroe was a Nike kind of guy, and most definitely not a traditional tennis player. He paid McEnroe $25,000 to stomp all over Wimbledon's grass in

a pair of Nikes the next year. It had been a heady two weeks for the 18-year-old: McEnroe was reviled on one side for his behavior, and paid handsomely for it on the other.

Today, on the Nike campus in Oregon, the conference room next to Knight's office is called the Wimbledon Room. It's located inside a building named after John McEnroe.

Borg carefully laid down his two towels, stood up from his familiar chair, and walked, loose-limbed, back to the baseline. His eyes were firmly on the worn-down grass in front of him. John McEnroe finished tying his sneakers, scratched his hair, pushed his lower lip forward, tugged at his shirt, spun his racquet in his hand, and moved with an outward boldness, and a touch of inner hesitation, to the other. From his position at the center of the baseline, McEnroe could see a line of windows to the right of the Royal Box. These were the outhouse-size warrens that housed the TV booths that would beam the match around the world. Crammed into one of them was NBC color commentator Bud Collins, the glib *Boston Globe* reporter whose nickname slinging and outlandish pants had become synonymous with the sport. In 1968, Collins had been the lone American reporter to cover the first open Wimbledon. On this day 12 years later, he was settling in to do his second live broadcast of the men's final, for a program that would forever heighten the tournament's profile in the United States: *Breakfast at Wimbledon*.

No sport had been remade as thoroughly by TV as tennis had been during those 12 years. Two decades earlier, the great unwashed had been allowed only fleeting glimpses inside the game's clubhouse walls. Coverage was limited to an hour or two of the U.S. Open final at Forest Hills each year. But the potential had not gone unnoticed. In 1966, *Sports Illustrated* ran a lengthy article about the

ongoing sports TV revolution. Of the dozen or so possibilities mentioned, only tennis, where all of the action could be framed inside the screen and every facial tic of the players thoroughly scrutinized by camera and audience alike, was rated as a "perfect" fit for television. The following year, the BBC made its first color broadcast—of anything—from the men's final at Wimbledon. The sight of all that blazing green, gold, and white in Centre Court helped convince the club's officials of the sport's moneymaking potential.

Still, until 1979, the Wimbledon singles final was shown on tape delay later in the afternoon in the States. The live 9:00 AM Wimbledon broadcast was the brainchild of former *Monday Night Football* producer Don Ohlmeyer. The idea that Americans would get up early on a weekend morning to watch tennis was initially met with considerable resistance, but Ohlmeyer soldiered on, and in 1979 the network's morning cartoons were preempted for a day.

There was just one problem. Ohlmeyer had a brief intro set to run at 9:00, before the players, Borg and Roscoe Tanner, took the court. Wimbledon officials wouldn't delay their entrance, even for NBC. Ohlmeyer appealed to Tanner's agent, all-purpose tennis insider Donald Dell, to "do something." Dell, another Yale Law grad, and a former Kennedy staffer, did the only thing he could think of: he had Tanner sit in the men's room for five minutes while the now-familiar opening montage of *Breakfast at Wimbledon*—Big Ben, double-decker buses, strawberries and cream, and the triumphal theme music of composer Clark Gault—played out on TV screens across America. When the underdog Tanner did NBC a second favor by extending Borg to five thrilling sets, Ohlmeyer had a hit. The American Empire had planted its flag—the NBC peacock, in this case—on the lawns, and the United States began a love affair with Wimbledon.

One year later the same montage had just finished running again on NBC. The players were done with their warm-ups. The clock next to the Rolex sign read 2:19. The Duke of Kent watched from his perch above the baseline. In Borg's guest box, Mariana Simionescu, having downed her traditional pre-final glass of Scotch, nervously stubbed out a cigarette that she had held by her knees, to escape her fiancée's notice. Three feet behind her, John McEnroe Sr., in his trademark white cloth cap, blew his nose. His firstborn son, the second-best tennis player in the world, stood at one end of the court and lined up his light blue Nike sneakers, one right in front of the other, along the baseline. He began to rock up and down, "like a broken toy," in the words of *Sports Illustrated*'s Frank Deford. McEnroe was ready to serve.

Borg, the best tennis player in the world, stood rocking side to side far behind the other baseline, his face a mask of utter detachment. All anxiety was expressed in his body, which did a nervous square dance around the spot where he would soon crouch. He was ready to receive. The buzz among the SRO crowd fell to an appropriately theatrical hush as chair umpire Peter Harrfey leaned into his microphone. The word he spoke, in a proper English accent, was also properly theatrical, for this greatest of all tennis shows. It came hurtling out of another era, another tennis empire, one that existed before IMG and NBC, before Nike swooshes and Fila patches and the bags of cash that were attached to them.

"Play," Harrfey said.

CHAPTER THREE

THE NEXT VICTIM

"If Bjorn Borg was behind me, the hell with everyone else."
—JOHN MCENROE

John McEnroe was no longer rocking up and down. He stood at the same baseline where he had started the match two and a half hours earlier, but now his shoulders were slumped. He waved his racquet back and forth morosely. All signs of defiance, of life, had seemingly been kicked out of his body. He lifted his head and barked out a bitter, disbelieving laugh at the dark London clouds. How had he gotten to this point, he seemed to be asking the tennis gods, how had he let it all slip away?

Unfortunately, one of those gods was on the other side of the net. And he had a very good answer. Bjorn Borg was moving from point to point more quickly than he ever had in his life. Veteran Borg observers had learned that, contrary to popular belief, the Ice Man often revealed his emotions on court. You just had to carry a pair of binoculars with you to detect them. A two-inch dip in his chin after a missed shot was the equivalent of a racquet hurled over the fence for most players. If he stared for a not-absolutely-necessary extra split second at a line judge after a close call, it had approximately the same effect as a 10-minute profanity-laced tirade from McEnroe.

Now everyone at Centre Court could see that Borg had picked up his pace. He was eager and confident, and why wouldn't he be? He could see the finish line; he had reached championship point for a fifth straight year at Wimbledon. Borg stood tall and set his arms loosely, almost casually, in front of him, the way he always began his service motion. The crowd raised its collective voice and applauded in honor of the occasion. They didn't sound at all surprised. What was ordained had come to pass again. Bjorn Borg was going to win. The world still made sense. The Angelic Assassin leaned forward, lifted both hands easily over his head, and fired the ball toward the far left corner of the service box.

The entire match had gone according to script. Borg had begun, as he had so often in the past, in a near-catatonic state. He wasn't ready for the speed of the court, which had hardened after two straight days with no rain. His service returns spun lamely into the net, and his volleys caught the tape. His strategy, to serve and volley and beat McEnroe to the net, had been an abject failure. He walked in tentative circles between points. He didn't even appear to be physically prepared; five games into the first set, Borg could still be seen stretching his legs. McEnroe, on the other hand, had been brilliant. All of his serves—the wide one that twisted away from Borg, the body blow that curved into his hip, the bullet up the T—had been clicking. He had broken Borg's serve immediately, with a deft lob, and then done it again. Twenty-seven minutes after it began, McEnroe had won the first set 6-1.

Borg had spent the last three years fighting off left-handed Americans in Wimbledon finals—men's tennis had come to seem like a lone Swede facing down the massed armies of America. Until now, Borg had held his ground. He'd escaped Connors in 1977, 6-4 in the fifth set, and then Tanner in 1979, by the same fifth-set score. But McEnroe was the most perplexing lefty of all for him, because of the particular quality of his serve. Tanner, the "Bulletman," hit the ball so hard that he had actually broken the net against Borg at the U.S. Open the year before. But Tanner didn't have McEnroe's

spin or disguise, both of which were products of the peculiar, side-winding service motion he had begun to use two years earlier, when he found that it eased his back pain. He appeared, in the words of the actor Peter Ustinov, to be "hitting the ball around the corner of a building." But while the rocking motion to start may have been funky and strange, the moment when McEnroe arched his back and extended his right hand in the air, with a touch of nonchalance, to toss the ball remains one of the most beautiful snapshots of a stroke in tennis history—"so perfect it's like magic."

Borg's position 10 feet behind the baseline only made McEnroe's hook serve even more effective. The American had been taught by Palafox to "hit it like you're throwing a knife," an apt term for such a lethal shot. It ran away from the Swede; Borg, wanting to have as much time as possible to sight the ball and unwind his long swings, was loath to move forward to catch it earlier.

According to McEnroe, there was a second, less-obvious advantage for him in this dynamic. "Because Bjorn stood so far back," McEnroe says, "I knew I couldn't ace him, so I didn't have to worry about hitting the serve as hard. I could go for placement and get in close on the net." The court was his for the taking.

It was often said that Borg had a fundamental emotional advantage over his old rival Jimmy Connors, because Jimbo fed on hatred, and Borg, the sneaker-gazing cipher, gave him nothing to hate. Against McEnroe, Borg was taking this idea one step further. He was giving the younger player nothing at all. And it worked. "It all came too easily," McEnroe told *Sports Illustrated* later. "I was in a daze out there. I actually let up a little in the second set. I was thinking, *This is Bjorn Borg playing in the finals, going for his fifth straight. This might not be the greatest thing for me to do.*"

At its deepest psychological level, the match was a case of a little brother trying to slay a big brother, an acolyte attempting to kill an idol. But Borg's hold on McEnroe and on the sport was such that the younger man, even when he knew he had the skill to, as he said, "whip his behind," couldn't bring himself to do it. Op-

portunities presented themselves throughout the second set. In the first game, McEnroe went up 0-30 on Borg's serve, only to miss a routine backhand volley that would have given him three break points. At a crucial moment two games later, he had Borg on the run again. Rather than finish the point, McEnroe appeared to toy with his opponent by attempting a delicate lob from a difficult spot. He missed by an inch. In the seventh game, up 15-30 on Borg's serve, he was presented with yet another wide-open court. Again, McEnroe's backhand floated an inch long. In one of his few displays of emotion that afternoon, he raised his hands to his neck and pretended to choke himself.

It was curious to tennis fans that McEnroe always remained on his best behavior when he faced Borg. He knew he couldn't waste any energy against him, but, more important, he respected Borg too much—or, as he said, he "respected the occasion too much" to mar it with a tirade.

A year earlier, McEnroe had, in his words, begun to "go a little nutty" in a match against Borg in New Orleans. At 5-5 in the third set, the Swede called him to the net. "*Is he going to tell me I'm the biggest jerk of all time?*" McEnroe thought. Instead, Borg put his arm around him. "It's okay, come on, man," he said. "Just relax, it's a great match."

McEnroe was touched by the compliment from the great man. "He was the first guy who really took me under his wing, accepted me, and showed me respect," McEnroe said. "To have the number one guy in the world do that was a tremendous boost to my confidence. It was so rare for Bjorn to say anything at all, never mind something like that. That has to do with respect, champion-to-champion stuff."

When McEnroe had first appeared on the pro tour scene, he had, predictably, been ridiculed for his antics by the game's old guard. In 1977, he had suffered a series of meltdowns in a match against Cliff Richey. Finally, Richey stopped the match, put his hands on his hips, and spent 10 minutes telling the crowd what a

disgrace his young opponent was and how much damage he was causing the sport. Richey was an ornery character himself, but he was also a product of the amateur era. Borg was young enough to understand McEnroe and the particular pressures the pro game put a young player under. He understood the immensity of McEnroe's talent, and the source of his anguish. As a young teen, Borg had been a self-described "madman" himself. He had thrown racquets, questioned line calls, accused opponents of cheating, and regularly lost his mind, until he'd finally had his racquet taken away. After that, he had learned to bury the anger out of necessity. But he could still sympathize.

"I felt like I belonged," McEnroe said of Borg's gesture, "when a veteran like him let me into his circle. I could shut some other people up who were giving me a hard time."

Now, with Borg's brotherly presence to calm him, Superbrat revealed his inner Clark Kent to the British public. It was a pleasant surprise to the fans in Centre Court, who booed him on sight but warmed to him as the match progressed. But it may not have helped his cause. When McEnroe's lob landed just long at the start of the second set, he briefly opened his mouth to protest, but thought better of it. Unwilling to vent his anger on such a momentous occasion, he seemed unsure of exactly how to act for much of the afternoon.

In truth, the leap from number two to number one was a bigger one for John McEnroe than it might have been for another player of his stature and talent. Up to that point, his persona could have been summed up in another of his nicknames: Junior. Peter Fleming, his doubles partner, had hung the moniker on him. Fleming, who is four years older than McEnroe, told British tennis writer Malcolm Folley that he began calling his partner Junior—he still calls him that—after a doubles match they had played against Fred Stolle and Roy Emerson, Australian legends of the amateur age. "One of them," Fleming said, "called out to John, 'Hey, Junior.' Well, he went mad. He yelled back, '*I am not* a junior. I am 19.' From that day on, he was Junior to me."

Like it or not, the name fit. Precociousness, as well as his size, had been themes of McEnroe's youth. When he was four, his father took him to Central Park to play Wiffle Ball. Johnny proved so adept at hitting the ball that a woman approached his dad and asked, "Excuse me, is that a little boy or a midget in disguise?" Always short for his age, John was known as Runt at the local playground. The image followed him into the pros. In his Grand Slam debut, at the French Open in 1977, McEnroe reversed a number of bad calls that went against his opponent, veteran Aussie Phil Dent. After the match, which Dent won in five sets, he put his arm around the teenager and said, "Sonny, this isn't the juniors, we play the calls in the pros."

McEnroe had also made his debut at an odd historical moment. The first wave of Open-era pros, led by Borg, Connors, and to a lesser extent Guillermo Vilas and McEnroe's fellow New Yorker Vitas Gerulaitis, had arrived between 1970 and 1974. Connors versus Borg was the decade's first signature rivalry. Fire and ice, rascal and gentleman, American and European—they divided the kingdoms of Wimbledon and the U.S. Open between them. It appeared that they would be the sport's headliners for the rest of the decade and beyond.

Entering the picture a few years later, McEnroe was too young to be their peer, but not young enough to be part of a new generation. He fit awkwardly into the sport's new professional-era narrative, and he didn't have the luxury of waiting for his turn at the top. He would have to chase the big boys down.

McEnroe's initial reaction to Gerulaitis, who trained at the same Long Island tennis academy, had been similar to his first impression of Borg. At 14, he had "gazed in awe" at Gerulaitis, who was already "Broadway Vitas," the Joe Namath of tennis, a fast-talking, fast-walking, hard-partying Brooklyn kid with a mane of yellow hair and a list of movie star girlfriends. Naturally, he was also a guy with little time for a 14-year-old. (Even when he did talk to McEnroe, the wisecracking Gerulaitis was something less than en-

couraging. "Here's what's going to happen on your first trip to the French," Gerulaitis told Junior when McEnroe left for the Continent in 1977. "You're going to play some guy from Europe that you've never heard of, and you're going to get your ass kicked.")

McEnroe, of course, did not get his ass kicked at Wimbledon that first summer. He was awed to see his name alongside those of Borg, Connors, and Gerulaitis on the scoreboard outside Centre Court on the morning of the semifinals. But he wouldn't feel accepted as a member of their superstar club for another few years. The moment came not at Wimbledon or the U.S. Open, or on any tennis court for that matter. It happened in a hotel lobby in Milan after an exhibition in the spring of 1979. McEnroe went out with Borg and Gerulaitis, and experimented with "something I'd never tried before." He ended the night being carried home by his two buddies. "I felt sick but wonderful," McEnroe said. "I had passed the initiation. I was part of the gang."

But McEnroe's friendship with Gerulaitis would quickly change as his status in the sport changed. It was an early casualty of competitive life on tour, not the last one that McEnroe would suffer. In the fall of 1979, the two New Yorkers faced off in the U.S. Open final. The home crowd booed; they wanted to see Borg and Connors. McEnroe won easily. Junior, the kid who'd been thrilled when Broadway Vitas had deigned to speak to him a few years earlier, had jumped past his friend on the tennis totem pole. Suddenly he had a Grand Slam title, and Vitas didn't. Suddenly he was next in line after Borg and Connors. But the victory felt hollow on one level. "Things were never quite the same between Vitas and me after that," McEnroe said.

Now, nearly a year later, he found himself on the verge of climbing an even higher mountain, of taking something from an even more mythic and important figure in his life. At 5-6, 15-0 in the second set, McEnroe followed his serve in and set up for a volley. Rather than punch it away for a winner, he hesitated, tried a risky drop volley, and dumped it into the net. In the BBC booth that day,

as he had been for many finals, was former player and broadcasting legend Dan Maskell. A man of few words, he was known to allow entire games to pass in silence. He chose this moment to speak up. "I wonder," Maskell said, in his thick, musing voice, "if that attempt at a drop volley will be so expensive as to cost McEnroe the set."

His words quickly proved prophetic. Two points later, Borg moved forward and timed McEnroe's wide serve perfectly for one of the first times that day. He snapped a backhand return down the line for a piercing winner. Out of nowhere, after spending the previous hour wandering aimlessly over the grass, Borg had two set points. The Assassin had found his mark at last. It was the moment the crowd had been waiting for. The applause went on and on; it felt like a wave of relief. A minute or so later, McEnroe drilled a volley into the net to give the Swede the set. The crowd leaped to its feet. It was Borgasm time. McEnroe must have found it hard not to take it personally when, for the first time that day, and one of the first times during the tournament, the sun came out.

––––––––––

McEnroe would later say that the two best years of his career were 1979 and 1980. These were not his best seasons, results-wise or rankings-wise. They were the years when he was, as he put it, "hunting down" Borg and Connors. He loved battling his way upward, "but still not being *the* guy." He enjoyed his role as the tortured wunderkind. The older men at the top shielded him from the brightest, harshest lights of stardom. They saved him from the extra pressure of having to represent the sport as a whole.

Having to be the guy—indisputably, objectively *the* guy—was still a fairly new concept for tennis in 1980. The weekly rankings that are such an unremarkable part of the sport's conversation today were only a few years old. For most of the century, a player might have been ranked once at the end of a calendar year, and his position would have been subjective. Sportswriters made personal lists.

More important were the rankings of the all-powerful amateur federations. These determined who could enter national tournaments, who would be chosen for spots on Davis Cup teams, and even who was allowed to play Wimbledon. The players had to live with whatever the officials decided.

In August 1973 the ATP, the fledgling men's players' union, issued its first biweekly computer rankings (they would go weekly a few years after that). This seemingly arcane development represented a significant power shift, away from tennis's officials and toward its players. A player's ranking was now strictly a product of his results over the previous 12 months. Politics was out; meritocracy in its most scientific form had come to the game. Bill Scanlon, an American whose pro career began in 1976, three years after the computer was first booted up, called it "The one perfect truth. That number arrives every Monday morning . . . pure, objective, apolitical, honest, and unwavering."

But meritocracy has its trade-offs, especially when it hits you in the face with such finality at the start of your workweek. The first player to be ranked number one, Ilie Nastase, an anxious and edgy soul to begin with, believed that some of the camaraderie went out of the game when the new rankings came in. Nastase had begun his career earlier than Scanlon, in the 1960s, when the tour was led by a group of Australians—Laver, Emerson, Newcombe—who played and drank and joked and traveled the world together with a macho, self-deprecating bonhomie. Nastase idolized the Aussies, and he loved nothing more than doing battle with an opponent—as well as with himself, the umpire, and every member of the audience, if possible—for two hours and then going out to dinner with him afterward. After losing to Borg in the 1976 Wimbledon final, he had leaped the net to congratulate his young friend. Nastase said that hanging out with other players was different once everyone "had a number over them." Hierarchy, rather than camaraderie, would become the rule in tennis. Or, as John McEnroe put it in 1981, "Deep down, nobody gives a shit about anybody else."

As the summer of 1980 began, Borg was the number one ranked player in the world. McEnroe was two. It had been that way for more than a year, and it was difficult for anyone to conceive of the roles being reversed. This included McEnroe. When he went to hit the backhand volley that would have given him three break points to start the second set, an unwelcome thought flashed through his head: "It's too soon. I'm not ready to be number one in the world." He wasn't ready to be the guy. Was *anyone* ready for the Merchant of Menace to replace Bjorn Borg as the face of tennis?

As the Viking God marched through the sunshine to a seemingly inevitable win, it didn't appear that anyone needed to be concerned with that disturbing possibility. By 4:53 PM, as Borg's first serve hurtled toward his backhand, McEnroe appeared ready to take his place as the latest in his opponent's line of comeback victims at Wimbledon. They were legion. Mark Edmondson, a burly Australian butcher and reckless net-rusher, had led Borg two sets to one in 1977 and lost. Same for India's Vijay Amritraj two years later. More astounding still had been Borg's win over Michigan giant Victor Amaya in 1978. The Swede was down two sets to one, 1-3 in the fourth set, and he was forced to hit a second serve at break point. Borg went for it all and hit an ace. Amaya never recovered. Gerulaitis played the match of his life in the 1977 semifinals, only to see it all go for naught when Borg slipped past him 8-6 in the fifth set.

Now, in 1980, McEnroe was about to become part of the Borg legend. It was 5-4, 40-15; double-championship point. The Swede's serve sliced into the corner of the box. The ball hit McEnroe's racquet and went straight into the grass in front of him. A mass shriek went up. The match was over.

But then a voice came from the back of the court: "Fault!"

The crowd laughed at its mistake. Borg, expressionless, put his head down and walked back to hit his second serve. In the stands, his future wife couldn't believe it. She had been sure the serve hit the line.

That's when, according to McEnroe, "something magical happened . . . I got my fight back." He threaded a backhand past Borg at the net to save one match point. He stepped forward to hit a spectacular swinging volley winner to save another. At deuce he knifed a skidding approach shot that Borg couldn't handle. He wrapped up the game with a backhand return winner. When the ball touched down inside the sideline, McEnroe let out his first roar of the match: "Come on!"

Confusion reigned in Centre Court. Mariana Simionescu covered her face with her hands. John McEnroe Sr. shrugged and smiled in polite disbelief. Borg put his head down again and walked back to receive serve at 5–5. McEnroe felt, for the first time in more than an hour, that he could win the match. No one knew it then, but his magical four-point sequence had just changed the course of tennis. He hadn't escaped the noose, but he knew he wasn't destined to be a victim of Borg's for long.

LINGERING DEATH

"And so to the tiebreaker. It's like dawn in the Middle Ages, when all the balconies in the scaffold square are booked because no one wants to miss the moment of the beheading."

—MARIANA BORG

Professionalism, prize money, TV coverage, weekly rankings, luxury watch logos, sneaker contracts, clothes with patches on them, razor blade endorsements—all of these marvelous advances had been rushed into tennis over the course of a few years. From the players' perspective, though, the most radical change had come in the scoring itself.

Wimbledon had long been a land of leisure, where every set had to be won by two. If that meant that it took 20, 30, or even 40 games to decide the outcome, well, there was no rush anyway, right? All of that changed with the arrival of television in the 1970s. The game now had to fit inside TV's programming limits and make room for commercials. It helped that tennis had been prepared for this eventuality by the pioneering work of one of history's least likely insurrectionists, a whimsical, bald-headed, ukulele-playing Old Goat Extraordinaire from Newport, Rhode Island, named James Van Alen.

Van Alen had been raised among Rembrandts inside Newport's oldest Gilded Age mansion, Wakehurst. He had Astor blood in his

blue veins and had been captain of the tennis team at Cambridge in the 1920s. By 1954 he was the director of an amateur tournament held each year at the Casino in Newport, a club designed by Mc-Kim, Mead, and White in 1880.

In the summer of 1954, Van Alen found himself in a steadily escalating rage as he watched the singles final at his tournament. The match was supposed to have been a blowout, but Ham Richardson had taken four hours to beat Straight Clark (names don't come any more lawn-friendly than these) by the infuriating, tongue-twisting scores of 6-3, 9-7, 12-14, 6-8, 10-8. Consequently, Van Alen had been forced to move the day's headline match, a doubles final between four of the world's best-known players, Australia's Lew Hoad and Ken Rosewall versus Tony Trabert and Vic Seixas of the United States, to a side court without adequate seating. "I was determined not to deal with anything like that again," Van Alen said, calling these "damnable deuce games" "Chinese water torture for players and fans."

So he invented an entirely new way to score the game, something called VASSS—Van Alen Simplified Scoring System—a not-very-simple set of new rules of which just one would survive: the tiebreaker. If the score reached 6-6, Van Alen decreed that the set was to be decided by a nine-point "extra game" (as it was first called). In its original form, the tiebreaker was the first to five points, win by one. "Sudden death," Van Alen vividly termed it.

The Newport Bolshevik, as Bud Collins dubbed him, peddled his crackpot scheme for 15 years but got nowhere with his fellow Old Goat amateur officials, who considered him a traitor to his class, if not his sport. In 1970, Van Alen finally found a taker in Bill Talbert, a friend from the Newport social circuit and the director of the U.S. Open. Talbert wanted to give the tournament's new TV sponsors, and its growing number of uninitiated fans, a "definite finish line" for matches. The players balked. "I feel like I'm getting a heart attack," veteran pro Pancho Gonzalez grumbled. "That's what it's all about," Talbert retorted, adding that "players don't buy tickets."

The tiebreaker made its debut at the 1970 U.S. Open at Forest Hills. It even came with its own flourish: When a set reached 6-6, a red flag reading "S x D," Sudden Death, was unfurled on court. The flag's color seemed appropriate, because the tiebreaker was the height of tennis radicalism. For nearly a century, since the All England Club laid them down in 1875, the game's rules and scoring system, as arcane as they may have been, had remained sacrosanct. Now the U.S. establishment, in concert with its partners in sports television, had taken it upon itself to change them.

The tiebreaker was an immediate success. By raising the stakes of each point, the format added a new edge of pressure and suspense. As Mariana Simionescu put it in 1980, as her fiancé and John McEnroe reached 6-6 in the fourth set, "Tennis was already a knife with a very sharp edge. But the tiebreaker made it cut both ways."

"It's eerie what the tiebreakers do," said Arthur Ashe, who detested them as much as any other player at first. "Those flags are out and the crowd is absolutely silent."

In 1980, the crowd inside Wimbledon's Centre Court was anything but silent. "Quiet, please, quiet," Peter Harrfey patiently requested, but a buzz continued to circle the stadium. This was, after all, a "poignant moment," as John Barrett said in the BBC booth. (The more excitable and poetic Barrett had replaced Dan Maskell a few moments earlier.) No men's final at Wimbledon had ever been decided by a tiebreaker.

The match might end, but Borg and McEnroe would not be subjected to sudden death. Instead, they would have to endure what Van Alen had called "lingering death." It was an equally vivid term, and a scornful one. Just when he thought he had killed off "win by two" forever, it had been smuggled back in to mar his brilliant creation. A player—not just any player, but the very best player, Rod Laver—had been the culprit. Believing that sudden death at

four points all was too extreme, he had helped create the 12-point tiebreaker—first to seven, win by two. It had become the international standard; even the U.S. Open stopped unfurling its red "S x D" flags and went to the 12-pointer.

"The tiebreaker will now come into operation," Harrfey announced. John McEnroe collected the balls to serve. He felt "happy to be in the match." On the other side of the net, Borg went through his anxious square dance yet again. His expression remained unchanged, but he felt the weight of his missed opportunities: "It was going through my head that if I lose this set I'm going to be in big trouble," he recalls. Balanced together on a tightrope, never more than two points from glory or oblivion, they would extend the "poignant moment" for 20 minutes while playing the most famous 34 points in tennis history.

The men's game today is a war of attrition, of multiple maneuvers and countermaneuvers from the back of the court. In 1980, points were over in seconds; it was thrust and counterthrust, as each man raced to beat the other to the net to avoid the bad bounces on the bumpy turf. "There was more of a premium on every shot in those days," McEnroe says. "Things went faster." While this tiebreaker seemed to go on forever, the momentum whiplashed from one side of the net to the other. The dizzying pinnacle was reached during a four-point sequence that began with McEnroe serving at 5-6 and facing his third championship point.

Borg hit a forehand return that looked, for a split second, like it was going to get past McEnroe. The American dove to his left and stabbed a volley winner from out of nowhere. "I guessed the wrong way," McEnroe says. He was too quick for it to matter.

At 6-6, Borg brought a gasp from the crowd with a stinging backhand pass. "There's the genius of the man," Barrett said in the TV booth. "One fleeting moment and he's through like a rapier."

Faced with his fourth match point, McEnroe struck his own perfect backhand pass. "Oh, I don't believe it!" Barrett cried.

At 7-7, McEnroe, on the full run, belted an even better back-

hand crosscourt. In the stands, Fred Perry, the last British man to win Wimbledon, shook his head and chuckled. Barrett sounded like he was going to jump out of the booth. It was a shot that would stay with McEnroe. Later that summer, when sportswriter Mike Lupica of *World Tennis* visited him at his house in Queens, McEnroe dug out the tape of the tiebreaker, fast-forwarded past the "boring points," and stopped at this one. His eyes widened. "Here, watch this," he said.

The moment must have gone to his head, because instead of going with his strength, the wide serve, on the next point, "I tricked myself by going up the middle," McEnroe recalls. Borg wasn't fooled. He rifled a forehand past him. McEnroe ended the point on his stomach. It was 8-7, championship point again for Borg. As he walked back to the baseline, McEnroe wiped grass blades off his face and spat them out of his mouth. "If this were a heavyweight boxing contest," Barrett said, "they'd stop the fight." McEnroe, naturally, gathered himself and hit a perfect forehand volley to win the next point.

On it went. Winner met with winner. Borg's thudding drives from the nether reaches of the court intercepted by McEnroe's delicate, cupped volleys at the net.

"Was there ever such tension in a men's final?" Barrett asked. Mariana Simionescu imagined two men on a tightrope suspended between the 20th floor of two buildings. "They go steadily ahead to meet in the middle, where one of them will fall."

Facing his fifth match point at 10-11, McEnroe hit a backhand that clipped the tape and fell over on Borg's side. "Surely nothing more can happen in this tiebreaker," Barrett gasped. "Now everything has."

He was wrong. At 15-15, McEnroe ran the width of the court to track down a Borg volley and hooked it up the line far beyond the reach of his opponent. When he saw it land in, McEnroe lifted his arms in his most visible display of determination that day. The shot had taken him within a foot of the first row. "I could feel the ex-

citement coming off those people in waves," he said. "I could sense that even people who didn't want me to win the match wanted me to win the tiebreaker." McEnroe had passed another audition. No one was booing now.

"Another step to the middle of the rope between the skyscrapers." That's what Simionescu was thinking as she watched McEnroe's forehand and puffed on one more cigarette. It would be her fiancé who would make the fatal misstep. Borg ended the greatest tiebreaker in the sport's history with the sport's greatest anticlimax. At 16-17, he dumped a volley into the bottom of the net. The Angel had fallen. "I *knew* I was going to win the match," McEnroe said.

Borg knew how he felt. "This is terrible," he groaned inwardly. "I'm going to lose."

That Borg didn't lose after blowing seven match points would be remembered as one of tennis's signature shows of mental fortitude, and the final proof of his immortality as a player. "I thought he'd let down a little, he'd already won four, but no," McEnroe said. "It made me a better player, seeing that heart."

As unfathomable as Borg's mental resources were, what saved him was the same shot that had begun his run of titles at Wimbledon in 1976: his serve. That year, Borg lost earlier than usual at the French Open, so, with some extra time on their hands, he and Bergelin decided to work on his serve a little. Bergelin had him move his front foot a few inches so that he would get more of his body into the shot. Borg practiced the new stance for a couple of weeks heading into Wimbledon and, voilà, he won the tournament for the first time, without dropping a set (such are the capabilities of the angelic athlete).

Borg's serve came alive in the fifth set against McEnroe. He lost just two points on it in seven games. McEnroe, who had played his semifinal against Connors the day before while Borg rested, began to tire, though he still managed to fight off six break points to survive into the fourteenth game. Finally, on his eighth match point, at 7-6 in the fifth, Borg got a bad hop as he set up for a backhand

passing shot. It was, ironically, the break he needed. With time only to lunge and swing, rather than to think about what he was about to do, he rifled a crosscourt pass an inch inside the sideline for his fifth straight Wimbledon. The crowd erupted for a final time. Borg dropped to his knees for the third straight year.

But after that sudden burst of damned-up emotion, Borg reined it all back in just as quickly. By the time he reached the net to shake McEnroe's hand, his face was expressionless again, his walk as measured and rolling as it had been when he stepped onto the court four hours earlier. As he sat down on the sideline, he looked shell-shocked. The camera closed in on his face. He whispered the only word appropriate to the moment: "Incredible."

The two men accepted their trophies, bowed again to the Royal Box, and walked out of Centre Court to thunderous cheers. One by one, they traveled back to the locker room. On the way there, both men passed under a signboard that held a verse from the poem "If—" by Rudyard Kipling: "If you can meet with triumph and disaster and treat those two imposters just the same." Kipling had been the poet laureate of the empire, "a prophet of British Imperialism," according to George Orwell. He disliked athletics in general, and despised the idea of anyone making money from them. Regularly warning his countryman about the dangers of going soft, of failing to carry the white man's burden, he wrote "If–" in 1895 after reading about a disastrously unsuccessful raid by British commander Leonard Jameson on enemy Boer forces in South Africa. While the battle led to defeat, Jameson himself was hailed as a hero.

The poem, a celebration of the British stiff upper lip and the "muscular Christianity" that built the empire, can also be read as a summary of the ideals of amateur tennis and the Victorian public school values from which they sprang. Victory and defeat are meaningless in themselves, but they are means of building character; of, as Kipling puts it in his poem's bombastic final line, becoming "a man, my son." Sports weren't careers in England; they were a way to learn the values and traits of class and country: teamwork, obedi-

ence, persistence, sportsmanship. In 1895 the head of the prestigious Harrow school maintained that "It is written that England owes her sovereignty to her sports and the spirit of organized games." The first Wimbledon winner, fittingly, was Harrow graduate Spencer Gore.

Now, at the end of the 104th edition of the tournament, Borg had held on to his grass kingdom for another year. But, as John McEnroe Sr. would later say, only a bit wistfully, of the 1980 Wimbledon final, "No one lost that match." It was contested by millionaire professionals in pursuit of tens of thousands in prize money and many more in endorsement dollars. But few matches have lived up to the amateur values of "If–" so thoroughly. Borg found a way to ignore disaster after the fourth-set tiebreaker; Kipling's words seemed to have been written with the Swede in mind. From all appearances, he treated the ups and downs, the many tiny triumphs and disasters, of a tennis match just the same. On the other side of the net, McEnroe, a young man who seemed forever disappointed by the imperfect world around him, had found his tennis satori with Borg and won over a country's fans in the process.

The people around him knew that they had seen a different John McEnroe. His younger brother Mark watched the match in agony and ecstasy from behind a set of aviator sunglasses next to his father in the players' box. "He was usually down after a loss," Mark says, "but he woke up and saw a lot of the good things that people were saying about him in the paper, the same papers that had been trashing him before, and he felt pretty good about that."

The youngest McEnroe brother, Patrick, agrees. "It was the most important match of John's life," says Patrick, who watched it on TV back in the United States. "It let him know what he was capable of, and showed him what it took to be a champion. He had come a long way on talent, but now he saw that you needed something more. You needed that heart. He saw that up close, and it motivated him to make the most of everything he had."

"From then on," says Mary Carillo, who played her last tourna-

ment as a pro at Wimbledon in 1980, "John wouldn't be just an artist. That's what he had been to that point, the temperamental artist. Coming back in that tiebreaker, he knew he had more in him."

Along with that motivation came new expectations. McEnroe realized that anything less than killing the king would be a betrayal of his talent. "I knew I could beat Borg," he thought as he shook hands with the Swede at the net, "but Wimbledon still belonged to him."

Watching from the press benches across the court from the players' box, the famous sportswriter Frank Deford concentrated on the champion. With his dispatches from Grand Slams and his profiles of the game's stars for *Sports Illustrated*, Deford had done as much as anyone to legitimize tennis in the eyes of American sports fans in the 1970s. Now he saw something different in Borg, signs of fear and exhaustion that he'd never noticed before, even in his darkest moments on this same court.

"The champion fell to his knees in exultation," Deford wrote of the 1980 final. "Only then did he show any signs of fatigue. If not in his step, it began to show in his face, in his eyes. He looked drained, frightened in some way, so different from all those about him who clamored with joy at what they had just seen of him and of tennis. But Bjorn Borg was the only one who could have seen clearly within himself, and, my God, it must have scared even him to discover how much was really there."

A biographer of Rudyard Kipling wrote that if you can meet with triumph and disaster and treat those two imposters just the same, you might indeed become a man. But you might become a madman first. Bjorn Borg and John McEnroe were about to drive each other over the edge.

CHAPTER FIVE

THE DARK PRINCE
OF QUEENS

"I want to change. I gotta change. I don't want to be some maniac."
—JOHN MCENROE, JULY 1981

There were few things that John McEnroe Sr. enjoyed doing more than watching his firstborn son play tennis. A high-spirited striver, John Sr. had made his way up in the world, from a walk-up apartment in the shadow of Manhattan's elevated Third Avenue subway line to a comfortable house in the leafy neighborhood of Douglaston, Queens. The son of Irish immigrants, he had worked his way through law school at night and eventually made partner at a prestigious New York firm.

Tennis, which was still largely a club sport in the Northeast when McEnroe moved to Douglaston in the 1960s, was a logical social pursuit for his newly suburbanized, newly upper-middle-class family. Along with his wife, Kay, and their three sons, he joined the modestly imposing private Douglaston Club, which had five clay courts. It was the sporting equivalent of moving to the right side of the tracks.

John Sr. picked up the game alongside 8-year-old John Jr. It took only two years for the son to start beating the father, who quickly

found himself doing a lot more watching than hitting. Day after day, year after year, McEnroe Sr., who was a good but not outstanding athlete—he had been the 12th man on the Catholic University basketball team—would sit at the back of a tennis court, smiling as his boy worked his mysterious magic with a wooden racquet. Even his son thought it was a bit much. "Take a break, take your wife out to lunch," John Jr. would find himself thinking when he saw his dad in his usual position, with his usual smile.

Senior didn't take a break. For years, as cameras panned across the stands at McEnroe's matches, his white hat stood out in the crowd. He was famous enough in his own right that, one year, many seasons after his son had retired from tennis, two fans showed up at Wimbledon in John McEnroe Sr. costumes: white hat, white shirt, dark tie, sunglasses. When John Jr. came out of retirement to win a minor ATP tour doubles tournament in San Jose in 2006 at age 47, his father was there, leaping with joy in the bleachers as if he had won Wimbledon all over again. While he never condoned his son's more boorish antics, McEnroe Sr. did his best to understand and, like a good lawyer, make his case. "It was just him," McEnroe Sr. says simply. "He couldn't help it; it wasn't an act. I don't know how many times I said to him, 'John, it's not helping you to act like that.' He'd put his arm around my shoulder and say, 'Pop, I promise it'll never happen again.'"

After the 1980 Wimbledon final, father and son flew home together. Junior fell asleep while Senior picked through a stack of London newspapers. Normally this was a moment to dread for anyone named McEnroe. But as the pages and stories went by, it became clear that, at least for this day, Superbrat had been forgiven by the British press. As the tales of Centre Court glory continued, and the praises continued to be sung for his son—Johnny Rotten had been transformed into Mozart over the course of four hours—tears began to slide down McEnroe Sr.'s face. The world had finally witnessed what he'd been seeing all these years.

The glow from the War of 18-16 didn't fade once they crossed the Atlantic. It could be felt that summer inside the McEnroe home on quiet Manor Road in Douglaston, in John Jr.'s den at the back corner of the house, where the only sounds were the birds chirping in the backyard. When he wasn't watching *General Hospital*—the saga of Luke and Laura transfixed the youth of America that year— McEnroe practiced with a new sense of purpose. In those four hours on Centre Court with Borg, he felt like he had discovered a new reason for playing the sport. Or maybe it was an old reason, one from an earlier era, and an earlier time in his life.

There had always been pressure to succeed in the McEnroe family. Achievement was in the blood, and in the air on Manor Road. John Sr. wasn't the only striver. His wife, Kay, who jokingly described herself as the "Wicked Witch of the West," was equally ambitious for her husband and three sons. When McEnroe Sr. finished second in his law school class at Fordham, she said that if he had just studied a little harder, he could have finished first.

Education was stressed, and John was sent to excellent private schools. He went to Buckley Country Day School on Long Island. Then, in ninth grade, his parents sent him to Manhattan's Trinity School. Founded in 1709, Trinity is the oldest continually operated school in New York City. It's also closer in spirit to a British boarding school—complete, in McEnroe's day, with a tweed-jacketed, pipe-smoking headmaster—than to a typical American high school. McEnroe's closest adviser there was an English classics instructor.

Faithful to his parents' wishes, McEnroe at first saw academics as work and sports as recreation. He didn't take tennis all that seriously until late in his teens. Unlike today's top juniors, he never dedicated himself solely to one sport. As late as his junior year in high school, McEnroe practiced tennis just two times a week in the winter. Even after reaching the semifinals of Wimbledon, he remained an amateur and went to Stanford for a year. The whole point of tennis, in his parents' eyes, had been for him to get a college scholarship.

But once it became apparent that the sport would be his career, McEnroe the achiever began to play it with the utmost seriousness; obliged to live up to his potential, he would remain unsure about how much he loved tennis, and how much he did it out of duty. Either way, academics took a backseat. In high school, McEnroe was better known as a back-row wit than a standout student. At Stanford, he started by enrolling in calculus and other challenging subjects, but ended up gravitating toward gut classes such as Paranormal Psychology. He eventually found his way to a teacher who required no tests or papers at all. Students just, as they said in those days, "rapped" about their issues. It was how McEnroe did on the tennis court rather than in the classroom that now would determine his success.

But the 1980 Wimbledon final hadn't felt like work. It had felt, instead, like a state of grace, McEnroe told *World Tennis* later that summer, as the U.S. Open and a possible rematch with Borg approached. It was the perfect world realized, a rarefied zone where the competition between two athletes was all that mattered. With the Swede on the other side of the net, McEnroe could block out all the other annoyances and disappointments and grievances, at least for a few minutes, and just play tennis. Losing to anyone else meant that he hadn't done justice to his talent. That wasn't the case when he lost to Borg. "If we could keep lifting our games," McEnroe said, "I didn't have to worry about the crowd or the linesmen or anything. It didn't matter if there was going to be one or two or three bad calls. See, it was the match that counted. Bad calls, you go on. Aches and pains, you go on. I learned a lot that day, about myself, about Borg, about tennis." With other opponents, McEnroe competed against his own potential, his own expectations of perfection. But his respect for Borg allowed him to play him head-on and forget himself.

As seriously as he treated the game, McEnroe, with values instilled by his education and strong family background, retained some of the spirit of the amateur. It was the theory of his biographer,

Richard Evans, that, as preposterous as it may have sounded on the surface, Superbrat was "at heart the true amateur sportsman."

"One can just see him," Evans wrote, "wandering around a tennis club with his socks around his ankles, clad in the same pair of wrinkled shorts that he had worn to whip some bemused opponent the week before, the arms of his school sweater wound around his neck. . . . McEnroe would have been much happier amid the camaraderie of the amateur sporting world with its code of honor than the code of conduct he faces on today's cutthroat professional circuit."

There was some truth to this. As a junior, McEnroe was known to make line calls against himself, and an ingrained aversion to phoniness of all sorts translated into a hatred for cheats on a tennis court. On tour, he was one of the few top pros who traveled the way the amateur tennis bums of old did, without a coach or an entourage. Asked in 1980 if he wanted a Lennart Bergelin–like assistant in his life, the 21-year-old replied, "Boy, is that the easy way out. You put all the problems on him. Make the plane reservations. Do the laundry. Do this. Do that. Get the racquets. It would make more sense for me to get a secretary."

Even as a pro, McEnroe was known to give away a point if he believed an opponent had been robbed. In a match with Borg at Madison Square Garden, the Swede felt he had gotten a bad call. Uncharacteristically, he began to argue. McEnroe walked up to the net and told him to go back and serve the next point. When Borg did, McEnroe knocked his return into the third row.

Evans, a British writer, emphasizes McEnroe's old school code of honor, but there was obviously a harder edge to him as well. Other writers compared him to Holden Caulfield, the antihero of J. D. Salinger's *Catcher in the Rye*. Both were New York prep school students, and both were in a perpetual state of rebellion against the status quo. But while Caulfield was a product of Manhattan in the 1940s, McEnroe was an updated version, one who rode the city's crumbling subways during the apocalyptic 1970s. McEnroe may

have studied Latin in school, but simple survival was part of the learning process in New York, too. No one who lived there at that time could escape the rough-and-tumble of urban life.

Getting from Douglaston to Trinity every day required a 50-minute subway ride, including a change of trains at the then-seedy Penn Station. Passing the West Side Tennis Club in Forest Hills each way, McEnroe made this journey, solo, from 1973 to 1977, a time when crime was spiking all over the city. He was almost mugged once, but his quick feet carried him away unscathed. Most memorably, he used his time on the subway to train his Caulfield-esque eye on the shady, hungry world around him. "A man with a sign around his neck saying 'deaf and dumb' was shuffling past us on the train," McEnroe once recalled, "and someone on the train called his bluff and goes, 'You're not deaf, you asshole,' and just for a split second, I saw the guy react. He had his back to us as the man said it, so I knew he had heard. That taught me a lot about New York City and what kind of phoniness there is around."

What was the result of all of these crisscrossing urban influences on McEnroe? He was a high achiever; an artist with a racquet; a keen, wary, and cynical observer of human nature; a kid with an innate sense of justice; a rock-and-roller; a survivor. According to one veteran of the tennis scene who encountered him during his early years on the tour, he also possessed the gum-cracking bravura of the kid hustler.

Photographer Russ Adams met McEnroe on the 18-year-old's high school field trip to Wimbledon in 1977. "He sat down next to me on the plane," Adams says, "and we started talking. I ended up driving him to a hotel in London. The whole way there he's saying, 'I like this car, I think I could drive this. Can I drive it?' I put it in a parking lot and got out, and he asked if he could just drive it around the lot. I rolled my eyes and left him the keys. A few minutes later a guy comes up to me while I'm at the front desk and asks, 'Is that your car out there? Because there's a kid in it doing 40 miles an

hour in circles around my car, in reverse.' I went back out and John looked up at me from the driver's seat and said, 'See, I told you I could drive it.' I said, 'move over, buster.'"

McEnroe forced confrontation. A serve-and-volleyer by nature, he was always, as he put it, "moving forward." It wasn't a coincidence that the profile in *World Tennis*, while it waxed on about the "state of grace" that McEnroe had found with Borg, ended up with a slightly less lofty title: "Now He Wants It All." Near the end of the interview, McEnroe was asked what it would be like to beat Borg on the Swede's favorite surface, clay. Standing up, shirtless, spinning his racquet in his hand and "whipping imaginary forehands and backhands" across the room, McEnroe stared straight ahead. A smile crept across his face.

"Wouldn't that be a bitch?"

———

Upon McEnroe's return to the U.S. Open in 1980, he could hardly have expected the fans in his hometown to show a native pride in his achievement at Wimbledon. He was a local kid, but he wasn't New York's kid. While the city's tennis fans hardly constituted its grittiest class of citizen, they identified more with the combative hard-knock kid Jimmy Connors, even if a good third of Connors's tough-guy charisma was a showman's bluster and blarney. "Connors got everyone believing *he* was from New York," McEnroe said, "and I was some guy from St. Louis."

The city's opinion of McEnroe at that stage was summed up in a *New York* magazine profile. According to one Queens resident interviewed in the piece, he was nothing more than a product of his environment. "Douglaston kids were wise guys," this unidentified New Yorker said, "great with the mouth. They always knew how to drive before you did, but you knew you could beat them up."

McEnroe, despite his Irish roots, had no Connors-like blarney

to offer, or even a hint of humor to make his anger go down more easily. To his eternal regret, he was unable to see anything fun or funny in a tennis match, unable to turn even the most absurd situation into a joke. (Neither McEnroe nor his future wife Tatum O'Neal liked photographs where he was caught smiling; it just wasn't Johnny Mac.) He thought there was something phony about pretending that competition was anything other than life or death.

McEnroe didn't play to entertain; he was alone out there with his own expectations. He even expressed resentment of the fans at times, who "sat back and ate cheese sandwiches" while he went out of his head. But as alone as he felt, the ultra-sensitive McEnroe was always attuned to the spectators' emotions, and which way they were swaying. In his own survivor's form, he would find a way to use the hostile crowd to his advantage at Flushing Meadows in 1980.

Whatever the locals thought of him, McEnroe was at home when he played the U.S. Open. As a child in the early 1960s he had lived in an apartment with his parents in Flushing Meadows, five minutes from where the stadium was being built for the 1964 World's Fair. Two decades later, in the fall of 1980, that arena would be the sight of the greatest sustained performance of McEnroe's career, what he characterized as his "ultimate physical achievement."

First, he succeeded in holding off the future of the game by beating up-and-coming 20-year-old Ivan Lendl of Czechoslovakia in a rugged quarterfinal, 7-5 in the fourth set. McEnroe then faced Connors in a savage five-set semifinal. As one observer put it, the match, which was decided in a final-set tiebreaker, "so ignited center court that the stadium lights were hardly necessary." A bearded Connors, who was at his crotch-grabbing, fist-pumping finest, had predictably whipped the crowd into a frenzy. At one point, he heard cheering from the McEnroe contingent in the players' box that he didn't appreciate. He glared in that direction for a few games. Then came more cheering after one of his errors. Connors walked slowly and menacingly across the court and, according to Patrick McEn-

roe, "hawked up a real nasty loogie" onto the cement. "He spit it right at us, just short of the box." Connors looked into the seats and said, "Hey, why don't you pick that up?"

From late in the second set to early in the fourth, Connors won 11 games in a row. But this time his act worked a little *too* well. Thinking the match was going to end in a hurry, the New York audience wanted to see more tennis so desperately that they were willing to root against their adopted son and cheer for their real one. There was an unexpected change in the nighttime New York air.

Like Connors, McEnroe had also been in fine form, taking time out periodically to demand the ouster of the chair umpire—or, as he was known to McEnroe, "Mr. Incompetent." Now McEnroe had been given a chance to do something different. He latched on to the crowd's burst of positive energy in his direction, while the wind went out of Connors's sails. By the end of the fifth set, of course, the fans had swung back toward Jimbo. But it was too late. Serving brilliantly in the fifth-set tiebreaker, McEnroe defied the 18,000 seated in the arena and slammed the door with one last beautiful delivery up the middle.

His reward was a return date with Bjorn Borg less than 24 hours later. Perhaps because of McEnroe's exhaustion, and the fact that Borg was hell-bent on winning his first U.S. Open and extending his quest for the Grand Slam (in those years, the Australian Open was played at the end of the season, and Borg had already won the French Open and Wimbledon), this final unfurled in a very different way from their Wimbledon classic. For once, Borg started quickly. There was a sense of déjà vu at 4-4 in the first set when, just as he had at Wimbledon, he anticipated a McEnroe serve out wide in the ad court and snapped a backhand pass by him down the line to break.

But McEnroe knew now that he could come back against Borg. In the next game, as he had late in the fourth set at Wimbledon, he threaded his own forehand pass around Borg to break back. He eventually won the set in a tiebreaker. Then something stunning

happened. Borg quit. He shanked a backhand into the flower beds at the side of the court. He missed 12 straight first serves. He had no feel, he said; he didn't know what was going on. In the words of *Sports Illustrated*'s Curry Kirkpatrick, Borg was "slogging along like a lonely basset searching for shelter."

Once again, it was all coming too easily for McEnroe. He didn't know what to make of the hangdog Swede. He had opportunities to finish Borg off early in the third set, when Borg couldn't buy a first serve. McEnroe went up 0-30 in the second game and 15-40 in the fourth. Both times Borg wriggled free. When he wriggled all the way through a third-set tiebreaker, the crowd broke free in a volcanic eruption. When he sneaked out of the fourth set 7-5, they went berserk. It was Borgasm time once more. They knew what was coming now. Borg was finally, after failing eight times at the Open, bringing his Houdini act to New York.

John McEnroe knew it, too. The same way that he knew he would win the 1980 Wimbledon final after the fourth-set tie-breaker, he knew now that he was destined to be "one more victim" of the Assassin. Since 1976, Borg had been pushed to five sets 13 times; 13 times he had survived. McEnroe could feel the crowd looking forward to number 14, and it helped him. Now he truly had nothing to lose.

As the fifth set progressed and he stayed even with Borg, McEnroe started to believe that he had a "surprise in store" for the fans. He was right. With some help from a bad call that went against the Swede, and a subsequent pair of inexplicable double faults from him, McEnroe defied the stadium faithful for a second straight day to win 6-4 in the fifth set. He had escaped the noose at last.

In the words of *Tennis Week*'s Gene Scott, over the course of four days the 21-year-old local kid had "absorbed the crowd's hostility, the Connors match, the unpopular task of foiling the Grand Slam, a troublesome ankle, and spit them out like so many stale bread crusts." He had "taken the heart out of his rival with his bare hands."

By 1980 the U.S. Open was gaining on Wimbledon as the world's most prestigious tennis tournament. The Open's old location, the lawns of the West Side Tennis Club in Forest Hills, had been seen as a kind of junior All England Club. But professional tennis, and the subsequent takeover of the sport by the United States, had begun to change that perception. Two years before, the tournament had left Forest Hills after 62 years and moved into titanic new concrete digs at the National Tennis Center in Flushing Meadows. The surface there, rubberized asphalt, was thought to offer a fairer test of the players' skills than those at the other majors, which at that time were grass or clay. There was a sense that the Open represented the sport's future while Wimbledon was part of its fast-receding past.

But the future hadn't arrived yet (and it would never come; with IMG's help, Wimbledon revitalized itself and reestablished its pre-eminence in the 1980s and '90s). While McEnroe defeated Borg in New York, he did not dethrone him. He still needed to do it at Wimbledon.

The prospect of that match-up began to haunt McEnroe as 1981 progressed. It even appeared to transform him physically. When he turned up at the season-ending Masters at Madison Square Garden in January after a long holiday, he was overweight. A month later, all of the extra weight, as well as any remaining baby fat, had vanished. Cutting out beer and dessert and making a concerted effort at exercising had taken him from 182 pounds down to 154. McEnroe looked like a new person—wiry and sprung where he had been adolescently soft. He started to play well again.

Still, the demons remained. He couldn't rest until Wimbledon was his. McEnroe complained about the heightened scrutiny that went with his new stature. Meeting more people just made him feel phonier, further from his true self, he said. Coming to the French Open, he'd felt good about his chances. But his mood quickly became a match for the foul weather in Paris. During one match, he

spotted someone at courtside holding one of the long "shotgun" courtside microphones that had been recently introduced to pick up the sound of the ball better; McEnroe strongly suspected they were there to pick up the sound of him, John McEnroe, better. "Keep that thing away from me, ya understand?" he barked.

The mike remained. "See this," McEnroe said to the man with the mike as he pointed at the top of his racquet. "In your mouth. Repeat that in French for everyone. You're gonna get it."

In the quarterfinals he faced Lendl, a player he had never lost to before. From the start, McEnroe played in an escalating fog of confused frustration that bordered on self-loathing. He started in on the chair umpire about the rainy conditions before the warm-up had even begun. He got the tournament referee out on court and harangued him as well—"Answer the question!" Playing as if he wanted to be somewhere else, McEnroe eventually lost to Lendl in straight sets. It was the Czech's first win over the American; it wouldn't be his last. "Who's a bigger disgrace, you or me, umpire?" McEnroe asked near the end. Apparently he already knew the answer. Afterward, he responded to a question about his performance. "Well, I'd say disgraceful is just about the best way of putting it."

Winning didn't help. The following week, McEnroe returned to London and the Wimbledon tune-up on the grass courts at Queen's Club. This was a tournament he owned—he would win it four times—even if, as usual, the crowds had their reservations about him. Two years earlier, McEnroe became embroiled in a dispute with a group of people who had called him a "baby" and a woman who told him "you're ugly"—before the match had begun.

It was business as usual at the Queen's Club again in 1981. McEnroe won the tournament despite doing battle with an opponent, fellow ornery American Hank Pfister; a line judge; and a chair umpire. What was worse for McEnroe was that the more confident he felt in his game, the more worried he became. In his mind, where talent and promise hung like a curse, feeling that he *could* win Wimbledon quickly turned into feeling that he *should* win

Wimbledon. "The pressure was incomprehensible," McEnroe said of his arrival at the All England Club in June 1981. It was incomprehensible, even if it was nowhere else but in his own head.

He was about to let it out.

It didn't help that, once again, McEnroe couldn't get away from himself in London. His annual visit had begun to seem like a one-man American invasion, an assault on a proud country and its traditions. The year before, a cartoon of his famous nest of hair had been plastered on billboards around the city, advertising his presence at the tournament at Queens. In 1981, Nike got in on the action, pushing his bad-boy image. Their ads showed Nike tennis shoes underneath the headlines "McEnroe Swears by Them" and "McEnroe's Favorite Four-Letter Word." His father, who doubled as his manager, reluctantly signed off on them. According to one Nike historian, when McEnroe Sr. balked at the idea of pointing out his son's foul language, a friend who was in the meeting with him said, "Come on, John. Let's face it, your son is not the Pope." McEnroe Sr. signed.

The soliloquies, disquisitions, and assorted rants, poses, and grumbles of John McEnroe at Wimbledon in 1981 did include their share of choice words, and they started early. In a notorious first-round match against Tom Gullikson, a match that nearly got him thrown out of the tournament by the Wimbledon committee, McEnroe dragged referee Fred Hoyles onto Court 1 and "four-lettered him," as *Sports Illustrated* put it, up and down the sideline.

But his schoolboy outrage over the next two weeks also had a poetic quality. The self-imposed pressure didn't just produce a touch of genius from his racquet, it also inspired a touch of adolescent genius in his words. "Chalk flew up!" "This incompetent fool." "The pits of the world!" "You're a disgrace to mankind!" "I'm so disgusting, you shouldn't watch; everybody leave!" And of course,

the game's most infamous and unnecessary clarification: "You can't be serious. You can*not* be serious!" These are the canonical texts of modern tennis literature. But McEnroe would turn out to be the Rimbaud of tennis ranters; his best stuff came in the blinding heat of youth. The anger, the aggression, the irrationality, the foul language, and the embarrassment afterward would all remain, but the caustic creativity would, for the most part, fade.

Before the 1981 tournament, McEnroe voiced his disgust with the conditions at the All England Club. "The only thing 'championship' about Wimbledon is its prestige," he claimed. When the matches began, he said, "This place stinks." He revised the assessment downward: "It reeks!" He called the fans "vultures."

During his semifinal, in which McEnroe was given another public warning, Lady Diana Spencer, then engaged to Prince Charles, was quietly ushered out of the Royal Box. "The wedding's off; her ears are no longer virgin," one reporter quipped. In a doubles match against the Indian brother team of Vijay and Anand Amritraj, McEnroe wondered out loud whether a line judge wearing a turban was "biased."

When the fortnight was over, McEnroe told a friend that it had put him as close to "going over the edge as I can imagine. The only way I could make it a positive experience was somehow to win." To do it, he would have to end the five-year run of his friend and sometime idol, Bjorn Borg, the man he knew he could, and should, beat. The two faced off before an even more raucous crowd than had watched their Centre Court classic the previous year.

Again Borg was coldly opportunistic while McEnroe agonized. The Swede had one break point in the first set; McEnroe had eight. But it was Borg who capitalized on his and won the set 6-4.

Again, McEnroe found refuge in the rivalry. So much so that he said he was "enjoying myself too much out there," and suddenly found himself behind.

Again the tiebreaker played a crucial role. McEnroe won the

only one they played in the 1980 Wimbledon final, and they had split two of them at the U.S. Open later in the year. Now McEnroe established his superiority in this crucial new feature of the modern game. He won the second and third sets in tiebreakers. The tide of their rivalry had turned for good.

The match was up for grabs in the third set, and each had his chance at it. Borg led 3-1 before McEnroe broke back. Then Borg, with McEnroe serving at 4-5, held two set points. The crowd inside Centre Court was the loudest that one veteran Wimbledon observer could remember; the groundlings seemed to have doubled in the last 12 months.

According to Gene Scott, the match was "like broken glass, brutal, deadly, and reckless. Excitement ran like blood from an open wound." It was McEnroe, rather than Borg, who was now stamping their matches with his signature emotional and playing styles. He served his way out of those two set points, and out of danger. The crisis had passed. He was going to be the champion. A "strange idea started to materialize" in McEnroe's head as he looked across the net at his opponent: Borg wasn't as hungry. The match was his to take.

When his last forehand volley curled inside the sideline and past a dejected Borg, McEnroe's hair seemed to stand on end, his brain fried by the experience. The Swede was the people's choice, the Angel who ruled by divine right. His kingdom was an enchanted one, and, as McEnroe knew, the vast majority of tennis fans, and even average citizens, never wanted to leave it. Toppling it had required McEnroe to stage a solitary rebellion, against his opponents and against Wimbledon. In the process, he gave the tournament a different kind of angelic figure, a dark angel of individualism and self-expression. He felt throughout that he had done it alone. "I don't know who I can turn to," McEnroe said afterward.

With his victory, McEnroe reached number one in the world at the same time that he became a symbol of all that was rotten and

overly permissive in post-1960s liberal society. He was a house-hold name, a lightning rod, a subject for the op-ed pages, someone whom the average citizen was supposed to have a definite opinion of. Wimbledon in 1981, he would later say, had made him "in-famous." On the one hand, McEnroe inspired a cult of young fans that year. The fans in the standing-room-only section had lifted their arms in a mad celebration when he won the final point against Borg. The English, who knew the figure of the tormented pub-lic schoolboy well, may have had a better grasp of what drove the seething McEnroe than Americans did.

On the other hand, at least one conservative British commenta-tor theorized that Superbrat's example helped set off the wave of youth rioting that swept Great Britain that summer. The ultimate tennis authority, the All England Club, voiced its opinion clearly when it was all over: McEnroe was the first champion not to be of-fered an honorary membership. He in turn became the first winner in memory to skip the Wimbledon Champions' Dinner. Years later, the memory of that snub inspired him to one more flight of harsh poetry: "I wanted to spend the evening with my family and friends and the people who supported me," McEnroe said, "not a bunch of stiffs who were 70–80 years old, telling you that you've been acting like a jerk."

To McEnroe's chagrin, the women's winner, Chris Evert, apolo-gized to the dinner guests for him "as an American." The day be-fore his opening-round match at Flushing Meadows a month later, Wimbledon committee members sent McEnroe a reminder that they hadn't forgotten his infamous two weeks there. They, along with the men's tour, slapped him with a $5,000 fine for his behavior during the fortnight. Disaster had been turned into triumph; tri-umph had been turned into disaster.

It wasn't just McEnroe; there was a generational conflict at the 1981 tournament that felt like the 1960s on tape delay. It was a conflict, on one level, between the old tennis empire and the new. Other American players, who were now used to running the pro-tour show, chafed at the high-handed treatment they continued to receive from the committeemen who ran Wimbledon. Jimmy Connors claimed that they treated the players like "nothings." Peter Fleming got the feeling that "if you didn't go to Cambridge, you're zippo."

The game had been professional for more than a decade by 1981, but it would be a few more years, and many more McTantrums, before its umpires and linesmen followed suit. In those days, each tournament cobbled together its own set of officials who were paid a nominal fee and often pulled from the ranks of the retired. Wimbledon, with its mania for authority, liked to use former military officers as chair umpires. The man who mistakenly believed he was being called "a disgrace to mankind" by a petulant 21-year-old—McEnroe was actually referring to himself—was former RAF wing commander George Grime. The club's highest-ranking official, Sir Brian Burnett, went by the title Air Chief Marshal. There was, in that 1960s phrase, a "failure to communicate" around the grounds, between young and old, American and Brit, McEnroe and everyone else.

Before stepping out to umpire McEnroe's first-round match, Edward James said to him, "I'm Scottish; I hope we don't have any problems." The Irish American didn't know what that meant, but he knew he didn't like the sound of it. Later, in his inevitable mid-match meltdown, McEnroe screamed, "You're the pits of the world." The elderly James thought he had said "piss." "The guy had obviously never been to Queens," McEnroe said later.

McEnroe's dark mojo spilled over into the pressroom. A reporter asked him about the state of his relationship with his longtime girlfriend Stacy Margolin. There had been rocky moments ever since

McEnroe decided, at the French Open the previous year, to admit that he had cheated on her. McEnroe took exception to the line of questioning and eventually walked out of the interview. His vibe didn't leave with him. A dialogue on the merits of celebrity journalism ensued between two reporters. It grew heated, and differences were finally settled on the floor of the pressroom, where bodies tumbled and punches flew.

Like a 1960s antihero, John McEnroe, in his madman's solo rebellion against Wimbledon in 1981, made people in and out of tennis choose a side: Was he a rebel or just a brat? Did he have the integrity of a perfectionist, or was he a harbinger of a world without authority? Did the unchanging Wimbledon need to change?

Back in New York, two days after the final, the John McEnroe Charity Ball took place at the disco Xenon in Manhattan. McEnroe, looking tragically forlorn in jeans and a T-shirt, the picture of misunderstood youth, donned a pair of sunglasses to play guitar onstage. Emcee Alan King announced that he was declaring McEnroe an "honorary Jew—which honors you to 2,000 years of retroactive persecution." When asked about the All England Club, the Wimbledon Champions' Dinner, and the membership snub, McEnroe shrugged. He said he wouldn't see them for a year anyway, if he even went back.

He had what he wanted: Bjorn Borg's crown. The next month, Borg would come to New York looking for his.

EXILE ON PARK AVENUE

"How long can Bjorn Borg last?"
—BJORN BORG, AGE 18

The night of the 1980 Wimbledon final, the champion returned to the Holiday Inn and spoke to no one for two hours. After gathering his wits and finishing the night with friends at a local club, he flew with his fiancée, Mariana Simionescu, the next morning to Bucharest, capital of her native Romania. There Bjorn Borg did nothing for the next three days. "He was in a trance," Simionescu said. While it had rarely been mentioned between them, the pressure on Borg to win Wimbledon had been even greater that year. The couple was going to be married three weeks later, and they both knew that a loss would have put a cloud over the occasion. As their friend Vitas Gerulaitis jokingly told Mariana, she would rather have married a king than a "viceroy."

As it was, the ceremony capped a dream month for Borg. The wedding took place in a monastery outside the town of Snagov, just under 25 miles from Bucharest. When the couple walked into the hall, a choir began to sing. Borg squeezed Mariana's hand a little tighter. At the end, the priest put a crown on Borg's head. "My husband the king," Mariana found herself whispering. "He's so handsome!"

On the way out of the chapel, the Borgs passed a row of solemn

monks—as well as the unmistakable yellow mane and toothy smile of Gerulaitis—and stopped to listen to the local abbot's words about the "mystery of the wedding vow." By Romanian peasant custom, they traveled in an ox-drawn cart to the reception a half mile away. According to another fellow player in attendance, Ilie Nastase, this was the cause of the day's only snafu. "It wasn't easy to walk behind the cart," Nastase said, "because the oxen had shit all over the road."

But a peasant wedding this was not. It had been arranged by Borg's agency, IMG. The new Mrs. Borg's dress, created by Ted Tinling, cost $6,000. There were 190 people at the reception, including Gerulaitis and Nastase, who jetted in from a tournament and would fly back out the next morning. The two players led the dancing, including a Transylvanian jig, into the early hours of the morning. As Bjorn and Mariana wandered off to bed at 2:00 AM, they could still see Gerulaitis's hair bouncing up and down at the center of the dance floor.

The friendship between Borg and Gerulaitis had begun three years earlier, the day after they staged one of the greatest tennis matches ever played in the 1977 Wimbledon semifinals. While it hadn't scaled the dramatic heights that Borg and McEnroe reached in 1980, the sustained excellence of Borg-Gerulaitis made it the finer overall match. The two men, with matching long blond hair and short white shorts, scrambled frenetically—they were as quick as any players in history—over every inch of Centre Court for five sets on a brilliantly sunny late afternoon.

The tennis was exceptional in its nimbleness, "like summer lightning," in the words of British tennis writer Rex Bellamy. But the ending wasn't hard to predict: Gerulaitis nosed ahead in the fifth set only to see Borg come back and steal it from him, as he would in so many other matches on that court, 8-6. The New Yorker's face was etched with devastation as he shook hands with Borg at the net. While the two men almost appeared to be twins, one famous spectator and friend of Gerulaitis's watching back in New York noticed something unique about his getup that day. Andy Warhol laughed

as he saw Gerulaitis pull a necklace out from under his shirt. He and the others in the room with him looked more closely. Was that Vitas's cocaine cutter hanging at the end of the gold chain, in the middle of his chest, glinting in the sun on Centre Court, on national TV?

The day after their 1977 battle, Borg walked out of the Holiday Inn to hit a few balls at his usual practice facility, London's Cumberland Lawn Tennis Club. He was stunned to see Gerulaitis coming toward him, wishing him luck, telling him that if he needed anyone to practice with, he was there for him. "I couldn't believe it," Borg says. "If I lose a match like that in the semifinals of Wimbledon, the last place I'm going to be the next day is on a tennis court." Gerulaitis, melting the Swedish ice with his Brooklyn street kid's warmth, would quickly become Borg's best friend on tour.

A few months before Borg's wedding, Gerulaitis threw the groom-to-be a four-day stag party on a yacht in Miami. According to Nastase, Gerulaitis reportedly tried to invite every woman Borg had ever "known." Whatever the result of that quest, the party was a success. "Professional athletes being naughty" was how Gene Scott, who ghostwrote Borg's autobiography (published when the player was 23; Borg had penned his own set of memoirs by the time he was 18) and who attended both the bachelor party and the wedding, described the Miami event. Drugs were in use, "but there was no sense of moral breakdown."

Gerulaitis was a card-carrying "night person" on the Studio 54 scene in New York. Over the three years they'd been friends, he had begun to show Borg, whose labor-intensive style was founded on spartan practice habits, how to play just as hard as he worked. But while they partied through exhibition tours together, the sport, particularly the big events, still came first for both men.

Whether it was drugs or just his natural New Yorker's excitability, Gerulaitis was revved up by the end of Borg's wedding reception. He finished it by leaping into Nastase's arms on the dance floor.

Like the rest of the world, Nastase believed that "everything was looking up" for Borg in July 1980. That night the Viking God, dressed in a white suit, had a new bride, a record fifth straight Wimbledon title, and he was in the midst of the most lucrative year of his career, one in which he would earn a then-staggering $5 million.

Yet a dedicated Borg observer might have descried a few signs of trouble. For one thing, he had just married a woman who had been the roommate of his first serious girlfriend, fellow Swedish player Helena Anliot. When he was introduced to Mariana, Borg said he "wasn't overwhelmed." And he had told Gene Scott just the year before, "I have no idea what it's like to be with just one woman for one's whole life. I think it must be very difficult. If you see each other every single day, I don't think it's good." But Mariana was a warmhearted and funny woman, and she was willing to sacrifice everything, including her own tennis career, for him.

But this only brought up another question: Why had Borg, who should have been entering his prime, decided to cut his schedule back to the minimum number of tournaments required that year? And what was that statement he'd made two months earlier at the French Open, when he was interviewed on court after beating Gerulaitis in the final? Asked what goals he had left in his career, he said that he wanted to "win Roland Garros one more time." One more time? Why not five more times, 10 more? Borg, a god on the red clay courts of Paris, had won the French Open five of the seven times he had entered it. Yet his words at the end of the 1980 tournament would be prophetic: he would win it just once more.

The Borgs had a second wedding a few days later, in the Swede's adopted hometown of Monte Carlo, with his parents in attendance. Borg, along with his mother and father, had made the city their residence in 1974, fleeing Sweden's 75 percent top income tax rate.

An 18-year-old at the time of the move, he was already the biggest sports star in the country; there had been no serious international tennis tradition in Sweden before him. When he left, the press pilloried him. Borg was hurt, and the relationship wouldn't be repaired until after his career was over. A few years later, when he returned to play the Stockholm Open, he was asked whether he had any particular feeling about competing in his home country. "No, no feelings at all," Borg answered, his icy monotone making his words seem utterly believable.

Borg hadn't chosen to live in Monte Carlo. IMG had selected the tiny tax haven for him and found him an apartment there. The company's business plan revolved around avoiding taxes whenever possible. Moving to Monte Carlo would help leave Borg, as well as many tennis pros of the future, much richer. The cut that IMG took from his earnings would in turn help the American-based company establish itself in Europe.

The move essentially left Borg without a country. He wasn't the only one. "I don't think tennis players are from anywhere anymore," Roscoe Tanner said at the time. As the 1970s progressed, the game's players became nomads. Where the amateurs, boys of summer, had followed the sun, the pros chased the dollar through indoor arenas and meaningless exhibitions from London to Tokyo, from Paris to Buenos Aires 12 months a year. It was a never-ending quest, and Borg was its first leader.

The bright cement playground on the Mediterranean was a long way from the Borgs' roots in Sodertalje, a manufacturing town southwest of Stockholm. If McEnroe, the entitled survivor, was a product of the suburbs and subways of New York City in the 1970s, Borg's tunnel vision was forged in this working-class city. In those days, the city was based around one industry, auto parts, and one sport, ice hockey. Borg loved hockey as much as any other Swedish boy, but he eventually dropped it for tennis. His obsession began when his father, Rune, won a local Ping-Pong tournament and re-

ceived a tennis racquet as a prize. His 9-year-old son was fascinated by the frame, and it quickly found its way into his hands.

Borg's tennis career began when he started going toe-to-toe with the most consistent, and least demonstrative, opponent of all: the garage door. There was a row of them below his family's home in a monolithic modern apartment complex, and young Bjorn spent countless hours by himself hitting balls against them. This is where, through mind-numbing repetition, with a grip borrowed from Ping-Pong and a stroke reminiscent of a hockey shot, he would develop his unparalleled ability to hit one more ball in the court than his opponent. In his mind, Borg always pretended he was playing for the Swedish Davis Cup team, and his opponent was always the United States. If he made 10 straight shots, Sweden won; if he didn't, his country lost. From the start, tennis was a solitary pursuit, played with maximum patience and an emphasis on ground stroke consistency. You can't practice serving and volleying against a wall, and you don't do it on a Ping-Pong table, either.

Borg lost none of his passion for the game when he moved from the garage to a real court. On long summer days, he would hang around a neighborhood club for upward of 10 hours, hitting with anyone and everyone. He began, like many young players, by using two hands on forehand and backhand because his racquet was too heavy for him. Instructors and other players at his club tried to get him to drop the second hand as he got older—through the 1960s, only a tiny fraction of accomplished players had ever used two hands on either stroke. Borg agreed to make the sacrifice on his forehand, but not on his backhand. He would later say, with the matter-of-factness of the truly bullheaded, "Even though I'd tell the guys that someday I'd change, I knew I never would. . . . The members got angry with me because I wouldn't listen. In the end I think that's the reason I got so far."

From his early duels with the door to the way he comported himself on court as a pro, Borg believed that the keys to tennis were control and simplicity. In his early teens, he had been a habitual

cheater and screamer who smashed dozens of racquets. "My obsti-
nacy knew no bounds," he said, laying the credit, or the blame, for
his extreme drive to win on his parents. When Borg was a child,
Rune and Margarethe had spent weekends organizing competitive
games of all sorts, all of which he hated to lose. Later, in a nationally
televised match, Borg exploded at what he thought was a bad call
and stomped across to his opponent's side of the net to circle a mark
on the clay. He lost, but the experience helped change him. With
his steely blue eye for the practical, Borg decided that getting upset
on court only lessened his chances of winning. This was hardly an
original observation, but what set him apart was his ability to follow
through on it. By his prime years, Borg could say, again with chill-
ing nonchalance, "People think I'm so cool and nothing bothers
me, but inside I'm seething."

Borg periodically talked of how nervous he was inside, how he
"could barely hold the racquet" at certain moments. Most people
found this difficult to believe. Every so often, though, the depth of
his desire to win was revealed. After he lost the WCT Finals to John
Newcombe in 1974, cameras panned in on the teenager as he stood
on the trophy stand getting ready to accept his runner-up prize.
Glistening just below each of his lower eyelids was a single tear.

Borg would be at the forefront of the professional tennis revo-
lution, but he shared a dream with the greatest amateur players:
to play the Davis Cup for his country. It didn't take him long to
get his chance. At 15 he made the team, despite getting into a
dispute with his future coach, Lennart Bergelin, then the Swedish
captain. In team tryouts, Bergelin was umpiring a match involv-
ing Borg. The young hothead challenged a number of calls and
eventually called Bergelin a cheater. Bergelin went berserk. He
pushed Borg over a bench and hurled a racquet at his head. Borg
left in tears, but Bergelin put him on the team anyway. It was a
tumultuous beginning to a partnership that would become famous
for its closeness and efficiency. Bergelin liked to work hard, and
he became devoted to Borg, whose metronomic game required

tedious hours of practice, of hitting one ball after another, to re-main sharp.

It didn't take long for Borg to perfect that game. One measure of how special he was as an athlete was how rapidly he developed. It boggles the mind now to think that any child could pick up a racquet for the first time at age 9, and six years later be selected to play the sport for his country. But in May 1972, a few weeks before his 16th birthday, Borg became the youngest player ever to win a Davis Cup match. As he would many times to many other players in the future, he lost the first two sets, to New Zealand's Onny Parun, then slowly ground the older man into the Swedish clay, until his opponent's game had "completely unraveled" by the end of the fifth set. When Borg coolly ignored a crucial bad call in that decisive set, his reputation was sealed. The Swedish press declared that Borg had *is i magen*—"ice in the stomach."

He was ready to climb higher. Earlier that year, Swedish authorities had allowed Borg to quit school. Apparently he hadn't been learning much anyway. When his ninth-grade teacher, after proclaiming him "lazy and stupid" in front of the class, tried to get Borg to answer a geography question, the budding tennis god dismissed her by saying, "There's no point in you asking me questions, because I know nothing anyhow." When the school caved and let him go, one of his teachers lauded Borg's initiative, "The boy has, in fact, actually chosen a profession." That a 15-year-old could make that choice about tennis would have been unthinkable just five years earlier, and it made headlines around Sweden. Coaches, players, journalists, school friends—the country was stunned.

Borg had made an irrevocable leap into a lifetime of abnormal-ity. For the moment, though, it appeared to be the right move at exactly the right time. The year was 1973, and the players were about to take over the sport once and for all. Borg would walk in the door just as all of the old rules and restrictions were flying out the window.

While the ITF had allowed prize money to be awarded starting

in 1968, it had prohibited anyone under 18 from accepting it. As if on cue, the Old Goats scrapped that rule the year Borg turned 17; now anyone could get paid. Also, in 1973, at Wimbledon, the newly formed players' union, the ATP, became embroiled in a dispute with the ILTF over the case of a player named Nikki Pilic of Yugoslavia. Wimbledon had barred Pilic for failing to play the Davis Cup for his country; he cited a prior commitment to a professional tournament as an excuse. The affair was obscure and inconsequential on the surface, but like another seemingly obscure event that had taken place in Yugoslavia nearly 60 years earlier, the assassination of Austria's archduke Ferdinand, it set off a world war in tennis. It would also be the final act in the saga that, beginning with the advent of open tennis, pitted professional players against amateur officials. The question was: How much control did tennis's administrators, who were largely volunteers, have now that the players made their living at the game? Could they still tell them where and when to ply their trade? (As in 1968, this fight echoed similar rebellions and transformations in the world at large. The ability of a national federation to mandate Davis Cup play was the tennis equivalent of a draft; 1973 was also the year that the United States ended its military draft.)

The players chose the nuclear option, threatening to boycott Wimbledon, their most important event, if Pilic wasn't reinstated. Both sides held their ground, while the English press and fans rallied behind the tournament officials. Who were the pros, and their American lawyers and agents, to mess with the tradition of Wimbledon? The upshot was that 79 of the game's top 85 players, including the defending champion, the dutiful American army corporal Stan Smith, refused to play. The Old Goats, believing the players had been bluffing, were beaten. If they couldn't compel them to play Wimbledon, their grip on power really was broken.

The immediate effect of the boycott was that the 1973 field at the All England Club was suddenly wide open. Three players of note chose to break ranks and play: Ilie Nastase, who made the dubious claim that his own country, Romania, had ordered him

to compete; Jimmy Connors, the young American maverick who bucked the ATP whenever possible; and Borg, who, at 17, was not yet a member of the union. The latter two capitalized on the depleted field to reach the quarterfinals. By the end of the fortnight, a changing of the guard had been signaled, away from the old pros who had banded together to fight for open tennis and who had, by skipping Wimbledon, just made their biggest sacrifice, and toward the first young beneficiaries of the pro era, Borg and Connors. Neither would go out of their way to express their gratitude; the new generation would represent itself above all else.

After weeks of depressing and confusing political rancor, the Swedish Teen Angel's run through the draw provided the tournament with a new youthful exuberance. His blond locks flying, Borg dove on the grass, whipped forehands with as much pace and spin as anyone had ever seen, and tried, with little success, to escape the girls who leaped out of their seats and chased him across Centre Court, shrieking all the way. The sport's first matinee idol made the ramrod American correctness of Smith and Arthur Ashe, and the mustachioed ladies'-man machismo of Australia's John Newcombe, seem distinctly stodgy. But the girls' obsession also scared Borg, so much so that he began a love affair with his hotel room, a relationship that would outlast most of his others.

"Every evening I looked forward to it," Borg said of escaping into his room, "an intense feeling brought about by the fact that I was the girls' legitimate prey even on the streets of London." The man with no country had found a home of sorts. By decade's end, Borg, legitimate prey wherever he went in public, had gained a reputation as the Howard Hughes of tennis, a man who rarely opened the shades of his hotel suites from one city to the next.

Borg, of course, didn't always run from girls. Early magazine articles talked about how hard-boiled he was for his age. "So Young and So Untender" was the title of a Borg profile that *Sports Illustrated* ran in 1974. In it, Borg, who estimated his actual age to be

25, complained that he "had too many girls, two a night if I want."
A logistical hassle, perhaps, but it seemed to suit him fine. He also
claimed that the last thing he wanted was a steady girlfriend. "I'm
convinced," the Ice Borg proclaimed, "that my career as a tennis
player will come to an end the moment I feel as much for a girl as I
do for that little white ball."

Still, he would get no peace from women of any age. In Hawaii,
a 19-year-old Borg was approached by a man who said he was on
his honeymoon. He went on to claim that the greatest gift he could
give his new wife was to persuade Borg to have sex with her. The
Swede walked into an elevator and looked back at the man, who
was holding his hands out to him prayerfully. As the doors closed,
Borg said, "Sorry, but I don't do it with married women."

The year 1973 would have been a heady one for any 17-year-
old. There was fame. There were women. And there was the third
point in the holy modern trinity: money. That year Borg sat next to
Mark McCormack at a press conference and announced that he had
signed a contract to be represented by IMG. He and his parents had
chosen McCormack over tennis's other super-agent, the aggressive
and free-wheeling former player Donald Dell. They liked IMG's
methodical and comprehensive long-term approach to his earnings,
and for years he would allow the company to squirrel his money
away in trusts where he couldn't get his hands on it. "What we in
America call superstars don't come along very often," McCormack
said that day. "But we think Bjorn has all the makings of one."

McCormack was being modest on behalf of his client. Borg was
already a superstar. Moreover, the player had already glimpsed the
dark side of wearing that label. In 1973, Borg estimated that he played
a tennis match every other day. By the fall, he faced what he called
a "great crisis." After losing in the second round in a small tourna-
ment, he "left the court totally played out." Soon after, he was un-
able to practice. "The chase after tournaments, points, and money,
and the general public's chase after [me] were about to break me."

By the start of the next season, the 18-year-old found himself wondering, along with many others in tennis, "How long can Bjorn Borg last?"

Seven years later Borg smiled as he greeted Princess Grace at his wedding reception in Monte Carlo. After hundreds of matches, hotel rooms, flights, girls, practice sessions, and acts of superstition later, he was still, despite all evidence to the contrary, just 24 years old. Borg had accomplished everything he could have hoped for in the sport, except for one thing. Somehow the U.S. Open had eluded him. Eight times he had entered it, and eight times he had walked away frustrated. As charmed as his life had been at Wimbledon, that's exactly how luckless he had been in New York.

If Borg had developed any superstitions in his travels around the city each fall, they hadn't worked for him yet. The enchanted spell he cast on Wimbledon turned into the "Borg hex" at Flushing Meadows. The Open's new, bigger digs, and the asphalt courts, colossal floodlights, and thundering airplanes that came with them, hadn't been good to the Borg game. He thrived on control, and New York offered nothing but chaos. He thought the courts' surface was too fast at first, and he hated to play at night in Louis Armstrong Stadium. He was pained by the memory of his career's bitterest defeat and biggest lost opportunity, which had happened at Forest Hills in 1976. That year, Borg faced Connors in the final, when the tournament was played on his favorite surface, clay. The two split the first two sets. In the third, Borg held five set points; he had been telling himself if he could win that set, he would be okay. But he couldn't drive a stake into a savage and bug-eyed Connors, who won the third-set tiebreaker 11-9, and the fourth set 6-4.

The following year, Borg exacted revenge on Connors at Wimbledon, but he suffered a shoulder injury that summer playing

World Team Tennis. It hurt to lift his arm at the Open, but somehow he trudged to the fourth round. He did it with no help from Bergelin, however. The coach publicly wondered why none of his charge's opponents were looping the ball and forcing Borg to raise his arm over his shoulder. Borg's next opponent, Dick Stockton, heard what Bergelin said and followed his advice. At the end of the second set, Borg, his arm feeling like it was about to come off, was forced to retire. Stockton wondered afterward what Bergelin had been thinking.

In 1978, Borg beat Connors badly at Wimbledon and faced him again in the Open final. The New York jinx held: In the semifinals, Borg suffered a thumb injury, which became infected. Shot through with painkillers, he could barely hold the racquet as Connors, looking even more psychotically aggressive than he had two years before, leveled him in straight sets before a roaring, bloodthirsty nighttime audience of 20,000. Borg never mentioned the injury.

Twice Borg had lost the Open to the man he had beaten the same summer at Wimbledon. In 1979 he defeated another American lefty, Roscoe Tanner, in the final at the All England Club. Naturally, he faced Tanner at Flushing, this time in a quarterfinal. Despite Bergelin's request for a daytime slot, Open officials scheduled Borg to face the bullet-serving Tanner at night, under the lights he so despised. Bergelin had a conniption and called an impromptu press conference at the National Tennis Center to vent his anger. It seemed that fate wasn't enough; the American empire itself was out to get Borg and to protect its own. Borg lost in four sets to Tanner.

In August 1980, Borg, Bergelin, and Mariana were cautiously optimistic as they checked into the Drake Hotel on Park Avenue. Borg was trying to become the first player since Rod Laver to win the Grand Slam. The sensation-loving New York crowds wanted to see history, and they backed Borg through the tournament. While struggling with his form—Mariana believed that the weddings and

honeymoon had thrown the "Swedish machinery" out of whack—
he avenged himself by pulling another Houdini act in the quarter-
finals against Tanner. The American led two sets to one and 4-2 in
the fourth before Borg made his move. In the semifinals, he beat
Johan Kriek in yet another comeback five-setter, by the schizo-
phrenic scores of 4-6, 4-6, 6-1, 6-1, 6-1. Listless for long periods
of the match, Borg appeared to be losing his concentration more
often than normal—Bergelin muttered that Borg was "somewhere
else" during the Kriek match—but finding it when he needed it. It
seemed now that he needed to create a challenge that he could rise
to. "I will be ready," Borg said with his usual terseness when asked
for his thoughts on the final.

Butterflies dancing around his stomach, Borg spent that Satur-
day night with Mariana in his hotel room. They watched as McEn-
roe and Connors each grabbed the other by the throat and didn't
let go for five sets. As the hours and the match wore on, it seemed
that Borg would have little trouble with an exhausted McEnroe the
next day. The Swede had beaten the American in their last three
meetings, and when he broke McEnroe and served for the first set
on Sunday, the New York crowd cheered in approval. History was
in the making.

But Borg couldn't hold on to his serve. The shot that had saved
him at Wimbledon was deserting him now. Before he knew it, the
first set had slipped away in a tiebreaker. It was the 1976 final against
Connors all over again. Maybe he really was cursed here. With
his head hanging and errors flowing off the frame of his wooden
racquet, Borg gave away the second set as well, 6-1. It was all too
much: one more American to beat, one more lefty to face down,
one more player whom he had already eked past at Wimbledon and
had to eke past again. How long could Bjorn Borg last?

When he mounted his expected comeback in the third and
fourth sets, the crowd backed him with all of the considerable en-
ergy it could muster. The passing shots began to find the lines; the
serve held steady. When he flipped a backhand return past McEnroe

to tie the match at two sets apiece, the stadium shook. Simionescu put her head between her knees. Even Borg let himself go, relatively speaking: He stood up straight, as if he'd received an electric jolt in the back. The look on his face was one not of joy but of surprise: "How am I still alive?" his eyes asked.

Borg may have been more skeptical about his chances than anyone else in the building. But that skepticism proved to be well founded. The crucial point came at 3-3 in the fifth set. Borg let a McEnroe return of serve sail past him. He thought the ball had landed out, but the line judge, a volunteer named Art Italo who sold Good Humor ice cream for a living, saw it differently. For once, the Iceman couldn't forget, couldn't ignore his anger. He stared with loathing at the line judge and the chair umpire who backed up the call. For all the tirades McEnroe had engaged in, it was Borg who let one affect him at precisely the wrong moment. He double-faulted twice and was broken. A few minutes later he stood on the trophy stand staring downward with wide, tired eyes, looking thin and haggard, trying to find words for his hazy disappointment. The Open, and the Grand Slam, were gone again. The New York crowd gave the gutted Swede a standing ovation.

The next morning, Borg dutifully slunk into a limousine and appeared for a series of promotional events in Manhattan. He taped commercials for a Japanese department store—it was introducing a line of Bjorn Borg wristbands—and a Canadian sporting goods store. He received a prize from Seagram's distillers and did a segment on the *Today* show. But he couldn't eat. Mariana pushed sandwiches at him, and he pushed them back. "I don't care so much about that," Borg told her distractedly.

Borg kept his eyes down as he tried to find an explanation for the previous day's disaster. "I wasn't tired or anything," he said, casting about for a reason for his unexpected failure at the moment of truth. "I felt strong, I felt confident. I think I lost the match because I've never served so badly in a final," he finally decided. But it wasn't all gloom and doom. Asked if his parents had stayed up late

to watch the end of the final in Sweden, Borg smiled. "No, they turned it off at 3–3 in the fifth and went to bed."

A few years later, after he had retired, Borg told a business partner that the night of the 1980 U.S. Open final, he "tried to drown his sorrows in champagne." He had been sad, but there was a new feeling mixed with it: one of relief. Borg was happy, at least, not to have to face the pressure of trying to win the Grand Slam in Australia.

The differences between champions and also-rans in tennis are often infinitesimal, and by that paper-thin measure, Borg had, for the first time, come up short when it mattered most. He had failed in the sport's ultimate test, a fifth set. And this time there could be no excuse for his failure at Flushing. He had suffered no injury, had played most of the match in the daytime sunshine, and had been facing an opponent who was exhausted even before he walked onto the court, and who said that by the end his "body was falling off."

At least one fellow champion believed that Borg wouldn't be the same after the experience. Billie Jean King, watching from her living room, could see that the impenetrable Borg mystique had been punctured, the shroud of myth pulled away. He would never intimidate opponents in quite the same way, she said.

More than any other athlete, Borg, in his results and his decorum, had courted perfection. What did an imperfect Bjorn Borg look like? Could he even exist? The clock was now ticking on the Angelic Assassin's career, but no one in Queens knew it that day in 1980. "I will be back," Borg told the press as he climbed into his limo on the morning after the disaster. "I will keep trying. I have many years still to come."

THE VALLEY OF ASHES

"There are probably few prettier scenes than that of which this contest is the center. Perfectly trimmed lawns swept by the freshest and daintiest morning dresses, young men in flannels, rosy with health and irresponsibility . . ."
—TRAVEL BOOK DESCRIPTION OF THE U.S. NATIONAL LAWN TENNIS
CHAMPIONSHIPS AT THE NEWPORT CASINO, CIRCA 1900

"A peculiar odor permeated the place and insinuated itself into the weave of spectators' clothing. On a fiercely hot day in late August, when the temperature and humidity hovered in the 90s, one could be forgiven for thinking the smell was of broiling human flesh. Most of the time it was just sizzling hamburgers."
—AUTHOR MICHAEL MEWSHAW, DESCRIBING THE
U.S. OPEN IN THE EARLY 1980S

At the end of August 1981, fourteen months after they had first scaled the sport's mountaintop together during their famous tiebreaker at Wimbledon, Bjorn Borg and John McEnroe joined 126 of their pro-tour colleagues in New York City for the U.S. Open. This was the tournament's 100th anniversary, but it would be held at its current venue, the National Tennis Center in Flushing Meadows, Queens, for just the fourth time. In the coming days, as the players walked into the Open's version of Centre Court, the steep concrete bowl known as Louis Armstrong Stadium, they

would not pass underneath any verses written by Rudyard Kipling. It was also unlikely that they would sense the poet's stern Victorian spirit among the 18,000 spectators dressed, as one fashion critic put it at the time, with "the cheerful slob flamboyance of the New York tennis fan."

As their gaze drifted upward, past the signs advertising watches, rental car agencies, beer companies, cosmetics, and CBS Sports—its booth and bright yellow banner were located in roughly the same spot as the Royal Box at Wimbledon—the players would receive a different message. Towering over the top of the stadium was a giant white billboard that read, "Coke Adds Life to the U.S. Open."

As unlikely as it may have seemed from inside Flushing's carnival of commercialism in 1981, the Open had long been an island of "If—," just like Centre Court. From the 1920s until 1977, those same lines of triumph and disaster had hung above the players' entrance to the stadium court at the tournament's old home, the West Side Tennis Club in Forest Hills. They had been put there at the behest of Julian Myrick, an amateur-era Old Goat who served as president of both West Side and the U.S. Lawn Tennis Association, or USLTA. A silver-haired martini lover and insurance executive— his business partner was composer Charles Ives—who was active in Republican politics, Myrick was, in the words of one tennis historian, "pompous and arbitrary" in his dealings with players. While he was comfortable in the company of musical genius, the same could not be said of his relationship to tennis genius.

Despite his considerable accomplishments in promoting the sport, Myrick is best remembered for his long-running feud with the most famous American player of that era, Bill Tilden. Their battle reached an early peak during the final of the U.S. Nationals in 1922. Myrick took a front-row seat as Tilden lost the first two sets and went down 0-3 in the third to his rival, the overwhelming favorite of crowd and USLTA alike, Little Bill Johnston. While walking to the side of the court to change ends, Tilden spotted Myrick. "Well, Bill," Myrick said with a smile, "it's been a good match."

"It's damn well going to be," snapped Tilden, who believed his enemy had chosen that seat to distract him. Tilden roared back to win the next three sets. In the United States, it seemed, it wasn't enough to face down triumph and disaster. You had to beat the president of your own tennis association, too.

While the United States would bring the sport to the marketplace by the end of the 20th century, the game began its life in this country in the same ivory tower that had protected it everywhere else. The first sets of Wingfield's lawn tennis boxes made their way into aristocratic circles near Boston and New York in 1874. By 1880, tennis had found a natural home between the two cities, in Newport, Rhode Island.

That year, Harry Stevens, Edith Wharton's boyfriend, brought the first tennis set to Newport, at the same time that James Gordon Bennett Jr., the wild and wealthy publisher of the *New York Herald*, commissioned McKim, Mead & White to build a personal retreat for him in the center of town called the Newport Casino. With ballroom dancing, concerts in its horseshoe-shaped piazza, and lawn tennis courts, it was the country's first European-style social center. It was also the beginning of a long association between tennis and the era's leading high-class architectural firm. In 1889, McKim, Mead, and White created the Georgian clubhouse at the Germantown Cricket Club in Philadelphia; in 1918 it designed the opulent Racquet and Tennis Club on Park Avenue in Manhattan.

The Newport Casino hosted the inaugural U.S. Nationals in 1881. Twenty-five men entered (the women's event began six years later), virtually all of them Ivy Leaguers. Nineteen-year-old Richard Sears of Harvard won the tournament before an audience that sat on stools and chairs. Sears, like most of his opponents, played in long pants, a long-sleeved shirt, and a striped cravat and cricketer's hat in the colors of Boston's Longwood Cricket Club, where he was a member. In his one concession to the late-summer heat, he removed his blazer and rolled up his sleeves to the elbow. Sears's tactics were not complicated: he would "tap the balls as they came

over," he said, "first to one side and then to the other." He won the next six National titles.

WASP society in the Northeast staked its claim to tennis at the same time that it was accumulating power in the United States and around the world. After the Civil War, the steel, oil, and railroad industries produced previously unimaginable amounts of wealth, much of which was located in New York City, and none of which was taxed (there being no federal income tax from 1872 to 1913). In the 1880s, according to sociologist E. Digby Baltzell, "members of new and old rich families were amalgamated into one national upper class through marriage and education at various Episcopal boarding schools and at Harvard, Yale, and Princeton."

As immigration to the United States from southern and eastern Europe increased, the new national establishment sealed itself off from the hordes. This was the world of the Social Register (a list of East Coast families who mattered, first compiled in 1888), the "400" (the number of people who could comfortably fit into Mrs. Astor's New York society ballroom, a term that was also coined that year), and the novels of Edith Wharton and part-time Newport resident Henry James. It was a generation that included future presidents William Howard Taft, Theodore Roosevelt, and Woodrow Wilson. Its members went to the same schools, married into one another's families, and spent their leisure time together. Socializing among these families was done at the club. A year after the first U.S. Nationals in Newport, America's first country club was founded in Brookline, Massachusetts. Golf was the attraction there, but tennis was soon established in this world as well, in Tuxedo Park, New York (1886); the Germantown Cricket Club (1889) and Merion Cricket Club (1865) in Philadelphia; the Orange Lawn Tennis Club (1880) in New Jersey; the Longwood Cricket Club (1877), outside Boston; and the West Side Tennis Club (1892) in Forest Hills. These clubs, all populated by the WASP elite, would form the foundation of the country's amateur summer tennis circuit until the end of the 1960s.

As they were in England, sports were transformed into a metaphor for the American way of life at a time when the country was beginning to think of itself as an empire. The 1890 census had marked the end of the "frontier"—the United States had settled the West. Teddy Roosevelt believed that the frontier mentality was at the core of the American character and should never be sacrificed. He looked for new places to conquer, in Cuba and the Philippines, and he believed that amateur sports—"when the money comes in the gate, the game goes out the window," Roosevelt said—in particular football, taught the fearlessness needed for this pioneering spirit. But the aristocratic TR, despite his poor eyesight, also loved tennis, even if he wouldn't allow himself to be photographed playing the game. He had the first court built at the White House and formed a "tennis cabinet." "I was president and Ambassador [J.-J.] Jusserand [of France] was vice-president," Roosevelt joked. "Anyone who defeated either Jusserand or myself was under the rules forever barred from membership."

Tennis grew rapidly at the other end of the frontier, in California, where a more egalitarian culture sprang up around the sport in public parks and on cement courts. Newport society held on to the Nationals until 1914, but the game had become too serious for the Casino, where it was still a see-and-be-seen event for its fashionable spectators. As the players began to come from outside the East Coast clubs, they were less tolerant of the crowd's inattentive chatter, and of the parasols that rotated behind the court as they were about to hit the ball.

The best of those California players, Maurice McLoughlin, of San Francisco, raced through the Nationals in 1912 and 1913. The California Comet's wins were a turning point, particularly his title in 1913. That year, he beat Richard Norris Williams in the final. Williams was the son of a rich Philadelphian and had been schooled in Switzerland. In 1912 he had sailed on the *Titanic* (he was coming to the United States to attend Harvard) and, legs frozen, watched as his father went down with the ship. Williams exemplified the spirit of society tennis. He played only for fun and rarely remembered the

details or the results of any contest. Later, as captain of the U.S. Davis Cup team, he skipped out on one of his player's matches because someone had asked him to be a fourth in a pickup doubles game on another court.

It was past versus future when Williams faced McLoughlin in Newport in 1913. McLoughlin was raised on hard courts instead of grass, and had no millionaire father. The Irish immigrant's son was the first national champion to learn the game in a public park. With his shock of red hair and dazzling athleticism—his leaping overheads left opponents flabbergasted—he was the game's first national star. McLoughlin's "cannonball" serve and unorthodox Western forehand introduced power—indecorous power—to the game. *New York Times* tennis correspondent Allison Danzig wrote, "The California Comet's spectacular style of play opened the eyes of the uninitiated to the fact that tennis was a vigorous sport and a stern test of physical fitness." Danzig's contemporary, Al Laney, who would watch and write about the world's best tennis players into the late 1960s for the *New York Herald*, maintained that McLoughlin was "the most glamorous and exciting figure in the history of the game." The first flame-thatched Mac in tennis, he took the sport from the blue-blooded matriarchs of Newport and gave it to red-blooded boys around the country.

McLoughlin established a dynamic that would drive American tennis from then on. As it expanded across class and country, the insider's game would continually confront and find a way to accommodate the outsider. Mexican American Pancho Gonzalez; African Americans Althea Gibson and Arthur Ashe; the women's movement, in the form of the tour founded by Billie Jean King; Czech defectors Ivan Lendl and Martina Navratilova; and the wave of Russians who have swept the game since the fall of the Iron Curtain—all would find their places in the sport, transforming it in their individual ways. (The irascible and unpopular Tilden, however, would never enjoy full acceptance in his home country. His homosexuality remained hidden.)

McLoughlin's peak—he was a supernova who burned brightly but quickly—came in August 1914, days before the start of World War I, when he drew overflow crowds for the Davis Cup final at the West Side Tennis Club. The following year, with the help of Julian Myrick's promotional energy, the Nationals were uprooted and brought to Queens. (The Astors and Vanderbilts of Newport may have had their minds on other matters: federal income tax had become law in 1914.)

In New York, tennis would be closer to the commercial heart of the country, but it wouldn't stray far from its social roots. The West Side Tennis Club, whose grass courts fanned out in a triangle similar to the All England Club's, stood at the center of Forest Hills Gardens, a privately owned and meticulously planned neighborhood of comfortable Tudor cottages and circular lanes laid out in 1908 by Frederick Law Olmsted Jr.—son of the man who designed Central Park—to discourage outside traffic. The community was the earliest example in the United States of a "Garden City," an urban planning movement started in England at the tail end of the 19th century. It countered industrialism's urban sprawl by calling for small, self-sufficient suburban neighborhoods. But as with any little utopia, and as with any club, someone had to be left out. By gentleman's agreement, Forest Hills Gardens would be open to WASPs only.

————————————

By the 1970s the power of the Northeast WASP establishment had waned as the country's economic base shifted to the Sun Belt's oil and aerospace industries. With that wealth, tennis followed.

Texas oilman Lamar Hunt began the first pro tour of the Open era, World Championship Tennis, and made Dallas a new hotbed for the sport. In 1973 the most watched tennis match in history was played not on Wimbledon's Centre Court, but in Houston's Astrodome, where Billie Jean King defeated Bobby Riggs in the

Battle of the Sexes. In 1977, as Georgia farmer Jimmy Carter entered the White House (he was only the second Southerner to make it there since the Civil War, and the first to play tennis as avidly as Roosevelt), the USTA followed suit and elected its first president from the Deep South, 66-year-old William Ewing "Slew" Hester of Jackson, Mississippi.

Invariably caricatured as Ol' Slewfoot, a bluff, beady-eyed, cigar-chomping wildcat oilman and scion of a state political family, Hester was also, like Julian Myrick, one of those rarities in the tennis establishment: a gentleman entrepreneur and an energetic force for change. "I'm a real hustler, a salesman," he said, someone who liked to "drink all night and play tennis all day." He had built the 26-court River Hills Club in his hometown in the early 1960s and then stumped the country, cocktail firmly in hand, successfully selling his fellow Old Goats in the USLTA on the idea of professional tennis. But Hester remained underestimated in New York, where he was, in the words of one journalist there, "pegged as a stupid redneck."

As with Newport before World War I, it was clear by the mid-1970s that tennis had outgrown Forest Hills. During the two weeks of the U.S. Open, the West Side Tennis Club (WSTC), now wedged in by high-rise apartment buildings, threatened to burst its own walls. The club's narrow pathways and viewing areas were overrun; fans lay facedown on the ground to see whatever they could see from beneath the windscreens at the backs of courts. There was limited room for the sponsor tents and merchandise booths that now ate up large swaths of ground at all tournaments. The grass, never as firmly rooted as in England, was chewed up so quickly and thoroughly that the courts had to be spray-painted green for the TV cameras.

An even bigger and more intractable issue was the lack of parking space for the new suburban fans who wanted to experience the "carnival at Forest Hills." There was very little space in the streets that Olmsted had designed 70 years earlier. By 1977, as New York's notorious "Summer of Sam" drew to a close, a spirit of lawlessness

had taken hold of the tournament. Trash spilled out of giant bins and floated on the courts after a rainstorm. A spectator was shot during an evening session match. Tennis's clubby past—members at West Side still wore all white—had come face-to-face with its colorful, big-money present.

Hester knew the tournament had to find a new location, and after looking out the window of an airplane one night in January 1977, he knew where that was. "You throw a dart in the dark and drill," he said of his job as an independent oilman, and that's pretty much how he went about moving the U.S. Open. As his plane flew into LaGuardia Airport that night, Hester glanced out at the land below him. There were several inches of snow on the ground in Flushing Meadows Park. Taken by the beauty of the scene, he looked more closely. He caught a glimpse of Louis Armstrong Stadium, an abandoned, graffiti-strewn outdoor arena built for the 1964 World's Fair and originally called the Singer Bowl. Hester had his drilling spot.

He also had a new partner. After 62 years, the WSTC was out, and cash-strapped New York City was in. The USTA agreed to spend $5 million to lease the land around Armstrong Stadium, which would be renovated. Hester's plan called for building a tennis center and using the space for sponsored events for two months out of the year. (It ended up costing $10 million.) The other 10 months, it was to be a municipal tennis facility. For the first time, a Grand Slam would be played on public courts, on a hard surface similar to the one used by the waves of recreational hackers who had picked up the game over the previous decade in parks all over the country. It was also, not coincidentally, a surface on which most U.S. pros thrived. Now all Hester had to do was have it finished by the fall of the following year.

Most observers familiar with New York construction thought this was impossible, that he would be eaten alive by the industry, if not by the city itself—the plan required the approval of nine different agencies before it could even get off the ground. Gene Scott, the

patrician, Yale-educated publisher of *Tennis Week* and self-appointed conscience of the sport, believed that the Open would likely still be in Forest Hills in 1980. "It brings a new dimension to believing in miracles," Scott wrote in an editorial. When another upper-crust city writer, Herbert Warren Wind of *The New Yorker*, visited the site in May 1978, he was stunned to find out how much work was yet to be done. He mentioned his concern to Hester, who "smiled broadly and easily" and said he believed that the new, eight-layer DecoTurf II surface would be laid down on August 27, three days before the tournament started. He was right. The courts weren't perfect, and as play began, the backs and sides of them were quickly covered with two trademark signs of the city: soda stains and wads of chewed-up bubble gum. But they were there.

On August 30, 1978, the National Tennis Center opened with 12 fast-food stands and nine bars in Louis Armstrong Stadium alone. This might have seemed a little dangerous, considering that the sides of the arena were steep enough that Hester would say, "If a drunk fell out of the 51st row, he'd end up somewhere on the sideline." Every one of the 70-odd flags on the grounds was red, white, and blue. There had been no time for landscaping of any sort—it was steel and concrete for as far as the eye could see.

The cheerful New York melting pot didn't care. They came in tube socks and T-shirts, chinos and sneakers, sleeveless denim jackets and skull-and-crossbones tattoos, Lacoste shorts and Madras jackets, short shorts and halter tops, designer jeans and polyester shirts unbuttoned to the waist, and often with no shirts at all. Behind sunglasses of every shape, color, and size, they stuffed themselves with shrimp cocktail and strolled around licking ice-cream cones. They yelled out as players were serving and jammed the outer walkways of Armstrong to survey the field courts below. Sometimes they jumped the fences and parked themselves on one court so they could get a better view of the match that was being played on the next court.

In the evenings—the Open was the first Grand Slam tournament to stage night matches—when the place was jammed, the 18,000 inside the stadium unleashed a formless, unceasing roar more commonly heard at NFL arenas than tennis clubs. Ten years after taking over the sport, the American tennis empire had its capital. The U.S. Open was no longer a baby Wimbledon. It had left the private club and the imitation English village for the public spectacle of the modern concrete sports arena. The lawns were made of asphalt now.

But tennis hadn't completely sold out to the great unwashed: There was plenty of quiche at the concession stands.

When the world's best tennis players gathered again in Flushing Meadows three years later, those asphalt courts, while still stained with Coke and gum, had come to seem like a tiny oasis within the colossal burned-out ruin of the city that surrounded them. By 1981 New York had endured a decade of blackouts, rioting, bankruptcy, exploding crime, and disco. Next to *The Empire Strikes Back* and *Chariots of Fire*, movie marquees advertised a third hit that summer: *Escape from New York*. Set two decades in the future, it foresaw Manhattan as a walled prison where the country's most dangerous criminals—and, for unexplained reasons, those with the trendiest New Wave haircuts—were dumped and left to fend for themselves. The following year, Michael Mewshaw, in his gloomy book about the men's tennis tour, *Short Circuit*, would describe the street leading to the National Tennis Center this way: "It was difficult to accept that this blighted area was part of the same circuit which ran through Paris, Rome, Monte Carlo, and Wimbledon. Here the halt and the lame, the drunk, the drugged, the demented, and the dispossessed staggered along the sidewalks, past the stripped-down hulks of abandoned cars and the bricked-up windows of abandoned buildings."

But while few realized it at the time, New York had turned an important corner in 1981. Six years earlier, the federal government had bailed out the city—the New York *Daily News* famously summed up the president's opposition to this plan with the headline "Ford to City: Drop Dead"—and put it on a long-term fiscal austerity plan. New York succeeded in repaying that debt in 1981; by mid-decade it would be soaring on the back of a Wall Street boom. Slew Hester's deal with the city, and his unlikely construction success, would play a small part in that renaissance. The National Tennis Center was, in its avaricious and jingoistic way, a concrete signal of progress amid the blight. (Three decades later, the two-week U.S. Open would inject more money into the city annually than either of its Major League Baseball teams.)

Hester had made some beauty out of garbage—at the beginning of the century, Flushing Meadows had been a dumping ground for all of Brooklyn's refuse. But he never would have put it in such grand terms. Asked to sum up his experience in creating a Grand Slam site in little more than a year, Ol' Slewfoot opted for caution rather than braggadocio. He pictured a photo of the National Tennis Center behind his desk back in Mississippi. "I'd point to it and tell my grandchildren, 'Don't ever get mixed up in a confounded mess like that.'"

But the "valley of ashes," as F. Scott Fitzgerald described Flushing Meadows in *The Great Gatsby*, had left its mark. To many spectators, it was unclear whether Hester really had stamped it out after all. It seemed to live on in the stench of trash, sweat, and cooked meat that arose during the two humid weeks of the U.S. Open, the ripest of all tennis tournaments.

In 1981 that trash finally exploded onto the grounds. The third-round match between Ivan Lendl and Mark Vines in the Grandstand—the Singer Bowl had been divided in two to form a main stadium and this more intimate, 6,500-hundred-seat arena—was stopped when clouds of noxious smoke and ash began to drift across the court. While Lendl was winning the first set, a pungent haze

settled inside the arena, and cinders began to fly. The young Czech soon had enough; he stalked off the court to shouts of "choke artist." A nearby garbage compactor had begun to burn, necessitating a call to the local fire company. As one usher told Bud Collins as they watched the black haze rise over the Grandstand wall: "I never seen a tennis match called on accounta fire."

CHAPTER EIGHT

TEARING THE COVER OFF THE GAME

*"I like my image. I'm a louse. But if you're going to be a louse,
I say be a good one. It's fun for me, and it's fun for the fans."*

—JIMMY CONNORS

A few days before Ivan Lendl's smoky exit, and 100 years after Richard Sears donned his striped cravat and won the first U.S. Nationals at Newport, two American players could be seen practicing at Flushing Meadows. Neither wore the colors of a cricket club, and they didn't tap the ball from side to side. Instead, each of their full-blooded swings was accompanied by an ungentlemanly grunt. If multicolored clothes were the great visual innovation of the professional era, the grunt was its sonic counterpart.

On one side of the net stood a slightly slouched John McEnroe. He had recently become the number one ranked player in the world, but he didn't seem to take much comfort in it on this day. McEnroe gazed at the sky and shook his head. In the distance, closing rapidly, was another signature feature of the U.S. Open at Flushing Meadows: a jet taking off from nearby LaGuardia Airport and flying very low and very loudly over the heart of the National Tennis Center.

Hundreds of planes ripped across the grounds each day. Their undersides looked like the bellies of titanic tin whales. When he was asked about the potential for the roar of airplanes during matches three years earlier, Slew Hester had been characteristically blunt: "We'll get some noise," he allowed.

This was McEnroe's fourth year at Flushing, so he might have been expected to accept the inevitability of the planes' presence. But as he shanked a few shots and the planes kept coming, he began to fume. He took a ball and hurled it as high as he could in the air. As another jet followed and drowned out all of the other sounds around him, McEnroe turned his face skyward and yelled, "Shut up!"

It may have come as a surprise to any fans in attendance to see that the man watching McEnroe fume from across the net was Jimmy Connors. Twelve months earlier, their rivalry had reached a savage peak in the semifinals of the U.S. Open. But a year later they had called something of truce. "We both decided we might as well be human to each other" was how McEnroe put it. That's about as far as camaraderie went in the roughneck early years of the pro era.

While McEnroe raged, Connors bobbed and weaved. He liked to practice fast, work up a sweat, and get off the court quickly. That's how his mother, Gloria, had brought him up; as his coach, she always left him eager for more. All these years later, Connors's familiar boyish mop of dark brown hair was still in place, and the soon-to-be-29-year-old husband and father belted each ball with the lusty abandon of a man who had just fallen in love with the sport. His grunts, as they always had, began somewhere deep in his chest and emerged as rasping barks of desire, a desire that was undimmed even after a decade on tour.

Today Connors practiced longer than normal, and with even more than his usual intensity. He also may have had other reasons than humanity for hitting with his greatest rival. Connors had a predator's instinct, and every rally that he engaged in with McEnroe brought him a little closer to understanding the young genius's game. Indeed, Jimbo would end 1981 with an important win over

McEnroe in London. Not long after, McEnroe stopped practicing with Connors. "I showed him too much," he told a friend of Connors's.

When the session was over, the sweat-drenched Connors walked over to talk to a young black man who was standing on the sidelines, Doug Henderson. Connors had met Henderson at Forest Hills in 1974, when, as a boorish and unpopular young punk, he was on his way to winning his first U.S. Open. Now the Bronx native served as Connors's bodyguard and aide-de-camp whenever he came to New York City.

Connors picked up his racquet bag and walked with Henderson to a spot under Louis Armstrong Stadium. He reached into the bag and pulled out a black jump rope endorsed by Muhammad Ali. Connors held the rope in front of him and looked Henderson in the eye. The two men nodded at each other in silence and Connors proceeded to skip rope for 10 minutes.

"I gave Connors that rope the year before, at the Open," Henderson says. "I'd watched him in the semifinal with McEnroe, and his legs had seemed less defined than normal to me. That's how you could tell Jimmy's shape, his legs. So I just handed him this jump rope before he left. He didn't say anything; he just took it."

Now Connors was showing Henderson that he hadn't forgotten. "He didn't say a word; he just started jumping with it. It was a message that he had been doing the work. He was ready to start all over again to win this tournament one more time."

———————

In the early 1970s, Jimmy Connors had emerged as the player that tennis, the tennis of television and the stadium, had been waiting for, even if many of its older fans didn't agree. He fit all the clichés of the popular sports hero: He was a blue-collar American star from the Midwest, an athlete and an entertainer rolled into one; a little,

feisty, vulgar, Vegas-loving kid from the wrong side of the tracks; a boxer with a steel racquet fighting above his weight; a champ you loved to hate.

While McEnroe was the number one seed and number one player in 1981, it was Connors who was scheduled to play the first match of the Open inside Armstrong Stadium. And that was appropriate. Slew Hester may have found that arena, but it was The House That Jimbo Built.

Connors was, even more than Bjorn Borg, a pure and exemplary product of professionalism. He played to win, to be, as his mom wanted him to be, a "tiger," to be a champ—"I'm going to be the best," he said, even before he'd won a thing. There was no such thing as a moral victory or a character-building defeat in his world.

In the mid-'70s, he had popularized the high-stakes, winner-take-all, one-on-one exhibition which would introduce huge sums of money into the sport for the first time. He referred to the court as his "office" and called playing tennis "taking care of business." The professional era that he helped usher in would, for the first time, make tennis a potential career path for millions. But the game was about more than money to Connors. It was about caring about something.

Connors obviously wasn't the first tennis player to care about success. But the old gentleman's code, which had been followed all the way into the 1970s by lean and upstanding Americans such as Arthur Ashe and Stan Smith, mandated coolness and grace under pressure. Connors never played it cool; he made his desire palpable. He communicated it in the way he launched himself, wet Raggedy Andy hair flopping around his head, into his fierce two-handed backhand. He communicated it in the way he swiveled his hips and raised his shoulders as he strutted from one side of the court to the other between points. Jimmy Connors played with his back up.

It was often said that he "tore the cover off the ball." It would

have been just as accurate to say that he tore the cover off the game: the cover of gentility, of class, of gentlemanly diffidence; of the code of amateur sportsmanship that had masked its most fundamental element—its psychological viciousness. Tennis had aspired to make competition pretty; Connors, whose strokes were never meant to be elegant, showed that a desire to win could be ugly, too. Instead of a line from Rudyard Kipling, it would have been more appropriate for the players who walked into Louis Armstrong Stadium for the 1981 Open to look up and see a verse written and recited by Jimmy Connors: "All these people want to see is two guys trying to kill each other out there."

John Lloyd had spent 1981 learning the truth of those words the hard way. Once a top 30 player and the British number one, as well as the husband of America's tennis sweetheart, Chris Evert Lloyd, he had been getting killed a lot lately. Lloyd had seen his ranking plunge below number 350 at the start of the season. The former heartthrob known in the tabloids as "Legs Lloyd" had been cast into a somewhat embarrassing new role: the sport's First Husband. His status was summed up in a 1980 *World Tennis* photo essay entitled, "Best in a Supporting Role: Some of the Stars and Their Valuable Helpmates." Lloyd found himself featured alongside, among others, Bjorn Borg's wife, Mariana; Jimmy Connors's wife, Patti; and Rosie Casals's dog, Midnight.

Lloyd was reduced to playing qualifying events to earn the right to enter top-level tournaments. But he didn't find himself welcome there, either. His opponents in the minor leagues were young and hungry—often literally so. Lloyd, who flew first class and stayed in the best hotels with his wealthy, world-famous wife, could see their annoyance from the other side of the net: "What's this guy doing here, taking the bread out of our mouths?"

That Evert Lloyd continued to dominate the women's game—

she won her third Wimbledon in the summer of 1981—made John's slump doubly obvious and doubly mortifying, and his negative attitude began to cause a rift in their marriage. Perhaps it was appropriate that, as time went on and his game failed to improve, Lloyd spent more and more time indulging in one of his favorite forms of relaxation: watching horror movies by himself.

Lloyd managed to win a round at Wimbledon and then traveled to South Carolina with Chris to train for the Open. But he couldn't summon any enthusiasm for the work, so he told himself that the tournament would be his career swan song. He went to New York hoping to be "drawn against someone who was an average, middle of the road player so I could play on an outside court, lose the match, and that would be the end of that."

His prayers, alas, were not answered.

Instead, Lloyd was scheduled to play the very first match of the Open inside Armstrong Stadium against Jimmy Connors, the New York crowd's adopted son. Throw in the fact that Connors had once been engaged to the pretty boy Lloyd's wife and you had the most anticipated first-rounder of the tournament. As the Lloyds' biographer, Carol Thatcher, wrote, "The match had all the makings of a publicity stunt: America's No. 1 watches her macho ex-fiancé challenge her good-looking, blond, Mr. Nice Guy husband."

If Lloyd was looking for a merciful end to his career, he had come to the wrong man. On a dismally drizzly afternoon, Connors won the first set 6-0 while losing just seven points. Lloyd's celebrated legs were betraying him. They felt like lead, and they only got heavier as the match turned into a horror show of its own—"I was tight as a drum," Lloyd confessed later. Connors won the second set, again 6-0. "I must put a game on the board," a now-panicked Lloyd urged himself again and again.

Down 0-2 in the third, 14 games into the match, Lloyd finally did. But Connors swept the final four games to win 6-0, 6-0, 6-2, leaving Lloyd feeling "totally and utterly humiliated." New York's tabloids might have made the Brit feel at home, though probably

not any better: "Chris Watches Connors Rout Hubby" was how the *Daily News* put it, with more than a hint of glee, the next day.

Asked about the match-up afterward, Connors claimed that he had no special feeling about it either way. He was, as usual, just taking care of business. "I don't worry about anyone," he said. "John and I each had a job to do and we went out and did it." Evert Lloyd watched from an undisclosed location high in the stands because, as her husband said, "She didn't want to spend the match with a camera up her nose." But she knew a thing or two about Connors, and even from far away she thought she noticed a special glint in her ex-fiancé's eye. "Jimmy seemed to have an intense determination to beat John," Evert Lloyd said a few months later. "Maybe he took this match a little more personally than others."

"Intense determination" was hardly something remarkable for Connors. He played every point with an abundance of it. Nor was taking a match "personally" all that surprising, as Evert Lloyd knew. She had once said of Connors, in the latter days of their mid-1970s romance, "Jimmy can't beat someone he likes. He has to hate the person he's playing." Still, she was on to something as she watched Connors rout her husband: he *was* determined to prove himself again. By the summer of 1981, it had been three years since Connors had won a Grand Slam. This would have been unimaginable only a few seasons earlier.

In 1974, at age 22, Connors appeared destined to dominate the sport for as long as he wanted. That glorious year, Connors won three of the four Grand Slams (he was barred from playing the fourth, the French Open, because of a complicated political dispute), and demolished Australian legend Ken Rosewall in the finals of both Wimbledon and the U.S. Open. Connors humiliated opponents with his two-handed backhand and scared them with his

bloodthirsty manner. Like Maurice McLoughlin 60 years before, Connors had parachuted in from a place far removed from the amateur lawns—in his case, from Belleville, Illinois, a working-class suburb of gritty East St. Louis. Like McLoughlin, Connors played with a new level of gusto and power; Bud Collins even bestowed him with a nickname reminiscent of the California Comet's: the Brash Basher of Belleville.

Unlike the gentlemanly McLoughlin, however, Jimbo was also known to drop his shorts during practice sessions, grab his crotch after missing shots in matches, put his hand down his pants at press conferences, and, on at least one occasion, jump into the stands to track down an offending fan. And it's doubtful that the Comet, no matter how angry he became, ever thought to scream "Syphilis!" after shanking a shot, which is what one tennis reporter overheard Connors do. "It was a non sequitur," this journalist says, "but Jimmy needed to find that kind of word when he was out there, to grab on to it, to get into the right mind-set."

It had appeared to some observers in 1974 that Connors would go on to win dozens of Grand Slam titles. It hadn't come to pass. It turned out that there were vulnerabilities below the bluster. In 1976, Borg took his Wimbledon title and never returned it. Three years later, McEnroe owned his beloved U.S. Open. There had been a ray of light at Wimbledon earlier in 1981, when he had won the first two sets before falling in a classic five-set semifinal against Borg; the following day, the London papers called the match "a banquet for the Gods." But Connors had followed that vintage performance with a poor summer. He came to New York on the heels of early losses in Montreal, Cincinnati, and North Conway, New Hampshire. In what seemed like a significant passing of the baton to a new generation, 21-year-old Ivan Lendl had leapfrogged him in the rankings.

So it was a testament to the enduring punch of the Jimbo persona that *Tennis* magazine chose to put him, rather than Borg or

McEnroe or Evert Lloyd or Lendl, on the cover of its 1981 U.S. Open special edition. "Can He Come Back?" the magazine asked, not for the first time.

As always, the man himself refused to admit to harboring any doubts about the answer. The interview was a tour de force of Connors bravado. He railed against his critics, those who thought he had blindly stuck with his brash bashing even when it was past its expiration date.

"The world is full of armchair QBs," he muttered dismissively.

Congenitally upbeat about his prospects, Connors chalked up his struggles to adjusting to life with a wife and son. And he concluded with a classic bit of blood-and-guts bluster: "Before I quit, before I die, I'm going to win Wimbledon or the Open again. It might kill me, too, but you know, I'm going to do it." (It was often said by friends and acquaintances that Connors hid a softer side from public consumption, so he may not have been pleased that the interview began by describing a conversation he was having with his 1-year-old son Brett's Kermit the Frog doll.)

While Connors remained stubbornly certain about his chances through the years, the same could not be said of the press. Hero or jerk, declining or reviving—the two leading U.S. tennis magazines of the 1970s never made up their minds about Jimbo. But they never stopped asking, either.

"Is There a New Jimmy Connors?" British writer Rex Bellamy mused in the pages of *World Tennis* in March 1976. Fellow Brit David Gray answered his question the following month in the same magazine: "Yes, Virginia, There is a New Jimmy Connors."

Two years later, *Tennis* believed Connors had undergone another transformation: "Jimmy Connors Has Changed: Have You Noticed?" That same year, Mike Lupica asked in *World Tennis*, "Has the Champagne Gone Flat for Jimmy Connors?"

In 1979, *World Tennis* had a new question on its mind: "Jimmy Connors: Star-Spangled Hero or the Ugly American?" The next year, the magazine seemed to have settled on an answer: "The Best

and the Baddest" was the title of another profile by Lupica. In it, Connors's first manager, Bill Riordan, summed up a decade's worth of Jimbo watching by the media. "If Junior changed for the better as many times as people say he has," Riordan said, using his McEnroe-like nickname for the man who had once been like a son to him, "someone would have to nominate him for Pope."

Connors had in fact changed over the years, in part to win over the fans at his favorite tournament, the U.S. Open. He had been booed as a callow champion in 1974 at Forest Hills. But he had found a home at Flushing Meadows, where he recast himself as a soulful survivor who had taken his knocks but kept coming back for more—it was a persona that clicked with the survivor mentality of New Yorkers in the 1970s.

Beyond that, though, the guardians of the game had always *wanted* Connors to change. His rise had been a double-edged sword. He was exactly what tennis was looking for in the early days of the Open era and the American empire: a charismatic U.S. star; someone with more youthful edge than the anachronistic, clean-cut Australian heroes of the day; someone who could project his personality into the far reaches of the gigantic new arenas where the sport was now being played and into living rooms around the country. Connors was all of these things, but he was also what the game was dreading when it opened itself up. With the charisma came paranoia, vulgarity, and a forthright egotism that had been mostly foreign from the sport in its amateur days. Golf's populist hero had arrived in the late 1950s in the form of grinning fan favorite Arnold Palmer. Connors inspired much more ambivalent feelings among tennis fans. In his glory year of 1974, the national figure he was most often compared with wasn't a countercultural icon or pop star or top athlete. It was his fellow paranoiac, Richard Nixon.

Even when the game went professional, camaraderie had reigned among the players. The first group of pros after 1968—sporting Aussies and Americans such as Laver, Rosewall, Ashe, Smith, and Newcombe—had formed bonds of solidarity as they pushed to-

gether for open tennis, and they formalized those bonds in 1972 by creating a player's union, the ATP. Connors, despite being the biggest beneficiary of the open game, walked alone. He refused to join the ATP, and even ended up suing the organization.

Tennis in the past also had a nationalistic flavor and purpose, like that other great amateur event, the Olympics. Sports were still seen as instilling the values of a nation or class, rather than as a vehicle for personal gain. To play for your country's Davis Cup team was an achievement and honor on a par with winning Wimbledon. Connors was one of the very few players in history to turn down a chance to play for his nation. With him, the sport took an irrevocable turn toward pure individualism. He proudly represented no one but himself. "He ain't one of the boys," said Arthur Ashe, a founding member of the ATP, in 1975.

How could he have been? Jimmy Connors had learned the game from two women. It was his mother, Gloria, and his grandmother Bertha (known as "Two-Mom" to Jimmy and his older brother, John) who taught him his pugilistic style and his champion's tenacity. And he didn't learn the game on a manicured lawn, but on the cement court Gloria built in their yard. He was "raised by women to conquer men" in the words of Frank Deford. Connors was also destined to be a little paranoid. The women had taught him that, too—everyone was out to get him, including, it seemed, his mother. "If I had a shot I could hit down his throat, I did," Gloria said. "And I'd say, 'See, Jimmy, even your own mother will do that to you.'"

From the time he started dragging a racquet around at age 2, it had been Jimmy, Gloria, and Two-Mom against the world. In the 1960s, mother and grandmother guided young Jimbo away from the comradeship of the good citizens of tennis, the amateurs, and delivered him into the hands of the game's outlaws, the men who fought each other night after night to make a living, the pros. It was down their lonesome roads that Jimmy Connors would carry his steel racquet.

TAKING LOVE ON THE RISE

"I'm 5-foot-5, 150 pounds. I've got broad shoulders and I can pack a punch.
Most of these guys are windbags anyway. If they ever try anything with me,
I'll be over the net fast."

—JIMMY CONNORS

Movies stars. Corvettes. Eternal sunshine. Half days at Rexford High up in the hills. All the pop you could drink. L.A. sure beat Belleville.

La-La Land in the late 1960s was hazy, groovy, colorful, and edging toward the sinister. By 1968, the summer of love had turned to the summer of doom. Jim Morrison, the bellowing Lizard King, staggered woozily on top of the mountain, while Charles Manson lurked in the canyon. But one thing hadn't changed: the tennis courts were the same dimensions as they were back in Illinois. What the city's other soon-to-be-controversial Jim, Jimmy Connors, wanted in those days was what he had always wanted, to do the "work," to "grind," to "hit the hell out of the ball." The Midwestern kid got his square kicks with Elvis, AM radio, and Dr Pepper. Otherwise, all he needed was the freedom to play the game he was born to play.

Connors had been introduced to the sport *before* he was born, in fact. His mother, Gloria, a tennis junkie of the first order, was carrying him inside her as she began building the family's court in East

St. Louis. Gloria Thompson was a very good competitive tennis player. Her bloodlines were athletic as well as pugilistic. Her father, Al, was a policeman and Golden Gloves boxer, and her mother, Bertha, played tournament tennis. "Jimmy had his game together by the time he was 5," Gloria said.

The style was, as Connors described it, "a woman's game inside a man's body," and like his professional contemporary Bjorn Borg's, it was a new one for the sport. While male champions had been serve-and-volleyers for decades, Gloria, as a woman, knew there were other ways to win.

At first, Jimmy wasn't strong enough to hold the racquet with one hand on his backhand side. In an act that might be interpreted as maternal indulgence, Mom and Two-Mom let him use two hands. It became his signature shot. Instead of the serve, the under-size Connors would use that backhand to make his return of serve his most feared weapon. He would use his opponents' power against them. The word *counterpuncher* could have been invented for him.

Connors gobbled up everything Gloria told him, punched back every ball she tried to hit down his throat, and always asked for more. Still, the frail-looking kid wasn't a world beater to start. He wasn't ranked number one in the country in the younger age groups. At 16, though, he won a national title, and Gloria decided her son would need to hear other coaching voices if he was going to live up to his potential. She met with an old friend from the circuit, Pancho Segura, who was now an instructor in Los Angeles, when he came through St. Louis. He was skeptical at first, but he was won over by the family's passion. He agreed to become the boy's coach. Jimmy, Mom, and Two-Mom packed up and headed for the coast. It was tennis over family. It was tennis or bust.

———

At 16, Connors, with his flat ground strokes and counterpuncher's mentality, could play like a woman. Now he needed to learn to think

like a man. In Los Angeles, he found a coach and a father figure in Segura. Even more than Jimbo, "Segoo" was the archetypal tennis outsider. Born in Ecuador in 1921, he had been a small, sickly child whose growth was stunted by rickets. Segura's father had a job as a groundskeeper at a tennis club, and his son served as a ball boy to its wealthy members. One day, he picked up a racquet that one of them had tossed away and began hitting balls against a wall. That's where he would teach himself the game. He would never take a lesson.

Tennis would become his life, but with no bankroll behind him, Segura quickly quit the amateur ranks and found his way to the barnstorming pro tours. There the crowd-pleasing little man with the big smile often played in the warm-up match before the head-liners. In the words of the tall, blond Jack Kramer, Segoo was the "animal act."

Like so many athletes who sit one step removed from greatness, Segura watched closely and learned well. He was a born teacher and a tennis lifer, and through the 1960s he was comfortably ensconced as the head pro at the Beverly Hills Country Club, home to the city's Jewish Hollywood elite. There were worse gigs, but by the summer of '68, Segura was sick of teaching celebrities who didn't live and die for tennis. With the arrival of the young and hungry Jimmy Connors, Segura would get to train someone like him, someone who played like him and thought like him.

It was the right kid at the right time. Earlier that summer, Segura had been thrilled to return to the first open Wimbledon, after 23 years away. He knew that the sport was changing, and his fire-breathing young student could be part of that change. Maybe Segura himself could get a little of the glory he'd missed when he was doing the animal act instead of showing off his famous two-handed forehand at Forest Hills. Drawing up tactical plays and diagrams on napkins, the crafty old coach broadened Connors's range beyond Gloria's repertoire.

In Beverly Hills, surrounded by the entitled children of wealth and celebrity, Connors would get a crash course in class hierarchy.

But he would also learn how tennis gave him the power to subvert that hierarchy—to punch back at it. "The movie stars were coming out to see me," Connors told *Sports Illustrated* in 1974. "I must have been somebody myself. Here's Dino Martin and the rich kids like that hanging around. [Dino] said I had no class. See, he had a famous father and several tons of dough and all the time on his hands and all the broads. Yet all he wanted to do was play good tennis."

Segura introduced Connors to the other Pancho: Big Pancho, Pancho Gonzalez, who had been the world's best player during the 1950s. A long, lean, moody son of Mexican immigrants, Gonzalez showed the mama's boy what toughness looked like on a court. Unlike Jack Kramer, who thought Connors didn't have the build to survive at the top of the game, Gonzalez knew that Jimbo had something special. Like Segura, he saw below the physical surface and found a kindred outsider's spirit.

In 1970, a few months after Connors graduated from Rexford High, Gonzalez introduced him to the big time. Jimmy, at 18, made his Grand Slam debut at the U.S. Open that fall. He lost in the first-round in singles, but Gonzalez, 24 years his senior, guided him to the quarterfinals of the doubles. "Hair, arms, legs, along with plenty of fur, flew as Connors bashed away in a game he so obviously loved," Bud Collins wrote of the left-handed rookie tagalong, who "laughed and scowled" with Gonzalez as they skidded across the grass of Forest Hills together. The torch had been passed: the education of Jimmy Connors was complete.

In Gonzalez's day, playing at the West Side Tennis Club and the other summer grass court tournaments had been called "going East." For the L.A. kids, it was an invasion of the ivory tower. There was fun for them there, but no money, and they left it as quickly as possible. Now, in 1970, another pro from another generation, a mop top with a two-handed backhand, had arrived from the hard courts of the West and been welcomed where his predecessors hadn't. Over the next decade he would remake the U.S. Open in his own image.

Jimmy Connors and the Open would grow up together. In 1974, at 22, he came of age there when he won the title as an unpopular young punk. The same year, the "tennis boom" hit its peak and became a media phenomenon. Thirty million Americans were playing the game, three times as many as had picked up a racquet at the start of the decade. Plastered across magazine covers together, Connors and his fiancée and fellow Wimbledon champion, Chris Evert, were the smiling young faces of the boom. It looked like they would dominate the sport, as husband and wife, for years to come.

But stardom, as well as the sport's new popularity, didn't prove easy to handle. Connors and Evert never married, and opponents discovered fatal flaws in Connors's game. At the same time, the boom turned into an epidemic, as Forest Hills was besieged by new, rowdier fans. It all came to a head, for Connors and Open alike, at the end of the summer of 1977.

In a sign of the anarchy to come, the head groundskeeper at the West Side Tennis Club purchased 11 hammers just before play got under way that year. At the end of the first week, he discovered that all of them had been stolen. This was a bad omen, to be sure, but not a surprising one. In 1977, the Open began at the hot end of a very hot and chaotic few months in New York. It was the year when the city broke, in every sense of the term. The world that American tennis had known for 60 years would break right along with it.

It was the year of Studio 54 and CBGB, when two of the city's underground musical phenomena, disco and punk, one a decadent escape from reality, the other a scabrous attack on it, moved off the street and into the mainstream. It was the year when three of the city's beloved sports heroes—Tom Seaver, Joe Namath, and Walt Frazier—were traded away, while a fourth, controversial slugger Reggie Jackson, arrived in the Bronx. His Yankees, heroes for a town with no heroes left, feuded their way to a World Series title.

Politically, it was the summer when 1960s-style liberalism broke for good. On July 13, lights went out all over the city and looters went on a 25-hour rampage. The destruction of ghettos by their own citizens brought little sympathy from the country at large. While the urban riots of the 1960s had a political dimension, this was widely seen as nothing more than criminal madness.

The madness didn't end there. In March, the story of the serial killer known as Son of Sam broke when a student named Virginia Voskerichian was killed in Forest Hills Gardens (the killer had also struck there in January). Forest Hills was the home of reporter Jimmy Breslin, who began to receive rambling letters from the murderer that fed a citywide terror. The final killing came on July 31. The Son of Sam, unmasked as David Berkowitz of Yonkers, New York, was caught on August 10. Two weeks later, on August 31, the last U.S. Open at Forest Hills began just up the road from the sites of two of his murders.

The Open wasted no time in following Berkowitz onto the front pages. The tournament began with a bona fide cultural event, Renée Richards's first-round match. Richards had played the men's U.S. Championships 22 years earlier as Richard Raskind; now, at 43, after undergoing sexual reassignment surgery, she had entered the women's draw. The USTA and the women's tour fought to keep her out, and there was fear that she would dominate the competition. But that fear vanished quickly when Richards was outmatched by Wimbledon champion Virginia Wade in the first round.

The sideshows began early on the men's side as well. Journeyman player Mike Fishbach made a one-man technological advance by spending 30 hours rigging up a "spaghetti racquet." A frame strung with fishing line, tubing, rope, tape, and who knew what else, it generated massive spin on the ball and helped Fishbach upset former number one Stan Smith.

There were noisy demonstrations against the USTA for allowing South Africa's participation in its events. "The restlessness of society had penetrated the ivy," Gene Scott wrote. "A decade ago

the crowds were 99 percent WASP with an ideological viewpoint that was as varied as a tin of asparagus." Now the Open represented enough of a cross section of society that local politicians felt the need to be seen there. Not that they were particularly welcome. The governor of New York was booed lustily upon his arrival, while every sighting of the USTA's president was greeted with derisive jeers.

Over Labor Day, fans staged a sit-down strike of their own. It wasn't a political move; they just wanted to see the game's newest star, French Open champion Guillermo Vilas, play. The muscular, mysterious Argentine made the perfect hero for these waning days of the counterculture—i.e., he wasn't an American. Vilas was also the antithesis of the puerile Connors. He sported long hair and was an amateur poet and filmmaker, even if the quality of both his poems and movies may have been suspect. Jorge Luis Borges, the blind Argentine writer and winner of the Nobel Prize, said that Vilas wrote verse about as well as he, Borges, played tennis.

Near the end of one day session, it was announced that the fourth-round match between Vilas and Spain's José Higueras would be moved to the evening and that fans would have to leave. The 12,000 adults in the stadium chucked whatever they could find onto the court and chanted, "We want Vilas!" Officials relented and put the match on. "In 50 years," Open referee Mike Blanchard said, "I haven't seen that kind of disobedience."

It got wilder. The same week, during a night match featuring John McEnroe, the city made its presence felt in a painful way when a fan was hit by a stray bullet from outside the grounds. He was carried out on a stretcher, but survived. Two days later, police pulled a pistol out of a fan's pants.

All of this was unprecedented, but it suited the cultural moment, and the man of that moment: ugly American incarnate Jimmy Connors. It had been a rocky and turbulent season for Jimbo. His father had died, he'd lost a heartbreaking final to Borg at Wimbledon after coming back from 0-4 in the fifth to tie it at 4-4, and he hadn't won a tournament since. By the time he got to New York, Connors was

a whirlwind of antagonism. He was ready to mix it up with anyone who wanted a piece.

"This is my championship, I own it," he announced right away. "When I win it, I'll be No. 1 in the world." He clashed with reporters, calling them "assholes" and saying that he didn't come to the media room "to answer stupid questions." According to *Sport* magazine, "During press conferences he would run his fingers up and down a microphone pretending he was masturbating." In the quarterfinals, annoyed that the crowd was supporting his Spanish opponent, Connors flashed them the finger. A woman yelled, "Fuck you, too, Jimmy." Connors barked back, "I'll fuck you anytime you want to."

The final straw for the spectators came in the semifinals. Connors, playing Italy's Corrado Barazzutti, hit a ball that was called good for a winner. The Italian disagreed and motioned for the umpire to check the mark. Before that could happen, though, Connors, who was tired of the Italian's repeated protests, barreled around the net and rubbed the mark out. Barazzutti was stunned ("He was like a crazy man," he said), and the crowd turned on their countryman. Connors fought his opponent and the audience to a grim straight-set win; along the way, he bellowed, "I'm the last one you've got left, so you better pull for me."

The final pitted Connors versus Vilas, the brat versus the poet. It was windy and chilly, and it got only colder as the sun went down and the stadium's electric lighting took over. There was no glamour to this evening, however; the starless city sky added only another sinister edge. Connors came out firing and won the first set 6-2. But Vilas began to attack Connors's vulnerable forehand with biting slice backhands. Connors slowly came unglued as the crowd cheered enthusiastically against him. Ashe, watching from the press box, said, "I've never seen anything like this. These people want blood."

Vilas went up 5-0, 40-0 in the fourth set; he had three match points. Connors got the score back to deuce, but Vilas reached

match point again. Connors hit a forehand toward the sideline, put away a volley, and walked back to the baseline. Then he started to see people jumping onto the court.

After Connors's forehand had landed, Vilas's coach, Ion Tiriac, and a pack of Vilas fans shouted, "Out!" Vilas looked to the elderly line judge, who creakily raised his arm to signal that the ball had landed wide. Fans stormed the court as Vilas leaped into the air. They surrounded the champion, ripped his headband off, and threw him up on their shoulders. "The aged chair umpire," Bud Collins wrote, "made a wise announcement: 'Game, set, and championship to Mr. Vilas.'—and hoped he and his high chair wouldn't be carried off in a human undertow."

Dazed, Connors stalked to the sideline; he was never able to reach Vilas at the net. A photographer pointed a camera at him and Connors, neck veins bulging, screamed, "Get that out of my face!" When the camera stayed where it was, Connors lunged at the photographer. Doug Henderson, Connors's bodyguard from the Bronx, picked Connors up from behind. Wriggling in Henderson's arms, he screamed again, "Who's next?" By the time Vilas's fans stopped parading their hero around the court and the trophy ceremony began, Jimbo was nowhere to be found. He had made a quick getaway across the grounds and into a waiting Pinto. "I'm moving to Monte Carlo to get away from this crap," the wannabe American hero grumbled. Driving out of the grounds on the last night of the last Open at Forest Hills, Connors made one final farewell gesture. He leaned out the window of the Pinto and spat on a tree.

––––––––––

Surveying the wreckage of the '77 Open, Bud Collins wrote that it "blended elements of the evacuation of Saigon, *Twilight of the Gods*, *Day of the Locust*, and a fiesta." But the ruin of Forest Hills, ironically, led to resurrection. Leaving the ashes behind, the U.S. Open and Jimmy Connors would be reborn at Flushing Meadows.

But that rebirth really began at another New York City venue in January 1978, and it began against Vilas. A buzzing sellout crowd at Madison Square Garden turned out to see the Open finalists duel again at the season-ending Masters. As Connors waited to be introduced, he was apprehensive about how the audience would receive him. Belying his cocky image, he nervously peeked out from behind a curtain. When his name was announced, the ovation was deafening. Henderson, who was standing with Connors, said the cheers "sent chills through my body." He chalked the reaction up to the "Archie Bunker effect": It was a blue-collar backlash against the treatment that Connors had received at the elitist West Side Tennis Club the previous year. New Yorkers had watched as one of their fellow Americans had been driven off the court and an Argentine lifted above it. The tide of public opinion had finally begun to turn Jimmy Connors's way. He would go on to beat Borg in the Masters final.

Still, once again, the Swede was impenetrable at Wimbledon. He crushed Connors in the final that June. Despite the humiliation, Connors, the man who loved nothing more than to be counted out, literally swore revenge. After the final, he growled, "I guess I'll have to follow that son of a bitch"—Borg—"to the ends of the earth."

Again Connors would draw his line in the sand at the Open— this time it felt like Armageddon. Not only did he want to expunge the memory of his Wimbledon loss to Borg, but he also considered the previous year's Open final against Vilas to be "unfinished business"—for years he would claim that the match was "still going," because his last shot hadn't been out. Saying that he had played "like a pansy" at Wimbledon, Connors vowed to be more aggressive on the hard courts at the new National Tennis Center. He showed up weeks before the Open began, and was the first player to practice on the DecoTurf surface. He actually got there too early; there were no nets on the courts when he arrived. The minute they were put up, he started tearing the courts up and dropping bucket loads of sweat

on them. As the tournament began, Connors ordered 55 pounds of steak to get him through the two weeks.

Just in case Borg and Vilas weren't inspiring enough as antagonists, Jimbo added one more person to his enemies list. The week before the '78 Open began, *Sports Illustrated* published an article by Frank Deford about Connors entitled "Raised by Women to Conquer Men." Deford probed the unique and intense relationship between Connors, his mother, and his grandmother more deeply and insightfully than anyone had before.

"It is strange that as powerful as the love is that consumes the Connorses, Jimbo has always depended on hate in order to win," Deford wrote. "And all along that must have been the hard way. There's no telling how far a man could go who could learn to take love on the rise." Connors, naturally, used his hate for the article to drive himself harder. He refused to speak to the press for much of the Open.

Flushing Meadows was made to order for Connors. He would later say that the freewheeling atmosphere reminded him of the parks and public places where he had grown up in the Midwest. In the end he would have his revenge on Borg, who played the final with an infected thumb. Connors—showing no mercy, staring bug-eyed across the net, and doing a menacing dance as he waited to receive serve—belted the ball past the helpless Swede with vicious gusto and won in three quick sets. Before the match, Connors had been locked up for hours in a room under Louis Armstrong Stadium with only his closest advisers for company. He played the match like a man in the midst of a jailbreak.

But that wasn't Connors's most memorable performance of the week. In the fourth round, he had faced Italy's Adriano Panatta, a stylish shot maker who had twice done what no other player could do: beat Bjorn Borg at the French Open. On this day he was good enough to serve for the match against Connors at 5-4 in the fifth set. When Connors belted two of his signature returns of serve to break, he was exultant. He pumped his fist and strutted across the

court. In the past, these hammy moves had struck tennis audiences as calculated and disingenuous; this time it was different. "Many of us in the past," Herbert Warren Wind wrote in *The New Yorker* after the tournament, "have felt that Connors' purpose in parading these antics was to show up his opponents and glorify himself. Not this day. Unmistakably, he was simply exhibiting for himself alone the joy he felt at playing such sensational stuff when nothing less would have done."

In the final game, at deuce, Panatta angled off a forehand volley that appeared to be out of reach. But Connors rocketed after it, reached with his left hand, and sent a one-handed backhand around the net post and smack onto the sideline for a winner. Panatta, gutted, double-faulted to end the match. "The shot of my life," Connors called his backhand winner. "It almost took the net judge's head off, but it was right on the money."

The year before, against an Italian opponent, Connors had run around a net post in a vulgar display of bad sportsmanship and misguided comedy. This time he hit a scintillating backhand around a net post to crush the spirit of another Italian. He was off the mat again. In 1977, as an angry and bellicose loser, he had bolted the trophy ceremony. In 1978, the winner sounded a new note of conciliation when he told the audience after the final, "Whether you like me or not, I like you." The American tennis empire had its hero at last. For the moment, he had learned to take love on the rise. From then on, the fans at Flushing Meadows would love him back.

CHAPTER TEN

MR. NASTY

"Personally, I never had a rule about not having sex before a match."
—ILIE NASTASE

t was late on the second day of the 1981 U.S. Open, and the wind had begun to kick up. Many of the 8,000 or so fans scattered among the upper reaches of Louis Armstrong Stadium had been drinking. There was one more first-round match left to see, and they were hell-bent on seeing it, so they began to climb down and fill the empty seats closer to the court. When one of the players, a long-haired 22-year-old from the Kentucky backwoods named Mel Purcell, appeared, he was greeted with a beery big-city salute: "Nice headband, ya sissy!"

Purcell may have been a country boy, but he wasn't used to this treatment in New York. In his few visits, he'd become a fan favorite. "Give 'em hell, Mel" was a common cheer, and the fans loved it when he walked out for one match in a New York Mets batting helmet. But on this night, Purcell was scared of what might happen to him. He was scared of the crowd, but he was even more worried about his opponent. "I've never been so nervous for any match," Purcell remembers. "You never knew what Nasty was going to do next. And I knew 90 percent of the fans were going to be for him."

His opponent, "Nasty," was Ilie Nastase, a 35-year-old Romanian who had spent more than a decade playing the part of tennis's

village loon. Two years earlier at the U.S. Open, he had added a new role to his repertoire: Prince of Darkness. In a 1979 night match against John McEnroe before an audience that, as McEnroe would later say, "had had a few pops," Nastase managed to get himself defaulted, have the umpire removed from his chair in a savage hailstorm of boos, start a near riot, get himself reinstated, engage in two sets of the finest tennis of that year's tournament, and finish the evening by losing for a second time—all while doing little more than standing around being Ilie Nastase.

On this day, as another set of similarly lubricated fans clambered down into their seats in the same stadium, Purcell thought back to that match and shuddered. Nastase's presence already seemed to be inspiring bedlam. A voice howled, "Go back to Kentucky!" It was going to be a long night.

As wary as Mel Purcell may have been, he knew he wasn't facing the Nasty of old, either as a player or a villain. Earlier that week, *Newsday* had summed up the state of the Romanian's game and life bluntly: "Nastase: Not Great or Nasty Anymore." Fifteen years on tour had taken their toll. He had won Grand Slam titles and played with a high-strung grace and genius virtually unmatched in the sport's history. Also unmatched was the crassly hilarious boorishness with which he behaved. He was perpetually frazzled, and his conduct knew no boundaries. In fact, it had been Nastase who forced tennis to put some boundaries in place for the first time in 1976 by implementing a "Code of Conduct," with penalties for hideous manners. The sport had never had to deal with someone who, if he was in the mood, could transform a match into a cross between a comical New York traffic argument and a sporting version of a play by Beckett.

Open tennis had promised more color and personality from its performers, but it hadn't promised someone with quite as much

of either as Nastase, whose act was always perilously balanced between the charmingly cheeky and the unpleasantly crude. Hectoring umpires, bantering obscenely with fans, imitating and insulting opponents—he called Purcell *porcello*, Italian for "pig"—yet making magic with his racquet, he was the living symbol of the circus that tennis had turned itself into when it entered the marketplace.

The Open era, and all of the new possibilities it offered players, appeared to have sent an electric shock through the man. Nastase had shown up on tour in the mid-1960s looking like any other amateur-era choirboy, in all whites, with his hair neatly trimmed and parted at the side. Painfully shy and skinny, he seemed to be little more than a sidekick to the older Romanian player Ion Tiriac. If the sport had remained a leisurely backwater, Nastase might have taken his place among its long line of lovably eccentric kooks. As it was, he was thrown into the center of a gigantic new sports entertainment business, where serious money was on the line and the opportunities to chase it were endless.

By the middle of the 1970s, Nastase's hair had grown long and wild, and a patchy black beard often covered his face. He wasn't always so lovable, either. He stalked the court with campy menace, the wires of his nerves sizzling, always on the brink of another rococo rant. The sport was testing its limits, and Nastase's.

Tennis was no longer a summer idyll. In the American empire, tournaments were run for profit, at the largest venues possible, and promoters competed for the services of star players. The tour, with no single governing body, became a boundless, airless circuit of player lounges, indoor stadiums, hotel rooms, and airports. The pro game would soon be played every week of the year. By the end of the decade, the men wouldn't even be able to fit their season into a single calendar year. Indeed, the Masters, the tour's version of the World Series, took place the January *after* each season, at Madison Square Garden.

Nastase had been a transitional figure and a guinea pig in this shift, an inmate of the amateur game and Communist Romania

who was given a chance to run the asylum as a star professional. But as the 1970s gave way to the '80s, he had become a trendsetter in another way: By 1981, he was, by all appearances, "burned out." This would become a fashionable phrase of the era, in tennis and in other professional sports, as the mercenary grind of big-money athletics began to take its toll on its performers. Sports such as tennis, which had exploded so colorfully and lucratively in the 1960s and '70s, were an entrenched industry now.

Talented kids were slaving at them full time by age 10. In 1980, 16-year-old Jimmy Arias had made his U.S. Open debut. He was the first product of the Nick Bollettieri Tennis Academy, a boarding school/tennis factory/boot camp in Bradenton, Florida, where children were drilled for hours in the hopes of someday securing jobs as professionals. Soon copied worldwide, Bollettieri's was the next step in tennis's evolution from the professional to the industrial. The academy was eventually bought by IMG, which added separate boot camps for golf, baseball, basketball, and soccer. Tennis led the way: among young women pros over the next decade, "burnout" would almost come to seem like a treatable medical condition.

As Nastase arrived in New York for the 1981 Open, the years, the rants, the flights, the fame, the sex, the round-the-world chase after the next buck—all had left him a shell of his former self. The man who had been the first number one on the ATP's computer rankings eight years earlier had drifted down to an inconsequential number 78. He had been dropped by his agency, IMG. He hadn't reached the final of a Grand Slam in five years, hadn't won one in nine. In fact, he hadn't won a tournament of any sort since 1977, and at the start of 1981 he was barred from playing Davis Cup for Romania. The wins may have stopped, but not the antics.

At 35, Nastase's physical decline was inevitable. But along with his game, he had also lost his nature boy's love for playing and performing. Some of his colleagues on tour thought that the mad Romanian, who had always flirted with the emotional edge, had finally "gone off the deep end," that his famous nerves were shot.

He showed up at tournaments with just two racquets, of different makes. He lost first-round matches to nobodies. Afterward, he repaired to the darkness, and the soothing TV set, of his hotel room. His friends had begun to worry about his health. One of them, his frequent partner in crime Jimmy Connors, had tried to help by inviting Nastase to practice with him in Florida. Nastase, too proud, declined.

Booked to play tournaments or exhibitions for 47 weeks in 1981, he couldn't get off the endless circuit that had come to be his life, even as it was draining him. "If I stay somewhere two weeks, I go crazy," he claimed. It was, as one Nastase watcher said, "the itinerary of a homeless man." Two days before his first match at the Open, he defaulted the final of a tournament because he had already committed to playing an exhibition the same day somewhere else.

Press sightings of Nastase didn't do much to reassure anyone about his state of mind. A May 1981 *Tennis* magazine article entitled "The Tragic Twilight" found him in a Memphis hotel room after another first-round loss, preoccupied with a novelty clock he had bought on the street. "It's fantastic," Nastase said, sounding more cheerful than he would the rest of the afternoon. "I can't stop looking at it." He wrenched himself away long enough to say, "Tennis is a very dangerous life . . . but what can I do, kill myself?"

Tennis Week's Linda Pentz met a similarly morose Nasty a few months later. "I don't enjoy it like before," Nastase said on the eve of the U.S. Open. "The day I don't enjoy it I will stop. Maybe tomorrow." He wasn't too sanguine about the state of the sport, either; even the way it was scored annoyed him now. "The game is boring anyway so I guess it's going to get much more boring. Even the score, 15-love, 15-all, is boring."

Nastase was reeling. His personal life had unraveled in a painful and public way over the last year. His thoughts were never far from the drawn-out divorce proceedings taking place between him and his wife, Dominique. "Tennis cost me my family because it isn't a normal life," he told Pentz. "To spend nine years with a person and

to have a child . . . to lose them because of a game is a big, big price to pay.

"I have a couple of friends, a couple only, that's it. I always feel you are never happy. If you have $100, you want $10,000."

That Ilie Nastase would be the first casualty of the Open era wasn't all that surprising. He had come to stardom midway through his career and been caught unprepared. Mobbed by teenage girls at Wimbledon one year, he shook his head incredulously, "I don't understand it. I'm 31 and very ugly."

Inhibited and innocent in his early days on tour—his friend and mentor Ion Tiriac had to pay for Nastase to lose his virginity to a Paris prostitute—and with no map laid out for him by any professional predecessors, when he did hit the big time, he had played too much, spread himself too thin, and overindulged in the temptations of the road. "Tennis is a sport where there's no shortage of girls willing to sleep with a player, just for the hell of it," he said. Still, just because he slept with one in one city didn't mean she got to travel with him to the next. "When you visit a beach each week, why take a bucket of sand with you from the last beach?" he asked.

Nastase's initiation to sex may have come late, but his fame allowed him to make up for lost time in a hurry. By the end of the 1960s, he could "usually find a girl before the week was out." He often slept on the couches of tournament volunteers, which made it tricky to smuggle the girl in. Thankfully, the problem often solved itself. "Sometimes they had a suitably attractive daughter, so I didn't need to worry."

From those humble beginnings, Nastase would grow increasingly cosmopolitan in his expertise with the fairer sex. As with everything else in pro tennis, Nastase tested the boundaries when it came to women. After winning the Italian Open in 1970, he celebrated at various spots across Rome until, he said, "By the end

of a very long night, I had, of course, found a beautiful girl to take back to my hotel. It wouldn't have been a big celebration otherwise, would it?" Nastase was sufficiently enamored of the woman, who may or may not have been an actress or a contessa, that he broke his cardinal rule about bringing sand to the beach and invited her to the next tournament, in Naples. After a picturesque week there, the woman asked him to come to Tuscany with her. Nastase was on the verge of saying yes when she casually added that her parents would be there, too. Now it had gone too far. Nastase bid her farewell. "I'm afraid, *amore mio*," he told her wistfully, "that I have another tournament to go to, and I am very busy this summer, so that will be difficult." Explaining his regular use of terms of affection such as *amore mio* and *mon amour* and *darling*—depending on what country he was in on a given evening—Nastase claimed that most women understood what they meant, whatever language they spoke, and it helped when you forgot the woman's name.

Nastase went on to discover that "German girls are among the most relaxed and open when it comes to sex." On the downside, he also found out that he didn't like doing it in a small car—a big American car was one thing, but a Mini was out of the question. "It seems like a great idea at the time," he said instructively, "but believe me, when you've played a long match, sex in a small place is not good." Nastase tried it once and was embarrassed when the "great athlete" seized up with a cramp in his leg. As he lay recovering from the ordeal, he decided he would never try that again after a big match. A little later, in Spain, he found that he wasn't crazy about sex on hotel balconies, either. The woman he was with wanted to see if people on the street below could hear them, but this ended up being a turn-off for Nastase. "I hate hearing other people having sex," he said, showing his concern for others, "so I can't stand the idea of others hearing me."

Nastase's most notorious relationship of the 1970s, though, was not with a woman. It was with his fellow hellion, Jimmy Connors. Nastase and Connors first squared off at an indoor tournament in

Salisbury, Maryland, when Jimbo was a teenager. Nastase won in three sets, and Connors dragged himself disconsolately back to the locker room. Gloria's tiger had discovered that life on the pro tours could be lonely. So he was surprised to see his eccentric, lank-haired Romanian opponent, whose English was still a work in progress, walk toward him, point his finger at his chest, and say, "You, me, dinner."

It was the beginning of a long and tremendously vulgar friendship. While Borg had introduced (innocent) sex to the chaste lawns of Wimbledon, Nastase and Connors took the next step by debuting the simulated sex act between male doubles partners. Nasty and Jimbo dove for a ball that was hit between them; afterward, there was nothing left to do but have a roll on the lawn.

They were an act. Loved by the sport's new fans for their sense of cheeky fun, loathed by the traditionalists for the same thing, Nastase and Connors defined the outrageousness of the early pro era. They wore bow ties and sipped champagne on court in London. They played in matching rugby shirts at Wimbledon, and paid the fines afterward. They tore around a soaked grass court during one final because they didn't want to let down the customers.

Nastase took Connors under his wing, and tried to impart some of his knowledge of women to the young American straight arrow. Connors, Nastase discovered, had a lot to learn. "He was always promising [women] things," Nastase said. "I would say, 'Why did you tell her you'd take her to Vegas? You don't need to do that.' After all, he was only trying to get laid. You could tell his mother influenced him beyond his tennis." Jimmy thought you needed to be in love with a girl before you could do anything. On occasion, Nastase took it upon himself to get rid of Connors's girl for him.

Nastase won the first eight times that the two played, providing confirmation of Connors's need to hate his opponents to play his best against them. With that record, and with Connors's victory-or-death approach, the friendship and the doubles partnership were doomed. It reached a low at a special event at Caesars Palace in 1977.

Nastase was late in arriving. Connors believed he had done it purposely to throw him off. When Nastase finally got to the court, he found Connors swiping the net with his racquet. "Fuck you, Nastase, fuck you," he said with each swing. The verbal barrage from Connors continued until Nastase brought out the big guns. "Why don't you get your bloody mother down here?" he yelled. "You know you can't win anything without her!" Connors looked as if he'd been punched in the face. He sat down in silence and didn't say another word. Nastase won easily.

Though they were no longer inseparable, their friendship continued. Nastase faded from the tour; Connors plowed on. In 1986, Nastase tried his hand at a surprising new career as a novelist. That year he published *Break Point*, a "thriller" set, of all places, in the world of the professional tennis tour. One of the characters, named Dumbo Cooper, bears a striking resemblance to a famous real-life American tennis player. Cooper's hotel rooms are notoriously ill kept, with socks, shirts, and underwear strewn over every square inch of floor and bed. One spot, though, is conspicuously kept clear: the space where Dumbo keeps a framed photograph of his sainted parent, Mother Cooper.

———

As coarse as Nastase could be, there was also an effervescent quality to his personality and his game. Few tennis players have come to the sport as naturally—or nakedly. Like Pancho Segura's, Nastase's father had been a groundskeeper, at Romania's national tennis center, the large and beautifully landscaped Progresul Club in Bucharest. Nasty liked to streak naked through the grounds, and one year he climbed up to the top of the stands that way during a Davis Cup match.

There was no history of athleticism in his family, but the sport surrounded and seeped into him as a child. Old tennis balls rolled on the carpet. Rackets were stacked against the walls. There was a

stringing machine nearby. And there was the sound of the sport, the *thwock* of balls against strings, all around. At 4 or 5, Nastase would spend hours watching the Davis Cup team practice, unconsciously imitating their movements. He didn't learn the sport so much as internalize it.

And that's how Nastase played it. Like later tennis artist John McEnroe, Nastase disdained practice. He didn't need it. He hit the ball with, in the words of British tennis writer Linda Timms, "that rarest of combinations, flair with precision." Nastase's game, like his career, bridged two eras. He could serve and volley—he won at Forest Hills and reached the final at Wimbledon, both on grass—but he was a clay-court touch artist by nature who could win from the back of the court and loved to use the drop shot. Nastase was a balletic player with his feet, and as quick as any pro in history. With his racquet, he looked like a maestro conducting with a flick of the wrist. "I want to play the game inside out," he said early in his career.

McEnroe used the tennis court as a canvas, Pancho Gonzalez as a refuge, and Jimmy Connors as a boxing ring. Ilie Nastase saw it as a stage. Shy elsewhere—attention in restaurants made him nervous—he was free to express himself when he was alone on court with a captive audience. A fine soccer player as a kid, he had chosen tennis over the team sport in part because it allowed him to show more of himself. This isn't unusual; tennis, which demands a blend of thoughtfulness and aggressiveness, attracts that seeming oxymoron, the outgoing loner. But Nastase wasn't content, like so many other players, to let his racquet do the talking. He loved to communicate verbally—with his opponent, the umpire, the audience. It's fitting that he began to fulfill his potential only in 1969, at age 23, when he won a tournament in Colombia because he said he was tired of hearing other players make fun of him for not knowing how to use his talent. During his 1972 U.S. Open final with Arthur Ashe, Nastase said that when he was behind two sets to one and the crowd was booing him—he'd given them the finger and hit a ball at a lines-

man—he spotted one man in the audience who desperately wanted him to win, and who was suffering with him on every point. It was enough to inspire Nastase to come back. "He changed my life," he recalled, "but I never met him."

Nastase lacked the drive to win that powered Borg, Connors, and all other great tennis champions. He could be bored by straightforward success, and he often courted failure. But his performances were unique; for better or worse, they obliterated whatever restraints remained in tennis from its amateur days and brought the game up to date with the culture at large. Nastase found the outer limits of what tennis fans and players could handle, and he has no descendants or imitators in the more rigidly professionalized tennis world of today.

As with any child, plenty of Nastase was puerile: moonings and middle fingers were a given. Plenty was offensive: he once called Arthur Ashe a "bloody nigger" on national TV, and referred to the doubles team of Harold Solomon and Eddie Dibbs as "Jew boys." (Nastase was later surprised to learn that Dibbs was Lebanese.) But he was an equal-opportunity offender. When he spotted a South African, he would greet him with a cheery, "Hi racist."

There was also plenty about Nastase the person that, like his play, was creative and original and even touching. No account of him would be complete without at least a partial list of his more memorable antics.

- At a tournament in Louisville in 1975, it was required that doubles teams wear matching clothes. Nastase, who was playing with Ashe, showed up for one of their matches in blackface.

- In the late '70s, Nastase played Borg in a meaningless indoor event. Nastase was on the way down; Borg was at his invincible peak. The Swede won the first set handily, but Nastase began to come back in the second set. After

each point that he won, he would stop, stand perfectly still, and stare questioningly at Borg's coach, Lennart Bergelin, as if to ask, "What happened to your Mr. Perfect on that one?" Even the Ice Borg eventually cracked up.

- In Stockholm in 1975, Nastase was agitated by a fan and began to yell at him. His opponent, once again his eternal straight man Ashe, grew annoyed. When Nastase finally tried to serve, Ashe held up his hand and said he wasn't ready. Nastase began his service motion again, but stopped halfway through and asked, in a teasing voice, "Are you ready, Mr. Ashe?" Then he did it again. And again. And again. Over and over he stopped and asked, "Are you ready, Mr. Ashe?" Finally Ashe snapped, walked off the court waving his arms, and later went berserk in the locker room. The next day, Nastase walked up to where Ashe was sitting in the hotel dining room with a bouquet of flowers. He was forgiven.

- At the French Open in the early 1980s, Nastase and Tiriac were playing the Italian doubles team of Adriano Panatta and Paolo Bertolucci. Nastase knew that Panatta, even more than Borg, was ruled by superstition. (One night he had been driving to a party with Panatta when a black cat crossed in front of the Italian's car. Panatta immediately turned the car around and went home.) Before the doubles in Paris, Nastase told Tiriac, "I think we can make it easier." Tiriac, immediately suspicious, narrowed his eyes and said, "What do you mean? What the hell are you planning?" Nastase hired a tournament employee named Mabrouk to find him a black cat. After roaming the neighborhood, Mabrouk came back with a gray cat. Nastase threatened to spray him black, so Mabrouk went out and found a real black cat. Nastase carried the cat,

wriggling in his racquet bag, onto the court and let him
out as the two teams were flipping a coin to see who
would serve first. The cat tore straight at the Italians.
Panatta jumped backward and shouted at Nastase, "You
idiot, you idiot, you're such a shit!" Nastase and Tiriac
won easily.

As Mel Purcell knew, Nastase had a special history with the U.S.
Open.

He met his first wife, Dominique, when he glimpsed her in
the stands at Forest Hills in 1971. The following year, Ashe (who
else?), who had just lost the final to Nastase, took a moment during
the trophy ceremony to reprimand his opponent for his behavior.
Nastase, in a move symbolic of the new pro era, answered Ashe by
picking up his winner's check and waving it in his face.

In 1976, Nastase played Germany's Hans Pohman in the second
round at Forest Hills before a full and very rowdy house. At one
point, Pohman, suffering from cramps, took a theatrical dive to
the court. Nastase thought he was faking it (he also thought the
guy was stealing his thunder). He blew up at the umpire and spat
at Pohman, thereby incurring the unbridled wrath of the audience.
When Nastase won, both Pohman and the umpire refused to shake
his hand. On the walk back to the locker room, hundreds of fans,
including the mildest-looking senior citizens, waited to curse Nas-
tase as he walked past. Once there, Nastase tried to bury the hatchet
with his opponent, but when he put out his hand, Pohman haugh-
tily refused to shake it. Nastase drew back and said the only thing
that Ilie Nastase could possibly say to a German at that moment:
"Fuck you, Hitler!"

Three years later, at Flushing Meadows, Nastase managed to
one-up the Pohman match with his evening encounter with McEn-
roe, a night that the American called "the circus to end all cir-

cuses." In a night match that had been promoted like a heavyweight fight, Nastase, bent on stirring up trouble, went into his customary stalling act and was defaulted by umpire Frank Hammond. But tournament director Bill Talbert, fearing a full-scale riot from the pro-Nasty crowd of 10,000, chose to remove Hammond instead of defaulting Nastase. Ten years of Open tennis had led to a complete reversal of authority: the pros, not the game's officials, were now in charge.

At one stage during the breakdown, Nastase heard McEnroe call him a "son of a bitch." Nastase told the referee, "You make him call me Mr. Son of a Bitch." Afterward, though, it was a different story. The performance was over. Just as he had surprised Connors and Pohman with his friendly gestures in the locker room, Nastase shocked McEnroe by asking him to dinner. McEnroe accepted.

The match had, in a twisted way, been a passing of the torch, from one decade's high-strung bad boy tennis artist to the next decade's. Looking back, several writers saw it as an unfortunate early lesson for McEnroe—Nasty had shown him that the players could get away with anything now. But another witness who was in the locker room saw it differently. Worried about the New York night audience, Nastase had asked Doug Henderson, Jimmy Connors's bodyguard, to sit in his box. ("Hey Chocolate," he'd said to the African American Henderson, "come watch me tonight, okay?") Afterward, Henderson sat with the players and looked at McEnroe, whom he had known since prep school. "I could see that Mac was learning to handle any type of situation," Henderson says. "He was becoming a guy who could survive out there." The following Sunday, McEnroe won his first U.S. Open. It didn't seem to bother Nasty. "I'm glad he came around," Nastase said of McEnroe. "Now they can pick on him."

There was one other U.S. Open event involving Nastase that showed a different side of the man. In 1979, Renée Richards entered the tournament for the third time. At that time, the trans-

sexual Richards was viewed as a freak by the men and with great suspicion by the women. Nastase asked Richards to play mixed doubles with him. "Not surprisingly, I got teased the whole time by all the players," he said. "'Only you can play with that person, not man not woman,' they said. But for me it was important to help a person who no one else was helping."

Nastase insisted they "make it fun." On the first point of their first match, as he put away an overhead, Richards slapped him on the shoulder, and he fell down as if she had hit him hard. The crowd laughed. The odd-couple team reached the semifinals that year and became a crowd-pleaser at two U.S. Opens.

But even while he was clowning with Richards, Nastase's personal life was coming apart. He rarely left the road. His wife and daughter couldn't go everywhere with him, but Nastase loved tennis and the camaraderie of the tour too much to leave it. He also embodied a conundrum of the pro era and the sports mass market: the nastier he was, the more he was in demand. In World Team Tennis, he was even introduced with a name more befitting professional wrestling: The Temperamental Nastase.

"By the end of the 70s," he wrote in his autobiography, "Dominique knew that I was no saint when I was away. She didn't need to ask me questions, go through my pockets, or peel off the long blond hair from my jacket (most likely the white hair from the horses at Studio 54)." According to one player, Nastase's indiscretions had become more blatant as the years passed.

The Nasty era, which had been synonymous with the first Wild West decade of the Open era, was coming to an end as he faced Mel Purcell in Louis Armstrong Stadium. But it wasn't over quite yet. The night crowd at Flushing inspired a little of his old dark magic, and he and Purcell battled through five sets. "Ilie was acting like a

jerk, as usual, yelling at everyone," Purcell says. "But it was a hell of a match."

In the fifth set, both players were nervous and began to dink the ball back and forth, not wanting to miss. "It got ugly," Purcell says. It was a style of play that had been a specialty of Nastase's in the old days, but it didn't work on this night. To the disgust of the well-lubricated audience, the Kentucky boy won the fifth set 6-3. Nastase breezed past him afterward with the barest of handshakes. "He was pretty pissed," Purcell says.

Two years earlier it had been widely noted that Ilie Nastase was the only player at the U.S. Open to have his face on the front page of the *New York Post*. The accompanying story was about his starting a riot against McEnroe rather than playing tennis. The consensus, even among the sport's more traditionalist commentators, was that this was the kind of exposure that tennis needed if it was going to continue to grow and appeal to bigger audiences, if it was going to take its place with baseball, football, and boxing. "People want excitement," Richard Evans wrote in *Tennis Week* after the 1979 Open, "and if they can't find it at a tennis stadium they will go off and seek it in less savory places."

Now, two years later, a photo of Nastase again appeared in a New York paper. But it wasn't on the front page. Instead, a tiny shot at the back of the sports section captured the paunchy Romanian doubled over the net during his loss to Purcell. He had tripped and fallen forward and nearly flipped over onto the other side of the court. For a player long known for his balletic grace around a tennis court, a player who liked to bound over the net even after defeats, it must have been a hard fall.

THE LORD OF DISCIPLINE

"They'll play how I tell them to play."
—HARRY HOPMAN, 1965

"I like players who express themselves."
—HARRY HOPMAN, 1981

Through the mist and the wind inside Louis Armstrong Stadium, John McEnroe could hear the cheers and roars of his 15,000 fellow New Yorkers. It hadn't taken long for him to inspire them. The new number one player in the world was 20 minutes into his first-round match at the 1981 U.S. Open when he began to argue that his opponent's serve had incorrectly been called good. The chair umpire disagreed, so McEnroe walked forward to argue his point more vigorously.

The aggressive posture was familiar to all, but McEnroe looked considerably different from how he had for most of his career, and considerably different from how the cartoonists in the city's daily papers continued to draw him. He was still the lean and mean Johnny Mac who had finally hunted down Borg at Wimbledon. But along

with the extra pounds and the baby fat, McEnroe had also shed his trademark electrified hair, and the headband that failed to hold it all in. He had his curls cut shortly before the '81 Open; he called it his "Bruce Springsteen haircut," after his rock-and-roll hero of the moment. Perhaps unfortunately, his mother, Kay, had approved. "Now you look like you did when you were a good boy, Johnny," she told him. McEnroe at 22 was no longer the unkempt image of competitive lunacy and tortured tennis genius. But to opponents, his new predatory athleticism was more menacing than ever.

If McEnroe hoped that the hometown fans would be more welcoming this time around, that they would be proud of their native son's success, he was soon disappointed. While he argued with the umpire, his opponent, Juan Nuñez, ranked number 193 in the world, turned his racquet upside down and sat on it, biding his time. The fans loved it. At the start of the day, virtually none of them had ever heard the Chilean qualifier's name, but now it was being shouted from various sections of the stadium, in brusque New York accents: "Nu-ñez!"

McEnroe knew how to rile people up—"No one was better at getting a crowd against him," his brother Patrick says. But he also knew how to win anyway." As the first set drew to a close in a tiebreaker, it looked as though he was going to face down Nuñez and his thousands of brand-new faithful. McEnroe served and volleyed his way to a 5-0 lead in the breaker. The crowd stayed with Nuñez, though, and sparked some life into the Chilean. The cries of his name turned to chants as he worked his way back into the tiebreaker and eventually won it 8-6.

That was the end of the road for the Chilean, whose backhand was described by one writer as something "he must have picked up in a bargain basement." McEnroe ran out the next three sets handily, 6-1, 6-3, 6-2. "He started doing his magic," Nuñez remembers. But there was little joy in the win, or in McEnroe's post-match reaction to it. "It's disappointing, very frustrating, to get this here," he

said glumly of the fans' attitude toward him. "I like being at home and playing here. I wish people would get behind me."

"I have to get used to it," he continued. "The first time I even sniff at a call, they start giving me a hard time." He knew that after Wimbledon, he was a marked man.

As much as the fans may have wanted to see him lose, there was no getting around John McEnroe in September 1981. He began the month by gracing the cover of *Newsweek* under the headline "The Champ You Love to Hate." The sport's resident lightning rod was the subject of countless sermons and editorials in papers across the country. Over in the gossip pages, Cindy Adams reported that a movie studio wanted to cast McEnroe in the title role of *Richie Rich*.

Where the London tabloids screamed with feigned outrage at every evil act perpetrated by the invading Superbrat, American columnists responded to his behavior like scolding parents. "Has McEnroe Heard the Golden Rule?" asked the *Sporting News*'s Dick Young. "I would love to hear an umpire at Wimbledon," Young wrote, "or at the U.S. Open say to that infant-mouthed player during a match, 'Mr. McEnroe, that was a lousy shot!'"

Young's colleague Ray Fitzgerald, in a column titled "McEnroe Makes It Difficult to Applaud," agreed. "OK, so he's a good kid. I've read it a thousand times and I believe it," Fitzgerald wrote in response to the McEnroe defenders who excused his actions as the natural product of playing in the heat of competition. "I also read all the time about how the kid who burned down the schoolhouse was a good kid, 'nice and quiet, you'd hardly know he was around.'"

Still, there were those who thought McEnroe brought an overdue dose of reality and honesty to tennis's ivory tower, and that the fans and writers who chastised him would be secretly disappointed if he *didn't* act up. "They come out to the courts at the National

Tennis Center hoping to see him become an American werewolf in Flushing," Mike Lupica wrote. "They sit on the edge of their chairs and hope that the first bad call will be like the rising of a full moon." If tennis wanted to appeal to the masses and join the mainstream the way it said it did, it would have to take a person like John McEnroe as he was. It was hypocritical to act as if his rage wasn't part of his appeal.

Even more disparate were the reasons given for his explosions. Why, as Ray Fitzgerald asked, did such a seemingly well-raised kid, from an exclusive private school, with a higher level of native intelligence than virtually any professional athlete in the world, act so crudely and irrationally once he walked out into the middle of a tennis court? His fellow players, led by American pro and perennial burr in the Johnny Mac saddle Bill Scanlon, were equally not amused. Scanlon believed that McEnroe's outbursts were nothing more than carefully timed breaks meant to stop his opponents' momentum.

In countering Scanlon and his fellow players, McEnroe said, "I wish I were smart enough to plan those things. Albert Einstein couldn't have thought up these things I do."

At the other extreme was Richard Evans, whose 1982 biography of McEnroe was called *A Rage for Perfection*. (When Evans broached the idea for the project, McEnroe initially answered, "Why don't you wait until I grow up first?") Evans thought that McEnroe was a perfectionist and a seeker of justice who asked the people working around him to hold themselves to the same high standards.

Only McEnroe knew the reasons for his behavior, but even he was at pains to explain it. At times McEnroe talked about how he held officials to high standards, but he also admitted, "Anger became a powerful addiction." Perhaps the closest he came to articulating it was in an interview he did with *Sports Illustrated* at the peak of his powers in 1984. Asked the eternal question of why he went nuts, McEnroe blurted a line that had the ring of embarrassed honesty: "Look, even my friends know I have no control. I just go into the ozone."

McEnroe never stopped trying to understand that rage, and he never stopped regretting his outbursts. Whereas a player such as Connors had learned the game from the old pros in Los Angeles who played like gladiators, McEnroe was taught by comradely amateurs who had little patience for bad behavior.

———————

As a kid, McEnroe had ridden the train west to Manhattan to get an old-world formal education at Trinity. But it was by riding east, to the Port Washington Tennis Academy on Long Island, that he would learn things that would be much more valuable to him.

McEnroe's parents enrolled him at Port Washington in 1970. The tennis school was just getting off the ground at the time, but everyone already knew that this wasn't just any junior academy. Harry Hopman, architect of the Australian dynasty of the 1950s and '60s, was its director. Through him and his fellow Australian coaches, McEnroe imbibed the spirit of that dynasty. "I got started hearing hundreds of war stories about all these incredible Aussie players," McEnroe later recalled fondly.

Hopman, a trim, tough man who was still a fit 135 pounds in his 60s, had been the emperor of the amateur game for three decades. To the press and his players, he was that ultimate oxymoron, a "fair martinet." He controlled every aspect of the sport in Australia; he brooked no arguments, and no one disputed his results. How could they? Hopman's players brought home 16 Davis Cups and innumerable Grand Slam titles. Hoad, Rosewall, Laver, Newcombe, Stolle, Emerson, Fraser, Sedgman—these humble, determined, good-humored men, many from the Aussie countryside, set the standard for hard work and sportsmanlike behavior by which all tennis players are still measured. Hopman was the man who set the standard for them. Not that he always did so with such good humor.

"At first I didn't like Hop and Hop didn't like me," says Aussie Davis Cupper Fred Stolle, who would end up giving a eulogy at

Hopman's funeral in 1985. "He thought I was lazy, so he wouldn't give me the time of day." John Newcombe remembers coming back to his room two minutes after his ten o'clock curfew to find Hopman going "ape-shit": "You have no discipline!" Hopman screamed at Newk. "And without discipline you'll never be a champion!"

Hopman's discipline began on the court. A coach and a motivator rather than a teacher of tennis fundamentals, he was a pioneer of fitness training. "He trained us as though we were going to run across a desert," Laver said. Hopman was also a devotee of practice. In *A Handful of Summers*, his classic memoir of life on the amateur circuit in the 1960s, Gordon Forbes, a South African player, described a week that he spent practicing with Laver.

> I practiced each morning with Rodney—rigidly effective
> Hopman type practice which forced you to make every
> shot with a purpose in mind—not the comfortable, free-
> swinging hit-ups which were so tempting and which made
> you imagine that you were beautifully in form, and playing
> like an improved version of Don Budge.
>
> Ten minutes of forehand crosscourts—ten of forehand to
> backhand, up the line, ten of backhand to forehand, ten of
> crosscourt backhands, then all four repeated twice over with
> alternate players volleying. All that added up to two hours,
> leaving thirty minutes for practicing overheads, services, or
> any special weaknesses. A half-hour practice set completed
> the three-hour session, which Rodney insisted we follow.
> By the end of the week I had never played better, and often
> in retrospect, I have thought of those far off sessions and
> said to myself wistfully, "If only, Forbesy, if only!"

A similar discipline was maintained off the court. Hopman controlled who played where and how much expense money they received. He fined players for even the tiniest infractions of his training regimen. He told them what to say to the press, which was

often nothing at all. "Can't say, mate. Better ask Hop" was a common Aussie reply to a reporter's inquiry. Most important, Hopman decided who would compete for the country's Davis Cup team. Tennis was a popular sport in Australia in those days, and for an American kid, making the team was equivalent to starting for the New York Yankees.

What Hopman ended up creating among his players was the code of amateur tennis. It was a macho Australian version of the British stiff upper lip. There were no complaints heard and no excuses allowed—"If you play, you're not hurt" was the Aussie way of talking about your injuries. Afterward, you left the court and hoisted a beer with your opponent, whatever the result was. "First to the net, first to the bar" was another slogan. It was a philosophy borne out of a time in tennis when there was more pride and fun on the line than there was money.

With so much at stake in the amateur system, Hopman fought open tennis as long as he could. When it finally arrived in 1968, he resigned his Davis Cup captaincy and, looking to coach young players, moved to the new center of the tennis world, the United States. Hy Zausner, a wealthy businessman and tennis nut from Sands Point on Long Island, hired him to run his nonprofit academy, which was dedicated, in the upbeat spirit of the sport's early boom years, to "getting kids hooked on tennis."

"Zausner wanted to get the best guy in the world," recalls McEnroe's doubles partner Peter Fleming, a student at Port Washington in the early 1970s. "So he went out and got Harry Hopman."

The white-haired American financier and the lean, no-nonsense Australian were known on the local tennis scene as the "odd couple," but with low fees and world-class facilities and instruction, they built Port Washington into a place that would briefly make New York a tennis hotbed and influence the way the sport was taught everywhere else. Nick Bollettieri served as an instructor under Hopman, and, besides McEnroe and Fleming, future pros Vitas Gerulaitis and Mary Carillo trained there.

"I loved Port so much I would cut school to go there and just hang out," Carillo says. "Everything about the place was neat, deluxe. And there were great players there all the time. There were international junior tournaments. You felt like you were at the center of something." The class atmosphere even extended to off-court time-killing activities. Zausner banned card games among the kids. They played chess instead.

Hopman's presence alone was enough to make the place feel special and important. "In the five years I was there," Fleming says, "the guy must have spoken to me about four times. He would walk over and say 'Aim for the lines,' and then walk away. But he had such an aura that it worked. Just hearing *him* say it gave me the confidence to go for my shots."

"When Mr. Hopman came around your court," Carillo adds, "you ran a little harder and stood up a little straighter. He knew how to get the most out of you. There was nothing fancy about what was taught there. It was old-fashioned two-on-one drills, and you just got worked to death."

The player at Port Washington who enjoyed being worked to death the least also happened to be the player whom Hopman loved to watch the most: John McEnroe. The man who had groomed the lefty Laver immediately saw the creativity in this young lefty's game: in the variety of serves McEnroe could hit even when he was a little kid; in the improbable angles he created at the net; in his easy movement around the court. "Mr. Hopman got a kick out of watching John," Carillo says. "He would stand back and laugh at the shots he came up with. What was amazing about John was that all of the shots people marveled at when he became a pro he was already pulling off when he was 13."

McEnroe, like naturally talented players everywhere, was not a fan of practicing. At times this aggravated Hopman, who, when John tried one too many fancy drop shots or no-look volleys, was known to exile him to the girls' court. But this version of Harry Hopman, the New York Harry Hopman, was no longer a martinet.

He couldn't be. The Open era, as he knew it would, had shifted the balance of power away from him. When his talented young student was mysteriously absent for a session of physical training, Hopman was just as likely to offer an indulgent excuse for him—"Oh, McEnroe's off hiding in the bathroom"—and go on with the drill.

"He no longer had total jurisdiction," Stolle says. "The players had other options now. Hop totally changed after that, especially with the way he handled John."

"I think he thought it would be a shame to break him, when John had all that talent," Carillo says. "He liked him the way he was too much."

Though he may have mellowed over the years, the old Davis Cup warrior instilled a reverence for the team competition in McEnroe that would stay with him his entire career. And while it was widely believed that McEnroe played doubles as a substitute for practice, the habit hadn't started that way. "Hopman called John and I into his office one day," Fleming says, "and told us that we should play as many matches as we could. Singles matches, doubles matches, whatever it was. He said getting that competitive experience was important. That stuck with both of us."

When McEnroe began to rise in the rankings, and his voice began to rise in anger, Hopman was asked what he thought of his behavior. "I like John's temperament," he said. "He's always trying to hit the perfect shot."

"I think some of us just about choked on our lagers when we heard that kind of thing," Stolle says of the old Aussie guard's reaction to Hopman's newfound tolerance. "In '61, Hop kicked [Australian player] Bob Hewitt off the Davis Cup team for hitting a ball out of the court. McEnroe did that once a week. But I also think Hop believed that John needed to let it out, that he couldn't play his best otherwise."

Indeed, Hopman had been skeptical that his most famous student would ever beat Borg at Wimbledon while remaining on his best behavior. "I thought he would be under too much pressure,"

Hopman said of McEnroe as the '81 Open began, "trying to play a game where he couldn't explode occasionally. [At Wimbledon in 1981] John showed he could play without giving vent to his feelings."

What if John McEnroe had been an Australian under the old Hopman regime, when the game's officials still ran the show? Would he have been broken? "That's tough to say" is as far as Stolle will go. Perhaps the most instructive comparison is the case of Earl Cochell, an American who played on the amateur lawns during Hopman's reign. In 1951 at Forest Hills, Cochell had an epic meltdown in the fourth round. He played with his opposite hand at times and tried to climb into the umpire's chair to tell off some hecklers in the crowd. During a break between sets, Ellsworth Davenport, the ranking USLTA Old Goat, walked into the locker room and urged Cochell to clean up his act. The player's response was immediate and decisive: "Go shit in your hat," Cochell said.

Cochell was immediately banned from all future USLTA events. His name vanished from the rankings. He became, in the word of Bud Collins, a "nonperson." Exiled from the lawns for his breach, Cochell was never seen again.

At the end of 1981, John McEnroe appealed the $5,000 fine that the tour had given him for his All England explosions. A three-person tribunal decided the case, and McEnroe was allowed to choose one of its members. He chose Harry Hopman. The ex-martinet sided with his student. The fine was dismissed.

CHAPTER TWELVE

FALLEN ANGEL

"There's a hollow feeling when the challenge of reaching a goal is gone. The goal is now to stay there. It's like looking for excellence in isolation."

—BJORN BORG, ON BEING NUMBER ONE

There was something surreal about the men's draw at the 1981 U.S. Open, something not quite right. It appeared that, like the tennis world it represented, the whole thing had been turned on its head. Bjorn Borg's name had sat on the highest rung every year since 1975. Now, in a turnabout that most tennis fans had not yet accepted, it was John McEnroe, the new Wimbledon champion and number one player in the world, who had risen to the top. Borg, as the number two seed, had suffered the indignity of tumbling 127 places, to the very bottom rung.

He didn't seem to mind it down there. "This year I'm not going for the Grand Slam," Borg said as the tournament began, referring to his loss earlier that summer at Wimbledon. "So there is less pressure, which is better for sure." It's understandable that Borg would have been tired of starting at the top of the draw. Even when you win, your name only goes down from there.

It was the Swede's 10th stab at winning in New York. Because of the evolution of the event over that time, his failure looked more glaring than ever. By 1981 the U.S. Open was no longer merely a tournament. At Forest Hills, on grass, it could be dismissed as a kind

of junior Wimbledon, the same idea but not as prestigious. After four years on the hot asphalt at Flushing Meadows, though, it had carved out its own identity. The Open was now widely described as a "test," the toughest in tennis. It was a challenge not just of skill, but of survival. Could you block out the planes, the trains, the boozy fans, the hamburger stench, the evening lights, and the city's stressful hustle? There was a sense in 1981 that while Wimbledon remained the sport's unofficial world championship, the Open had become the truest representation of what modern professional tennis was supposed to look like.

Failing in New York was not like failing anywhere else. It didn't so much show a lack of talent as hint at a lack of basic fortitude in your character. This was the land of Jimmy Connors and John McEnroe. Self-aggrandizing, win-at-all-cost Americans, not reserved Europeans or self-deprecating Australians, thrived in the Flushing jungle. Borg also knew that the tournament did what it could to help its own. In the first three years at the new venue, all six singles titles had been won by Americans: McEnroe and Connors had monopolized the men's side, Chris Evert and Tracy Austin had done the same on the women's. In that time, Open officials had twice sent Borg out under the lights he despised, first to face a savagely hyped-up Connors in the 1978 final, and again when he played Roscoe Tanner the following year. Both times he had walked off defeated. It wasn't just the lights that played tricks on him. The surface did as well. The courts at the Open were bouncier than most others at that time. Only there did photographers catch the serenely smooth Borg reaching for balls and hitting them when he was off-balance.

Everything worked for Borg at Wimbledon; nothing did at the Open. For one, the tournament had always come a little late in the season for him. His focus and energy peaked during the six-week period in the middle of the year when the French Open and Wimbledon were held. Borg won them back to back from 1978 to 1980, a feat that eventually would achieve a kind of mythic status.

(It wasn't until 2008, when Rafael Nadal pulled it off, that another man would win the "Channel Slam.") In 1981, with his streak at Wimbledon now broken, Borg decided he would "try like hell" for the Open.

This time, rather than fight the American empire, he joined it. Borg and Mariana bought a mansion—described as a "castle by the sea" by the local press—in Sands Point, Long Island (hometown of Port Washington academy founder Hy Zausner). The Swede had finally left the refuge of his hotel room and brought as much of home as he could along with him. Over the two weeks, he and Mariana were joined by Bergelin, Borg's mother, his mother-in-law, and his grandmother. All of them pitched in to cook for the great man. "My main ambition now is to win the U.S. Open," Borg claimed.

In hindsight, it might be noted that the one thing that Borg's castle on the seashore lacked was a tennis court. In the past, he had practiced during the tournament at Gerulaitis's home in nearby King's Point. Neighborhood kids would poke their heads through the bushes to get a look at the two stars as they drilled themselves through four- and five-hour workouts.

But since his gutting defeat at the Open the year before, Borg had curtailed his time on court. Despite his claims that the Open was his biggest goal, he hadn't played a single tune-up match after Wimbledon. Since his simultaneous breakthrough and burnout in 1973, Borg had shifted some of his schedule from tournaments to exhibitions, but in 1980 and '81 he cut his ATP calendar to the bone. Coming into the Open, Borg had played just 11 tournaments in the previous 12 months. He had won four of them, which would have been an outstanding record for anyone else. But with Borg it was taken as evidence of decline. In the lobbies of the player hotels in New York, where the tennis cognoscenti gathered, there was more buzz about Borg's decline than about McEnroe's ascendance. Was the Angelic Assassin tough enough for New York?

Borg was almost as much of an enigma to his colleagues as he was to the sport's fans. Players didn't just see him in the locker

room; they reported sightings the way you would of a UFO. "He would materialize behind your right shoulder," said one contemporary. "Then he'd stride past you and disappear again. You'd wonder if he was ever there. It would have been intimidating if he hadn't been such a nice guy." Nastase, who dubbed Borg the "Martian," a man not quite of this world, recalled that Borg would walk into the locker room after a match, take off his clothes, and immediately start his silent, measured stride toward the shower. Who knew if he had just won or lost?

Now the Martian had landed again in New York. He had materialized in the locker room at Flushing Meadows to play his first-round match against an unknown named Markus Gunthardt. Speculation about the mysterious man among his colleagues had begun to leak into the press. The day of Borg's opening round, the consensus was summed up by one anonymous player in the *Boston Globe*: "Borg is finished," he said.

There was no question that cracks had developed in the Ice Borg since the heady summer of 1980. During those three months, he had experienced the high and low points of his career, and gotten married in between. What else was there for him? Borg seemed unsure himself as 1980 ended. He lost to players he had always handled before: Ivan Lendl in Basel and Bill Scanlon in Tokyo. Yet in the one tournament he did win, in Stockholm, Borg displayed as much desire and emotion as he had since he was a 13-year-old holy terror. While waging a cold war with the Swedish press—Borg skipped all press conferences until after the final, then refused to speak in anything but English—he won his home tournament for the first time. Just as important, he beat McEnroe, in straight sets, in the final to do it. After the two shook hands, Borg stepped back and threw his face upward, toward the ceiling, in an unprecedented display of joy. "It was an unconstrained gesture," his wife said later, "from a man who, after 10 years on tour, had allowed his mask of coolness to slip for a moment, the coolness which had made him great, but had also made him the target for every invader."

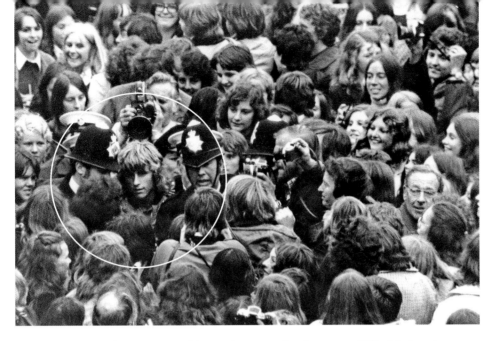

Borgasm: The 17-year-old Swede created a frenzy at Wimbledon in 1973. *(Russ Adams)*

Brat Meets Superbrat: McEnroe and Connors after their first match, Wimbledon 1977. *(Getty)*

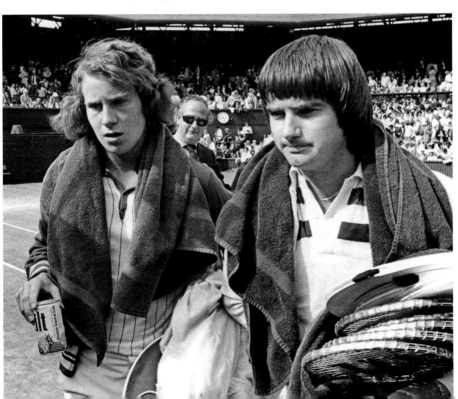

The Angelic Assassin:
Borg gets ready to fire one
back at the 1981 U.S. Open.
(Russ Adams)

High Five: Borg wins his
fifth straight Wimbledon,
July 1980. *(Getty)*

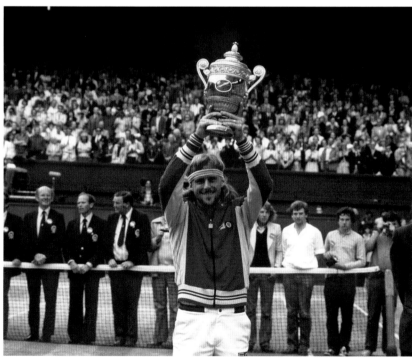

Rage to Win: McEnroe at the U.S. Open in 1981. *(Michael Cole)*

The King of Queens: McEnroe on the mountaintop after winning the title. *(Getty)*

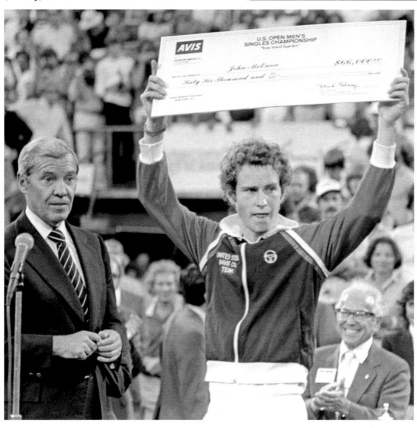

Badfellas: Connors and Nastase took their outrageous act on the road in 1974. *(Getty)*

"The older brother I never had": McEnroe and Gerulaitis at a charity event in New York in 1982. *(Getty)*

Work Hard …: Vitas Gerulaitis in action in 1980. *(Getty)*

…Play Harder: Gerulaitis and Nastase get a good look at Cheryl Tiegs at Studio 54 in 1977. *(Getty)*

Double-fisted: Connors tearing the cover off the ball at his second home, the U.S. Open. *(Getty)*

When Bad Boys Collide: Connors warns McEnroe in their 1980 Wimbledon semifinal. McEnroe won the match. *(Getty)*

The Inmates Take Over the Asylum: Referee Mike Blanchard makes a futile attempt to keep the peace between McEnroe and Nastase at the 1979 U.S. Open. *(Russ Adams)*

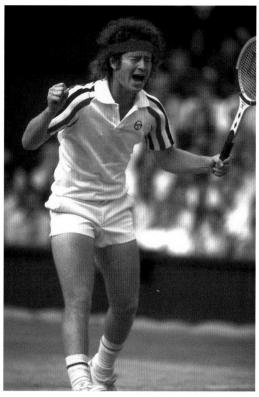

MacAttack: John McEnroe loses it, again, at Wimbledon 1980. *(Getty)*

Just Pee-Yu It: McEnroe lets a line judge know what he thinks of a call at Wimbledon in 1979. *(Getty)*

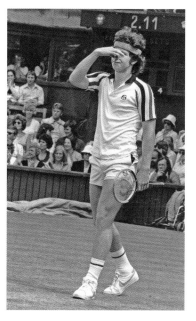

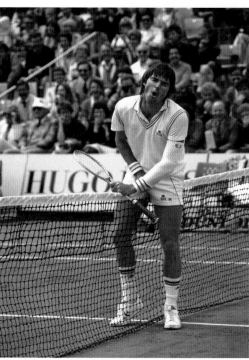

Ballbuster: Connors at the 1980 French Open. *(Getty)*

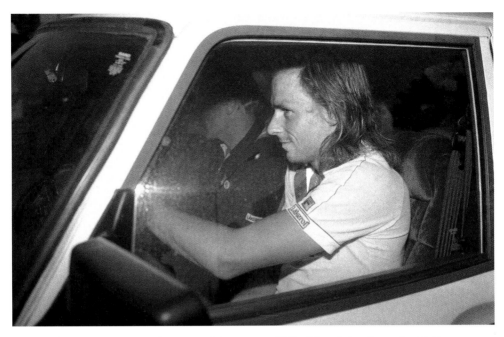

The Ice Man Goeth: Borg drives out of Flushing Meadows in 1981—and out of tennis for good. *(Getty)*

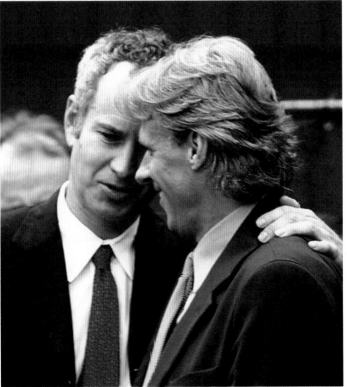

Old Rivals, Old Friends: McEnroe and Borg reunite at Wimbledon 20 years after their classic final. *(Getty)*

Three months after that, as 1981 began, Borg cracked again. Back in New York, he met McEnroe in the semifinals of the season-ending Masters tournament at Madison Square Garden, in front of 19,000 rambunctious fans, the largest crowd ever to watch a tennis match in that fabled venue. Borg won the first set, and the two played to a second-set tiebreaker. At 3-3 in the tiebreaker, McEnroe approached the net, and Borg hit a forehand passing shot that McEnroe let sail past him. The ball landed near the line and was initially called in by the linesman. But chair umpire Mike Lugg overruled him and gave the point to McEnroe. Borg approached Lugg and demanded that he ask the linesman where the ball had landed. Lugg refused, and Borg in turn refused to move. He stared up at Lugg, his blue eyes showing more than a little of the famous obstinacy that everyone believed he had left behind.

In the commentary booth, the BBC's John Barrett narrated the subsequent turn of events. Just as it had while he was announcing the 18-16 tiebreaker between these two players the year before, Barrett's voice began to register, in an exceedingly English way, the shock that went through the audience when Borg wouldn't budge.

"Borg is just checking, I'm sure," Barrett began reassuringly. "He'll get on with it in a second."

Thirty seconds later: "This *is* unusual, Borg hasn't started again."

A minute after that: "Well, this is most unusual, *most* unusual. Borg has *still* not resumed."

Another minute passed with no movement. Borg had stopped speaking; he stood mutely holding his racquet. Even the tournament referee, who had been called to the court, couldn't make a dent in his cold stare. Finally, Lugg docked Borg a penalty point for delay of game.

"Well, I've certainly never seen Borg do anything like *this* before," Barrett said. "He really will have to get on with it. This is *most* serious for Borg."

After Lugg assessed Borg another penalty point, the Swede grudgingly returned to the baseline, and, amid a torrent of boos,

served. The New York crowd had been stirred up by this unprecedented event. In the middle of the next point, someone in the audience yelled, "Hey, ref, you stink!" The heckler was immediately rebuked: "Shaddup!" someone yelled at him from across the stadium. Meanwhile, as these words were exchanged, Borg and McEnroe continued to rally until the American won the point and the set. "I was in total shock," McEnroe said afterward about Borg's silent protest. "I mean, I didn't believe what I was seeing."

Whatever frayed nerves he had exposed to the world in that moment were quickly covered up. Borg went on to beat McEnroe in the third set and to play some of the most imperious tennis of his career in beating Ivan Lendl 6-4, 6-2, 6-2 in the Masters final.

It was a dynamic that would continue for the remainder of 1981. Borg would show weakness and disinterest; incite wild speculation about his lifestyle, his future, his whereabouts, and his state of mind; and then emerge from seclusion to remind everyone, with another world-class beat down, who was still king. After the Masters, Borg had a bad spring, suffering surprising defeats to Rolf Gehring and Victor Pecci. In a match with McEnroe in Milan, he tried to break out of his normal metronymic game and go on the offensive. It didn't work. McEnroe won.

"Bjorn seemed to want to be someone other than himself at that point," tennis journalist Richard Evans says. The Swede mused about a desire to cut off his famous blond hair and try a career in ice hockey. "He had never known what it was like to be anonymous," according to Evans, "and I think the idea appealed to him, the same way being famous appeals to almost everyone else."

"He had this image as the perfect person," says Doug Henderson, who, despite working with Connors, befriended his Swedish rival. "He needed time away from that. He needed time away from having to be Bjorn Borg all the time."

Nursing a sore shoulder, Borg took two months off. In that time, according to *Sports Illustrated*'s Curry Kirkpatrick, the tennis gossip

mill began to churn in earnest. "Borg had dislocated his shoulder," Kirkpatrick wrote of the various theories whirling around the tour. "Borg had become lazy and apathetic. Borg wanted to quit the game and settle down with his wife, Mariana, to start a family. Borg had become senile—growing his fingernails long, baying at the moon, and demanding that huge quantities of Baskin-Robbins be smuggled onto his private island by Scandinavian frogmen. All the usual stuff."

Upon arriving in Paris for the French Open, Borg answered the questions and doubts with his usual terse self-assurance. "I am not going down," he said. And he wasn't. He advanced to the final with little trouble and there held off Lendl in five sets for his sixth title on the slow red dirt of Roland Garros. Once again it was Borg's physical superiority and his mind-numbing patience that spelled the difference. "In the fifth set, anyone can win," Borg said after the match. "I was ready to give everything, to stay out and rally and not take chances." His tactics hadn't changed since his first Davis Cup victory as a 15-year-old.

Borg's most impressive performance in Paris had come in the fourth round against American Terry Moor. Borg won the first 17 games to go up 6-0, 6-0, 5-0 before missing a couple of shots and, to the delirious roar of the crowd, handing Moor a game. "I felt like going down into Bjorn's Wimbledon on-his-knees drop," Moor recalled. "The man is on another level. Other guys, once in a while, they miss. I felt lost. The thing was, he looked *bored*."

If he was in fact bored by one more match, one more win, even one more Grand Slam title, it would have been hard to blame Borg. His style was such that even blowout wins required a high level of consistency, stamina, and patience. He earned few cheap points while standing five feet behind the baseline and rolling one ball after another into the court. In the 1981 French final, he and Lendl had planted themselves in what looked to be the middle of the Bois de Boulogne and lofted moon balls back and forth. On the final

point, it appeared that Lendl, his hair plastered to his skull with sweat, sent a shot wide of the sideline half-intentionally rather than hit one more ball.

Borg could still wear down even the fittest opponents, but by 1981 he had, as Jack Kramer predicted years before, been "worked to death." While 35-year-old Ilie Nastase's burnout had reached an advanced state by that summer, the 25-year-old Borg's seemed to be germinating from week to week. Like Nasty, he had been one of the Open era's guinea pigs, unable to say no to the easy money that was suddenly on offer. The previous generation of pros, the Lavers and Rosewalls and Ashes, had been happy to play as many tournaments as possible for prize money. After years of meaningless one-night exhibitions, they felt as if they had finally gone legit, that they were being paid a fair wage for their efforts. But as tennis exploded and players went from being hardworking professionals to international celebrities, fans everywhere wanted to see them. In cities that didn't host tournaments, they would fill arenas to watch Borg and Nastase and Connors play meaningless "special events." The two-man barnstorming tours were back, with exponentially more money involved.

Back in January 1980, Borg had announced that he was reducing his playing schedule to the minimum allowed by the ATP. On the surface, this seemed to be a signal that the most prominent professional was finally showing signs of fatigue with the grind. But it was a decidedly mixed signal. The next month, Borg was scheduled to embark on a two-week, two-continent exhibition tour. The itinerary went like this:

Monday, February 25: Caracas
Tuesday, February 26: São Paulo
Wednesday, February 27: Paraguay
Friday, February 29: Chile
Saturday, March 1: Chile
Sunday, March 2: Buenos Aires

Tuesday, March 4: Copenhagen
Wednesday, March 5: Copenhagen
Thursday, March 6: Munich
Friday, March 7: Munich
Saturday, March 8: Stuttgart
Sunday, March 9: Stuttgart

IMG and other agencies loved exhibition tours. The money, and the agency's cut, was guaranteed and almost always tax-free. Bergelin hated them. He called barnstorming a "killer," and complained that the strain involved in traveling and playing, even when there was nothing on the line, was underappreciated. He believed they would only hasten the end of Borg's career, either through burnout or injury. IMG and Borg himself maintained that the final decision on whether to play any exhibition or agree to any endorsement was always left to the player. Borg wanted to get what he could, while he could.

It wasn't as if he had many other outlets, or the desire to do much besides play tennis. His life away from the court since he had dropped out of ninth grade had been as minimalist as his game. A young fan from Long Island once encountered Borg in the clubhouse at Forest Hills in the mid-1970s. He had a stack of shining, white wooden Slazenger racquets stacked next to him. On top of them was a comic book. "I like to read comics books when I'm not playing," Borg told his young admirer. *Kalle Anka*, "Donald Duck," was a favorite.

Politics, like heavy literature, were not on Borg's radar, either. He and Gerulaitis were oblivious enough to them that, in 1978, during a promotion for an exhibition in Israel, they allowed themselves to be photographed in Israeli army gear, complete with machine guns slung over their shoulders. Borg was soon the subject of death threats from the Palestine Liberation Organization.

Borg had friends on tour, but he had the mental control and the ruthlessness essential to keeping friendship and tennis separate. In

1976, a 19-year-old Borg briefly came under the sway of Argentina's Guillermo Vilas, who was then 23. The two were inseparable for a few months. Vilas bought an apartment in Borg's building in Monte Carlo, and they traveled to the Argentine's hometown for vacation. When they faced each other in the WCT Finals in Dallas that year, they practiced together in the morning and joked about sharing the jewelry that came with the winner's trophy. Then Borg went out and thrashed Vilas for the title. They were inseparable no longer. The following year, Borg began his lifelong friendship with Gerulaitis. The only thing that the Swede wouldn't do for his buddy was lose to him. Ever.

Tennis, and the women who came with being a tennis player, continued to be Borg's twin points of focus. Indeed, Richard Evans advised, "The way for an attractive young girl to get to know Bjorn Borg was to follow the advice in Matthew 7:7: Knock and it shall be opened unto you. All you needed to seek out was the right room number."

However strenuous his extracurricular activities may have been, Borg was steely enough to keep them from affecting his performance, as one employee at a tournament in the 1970s heard firsthand. According to him, after spending his nights ensconced in a hotel with a famously beautiful woman, Borg arrived on the morning of the final complaining of being "sore." He won easily. As Evans wrote, with delicate understatement, "Borg, to a more serious degree than most of his public realized, was very keen on the opposite sex."

———————

Whatever happened during the rest of the season, whatever disaster struck in New York, however bored he became at the thought of hitting one more tennis ball over a net, Borg could always fall back on Wimbledon. It was his last redoubt. If he could defend his turf on Centre Court, he was still the de facto world champion. Such

was, and is, the prestige of the event that it has served as a similar psychic stronghold for champions such as Martina Navratilova, Pete Sampras, Venus Williams, and Roger Federer. Even after they had won Wimbledon multiple times, they never failed to make winning it again their biggest goal for each new season.

When Borg was finally toppled on Centre Court that summer by McEnroe, he had looked "oddly relieved" in defeat, according to his conqueror. It would hardly have been surprising. The burden of the streak, which had grown with every year, every match, every great escape, every passing shot threaded within an inch of the line, was gone. The system of superstitions that had expanded until it ruled much of Borg's life, and that had pulled him back into the past each June, could at last be discarded.

What *was* surprising was the way Borg left Centre Court in 1981. In the past, NBC's Bud Collins had interviewed winner and runner-up after the match. Now Borg, the loser for the first time, waved Collins off. "Talk to the champion," he said as he disappeared through the door and back toward the locker room.

Collins believed it had been another gentlemanly act from an exemplary sportsman. Others disagreed; they thought the quick getaway showed a more petulant side of Borg. "He knew that the other people who had lost had to do those interviews," Steve Flink of *World Tennis* says. "That was the first time we saw him react badly to a defeat and not handle it so graciously."

As the Viking God's rolling, measured strides carried him back toward the locker room and under the words of Kipling once again, had he finally failed to treat triumph and disaster just the same? Whatever his thoughts were at that moment, it was the last time anyone would see Bjorn Borg on Centre Court.

NOBODY BEATS VITAS GERULAITIS . . .

"People come up to me on the street and say, 'Hi, Borg.' I just say something in Lithuanian and keep walking. They think it's Swedish."

—VITAS GERULAITIS

O ver the course of his 10-year career, Vitas Gerulaitis had been compared to, among others, Joe Namath, Elvis Presley, and, most often, his good friend and tormentor Bjorn Borg. But after his first match at the 1981 U.S. Open, Gerulaitis sounded more like one of his fellow Brooklynites, Vinnie Barbarino, the "Sweathog" played by John Travolta in the TV series *Welcome Back, Kotter.*

In the obscure outer reaches of the National Tennis Center, Gerulaitis walked off a jam-packed Court 16 after beating Terry Moor in five sets. He was met by his father, Vitas Sr., a tennis instructor who had first put a racquet in his son's hand, and who had been the first head pro at the National Tennis Center. Senior gave junior a congratulatory kiss on the cheek. His son thought it was a bit much.

"Jeez, Dad, now it's a big deal when I win one round, huh?" the younger Gerulaitis said with mock annoyance. "Don't have a coronary over one match."

But Gerulaitis was as happy and relieved as his father. "This is the kind of match I've been losing," he admitted.

Up to that point, 1981 had been a lost season for Gerulaitis. For half a decade he had been a fixture near the top of the rankings and a regular semifinalist and occasional finalist at the Grand Slams. A year earlier, Gerulaitis was the 5th seed at Flushing. Now he had plummeted to number 15. He came in to the tournament, according to the *New York Times*, as an "afterthought"; or, in the less charitable words of the *Daily News*, "a guy who didn't belong with the contenders or even the pretenders."

Like Nastase and Borg, Gerulaitis had spent much of the 1970s playing and living hard. As a new decade dawned, the candle he had burned at both ends had begun to burn back. Part of this was the inevitable aging process. At 27, Gerulaitis discovered that he couldn't maintain his legendary, round-the-clock Broadway Vitas pace and still expect to hold it together on the court. "I took a month off and didn't practice," Gerulaitis said as the Open began. "In the past I was able to take a week off, play around, party, and get by. This time I found out I couldn't. I guess I just lost some interest in tennis this past year."

A few defeats early on had shaken his confidence, and a trip through the European clay-court circuit had been a disaster. "I wasn't in the best shape, and it showed," he said. "I lost a couple matches and said, 'Ahhh, no big deal, I'll come back.' I lost a few more and I heard people say, 'He can't run anymore.' Then I got the self-pitying trip. You know, 'poor Vitas this, poor Vitas that.'"

By the time he got to Germany during that tour, the self-pity had seriously begun to infect Gerulaitis, though he could still play it for a laugh. Before leaving for Europe, he contacted Robert Lansdorp, a California coach who had mentored Tracy Austin, and asked him for help with his training. "We went to Germany to play the Hamburg Open," Lansdorp recalled, "and he was playing this little Spaniard who I thought was a ball boy. Vitas cramped. He finally lost in a tiebreaker, and they had to bring out a stretcher to carry

him off. As he's being wheeled by me he looks up and says, 'Lansdorp, go home. I'm ruining your reputation.'"

It wasn't just Gerulaitis's age that had begun to show. While he remained a friend to all, inside he had grown weary of his role as an eternal sideshow act to Borg, McEnroe, and Connors. After turning pro in 1972, Gerulaitis had improved and risen steadily until 1977. At Wimbledon that year he reached the semifinals for the first time. But there he ran into the man who would become his personal glass ceiling, Bjorn Borg. Slam after Slam, year after year, when Gerulaitis made a great run, the Swede would be waiting for him at the end of it. While he stretched Borg to five memorable sets that day, a pattern had been set. "I sometimes wonder what would have happened if he had won that match against me," Borg said years later. "If he had beaten me, his career might have been very different." It was the first in what would be a life filled with what-ifs and might-have-beens.

While he stalled at number four in the world, Gerulaitis watched as McEnroe, his Port Washington kid brother, took what he had always desired most, a title in his hometown at the U.S. Open. Finally, in 1980, there had been a breakthrough. At the Masters in New York, Gerulaitis beat Connors for the first time, after 16 straight defeats. True to Vitas's freewheeling style, the win inspired him to the heights of self-deprecatory chest puffing, while giving tennis a lasting bon mot: "Nobody beats Vitas Gerulaitis 17 times in a row."

Nobody, that is, except Bjorn Borg.

Coming into the 1981 U.S. Open, Gerulaitis's record against his friend was a mortifying 0–20. (Today it's officially listed as 0–16 by the men's tennis tour; maybe he actually wasn't joking after the Connors match.) Gerulaitis once said that he began every match with Borg with a dozen new ideas about how to beat him, and then watched as his nemesis blew each of them to pieces. But 1980 had been the breaking point for Vitas. After beating Connors in January, over the next five months he would lose to Borg four times, in-

cluding a dismal 6-0, 6-2 drubbing in Monte Carlo, and an equally lopsided blowout loss in the French Open final, 6-4, 6-1, 6-2.

"I got to Connors," an agitated Gerulaitis told John Feinstein of the *Washington Post* in September 1981, "I got to McEnroe, but I just couldn't get Borg. It got frustrating. I just got tired of chasing, chasing, not getting there. I took time off because I wanted to get away from tennis for a while."

Whereas the rigidly self-contained Swede could separate his personal and professional lives, it wasn't as easy for Gerulaitis, who thrived on interaction with friends. He gave a piece of himself to everyone. "He would be called a connector today," says Peter Fleming, who also played with Gerulaitis at Port Washington. "He had different groups of friends, and he would move from one to another. John [McEnroe] and I were just one of those groups. Everybody kind of intersected through him. Bjorn and John were in different camps, but Vitas could bring them together."

"Vitas was a nice guy, without a huge ego," adds Fred Stolle, his sometime coach and the man whom Gerulaitis called upon to help him get "out of the ditch" at the '81 Open. "Maybe he was too nice to be the top guy, but that's what he chose. He couldn't be any other way."

And he couldn't be any other way with Borg. "They were an odd match," says Ruta Gerulaitis of her brother's competitive friendship with the Swede. "They started out with this mutual respect after that incredible match at Wimbledon, and then they built on that. Bjorn would come out to our place in King's Point 10 days before the Open, and they would do two workouts a day. But it was more than tennis. I think my brother was one of the few people who could draw Bjorn out of his shell." They grew close enough that Gerulaitis's mother, Aldona—"Mrs. G" to her son's friends—treated Borg like a second son, even doing his laundry.

At the same time, Borg showed Gerulaitis what a champion's intensity looked like. "I learned a lot about mental stamina from Borg," Gerulaitis told *Tennis* magazine in 1977. "He plays in prac-

tice like he plays in a match. We play three out of five sets and he never, ever gives away a free point. It's a lot different than messing around for an hour and then quitting to have a couple of Cokes."

It wasn't just Gerulaitis's game that had soured in 1981; so had his mood. He was no longer the effervescently popular figure he had always been. Whether it was with the fans, the press, or his fellow players, relations had grown strained. Like McEnroe, Gerulaitis had never been much of a crowd favorite in his hometown, and the audiences at that year's Open were firmly on the side of his opponents. After his first-round win, the players in the locker room passed him by on their way to console Moor.

Gerulaitis would return the favor to the media over the course of the two weeks, preferring to incur a $500 fine for skipping each press conference rather than talk to the people who had been bashing him and, he felt, betraying him during his struggles. "I've learned a lot about people from this experience," Gerulaitis said with uncharacteristic bitterness during the tournament's second week. "A lot of people who used to come around and slap me on the back and be my buddy changed when my game went down. I don't regret it, though, because I've weeded out a lot of people."

For years, Gerulaitis had put on tennis clinics for children in Harlem and around New York City. It was more than a photo op. The Brooklyn kid was a patient and empathetic instructor who devoted a significant amount of his time to helping the sport grow outside of its usual confines.

"More than the other pros who do things," Mary Carillo says, "Vitas really taught the kids." His favorite line when he was urging on a child who couldn't get the hang of a certain shot was "We're gonna go through this a few times together, and maybe it'll help us both get it right." But now the man who knew no strangers was ornery and out of patience. After each match, Gerulaitis hustled briskly past the autograph seekers he had once happily indulged and made a beeline for his yellow Rolls-Royce in the parking lot.

That spring Lansdorp had been left to wonder how much Geru-

laitis's legendary nightlife had begun to affect his attitude toward the game. "He lied to me," Lansdorp said. "I would ask, 'Do you do drugs?' and he would say, 'No.' But then he would disappear on me for a whole week. I'd call the hotel, but I wouldn't see him for a day or two. I asked him in the beginning, but then I never asked again. It was my business but it wasn't my business."

Gerulaitis was a social cocaine user in the 1970s. Like Borg, nothing he did off the court seemed to slow him down on it. According to his friend Ilie Nastase, it was rumored that he had been up all night doing drugs before playing, and winning, the final of the 1977 Italian Open. For a teetotaler like Gerulaitis, cocaine functioned similarly to the way alcohol had for the old Aussie players, as lubrication for a night out, a way to ease the transition from competing to socializing. There was a hard-partying ethos he had learned at Port Washington from the Australian instructors who worked under Harry Hopman. "The Aussies were energetic about everything, whether you were practicing or playing or having a good time," Mary Carillo says, "and boy, did Vitas buy into that."

With the Aussies, it had been first to the net, first to the bar. With Gerulaitis, it was first to the net, first to the limo, first to the designer boutiques, and first into the VIP room and up on the white horse at Studio 54.

While John McEnroe drank in Hopman's words about team play, Gerulaitis spent those same years in the early 1970s buying into Mr. H's no-nonsense discipline. "Vitas was always working, working, working," recalls Tony Palafox, a Port Washington instructor who became McEnroe's personal coach. "He might be on the court for 10 hours a day. It didn't matter how long it took; he would practice something until he had it right."

Gerulaitis met Hopman when he was 15; the coach recognized his potential early. "He always stressed practice and physical condi-

tioning and strategy," Gerulaitis said in 1975. "He made me believe in myself. He's my all-time person."

Vitas Sr., a former Davis Cup player for Lithuania, had come to the United States penniless. He drove a truck at night and taught tennis, but at first he couldn't pry his son away from the team sports that surrounded him. "He pushed it," Ruta Gerulaitis says of her father, "so I don't think either of us really wanted to get into tennis at first."

Vitas eventually discovered that basketball would never be his thing—he later claimed to have been "14th string" on his high school team. By his early teens he was spending summer days finding pickup tennis matches at the public courts in Queens' blue-collar Howard Beach neighborhood. "You'd show up in the morning with lunch, grubby shorts, worn sneakers, and plenty of iced tea," he said. "Then you'd be there all day long."

Hopman's academy in Port Washington was a big step up from Howard Beach, but Gerulaitis quickly became a star there as well, and an easily recognized figure on the New York tennis scene. He made a big first impression, with his blow-dried golden locks and elegantly fleet-footed game. McEnroe never forgot seeing his "little bunny steps" for the first time at Port Washington. Carillo, whose best friend growing up was Ruta Gerulaitis, first glimpsed a 16-year-old Vitas—"a total stud," to her 13-year-old eyes—warming up with Hopman himself. As he was playing, Gerulaitis took off the sweater he was wearing, even as he kept a rally going with his coach. When he had it off, he tossed the sweater to the side of the court and kept hitting. "It was one of the most graceful things I'd ever seen," Carillo says.

Fleming had his first encounter with Gerulaitis around the same time, at the West Side Tennis Club, where Vitas went from working on the grounds crew for $3 an hour to being an all-white-wearing member. "Even at 16 he had this huge personality," Fleming remembers. "The room always lit up. That day at Forest Hills, he sat

down in the clubhouse and got on the phone with his dad, and he went into this fake Russian accent for about 10 minutes, with all the hand gestures. His dad didn't have a clue who he was talking to. The whole place was cracking up."

Girls noticed Gerulaitis early as well. As an 18-year-old, he traveled with Hopman and a group of young players on a tour of Australia. In Sydney, Gerulaitis walked out of their hotel to meet Hopman. He was with two young women who, he said, wanted to come along and join the fun in Melbourne. "I'll take a different flight and meet you down there, Mr. H.," Gerulaitis said, starting to walk away. Hopman pointed at the bus that was waiting to take his players to the airport. "Vitas, there's the bus," he said. "Get in." Gerulaitis put his head down and boarded the bus. As it was pulling away, someone said, "Well, I guess that's the last we'll see of those girls." Hopman shook his head. "I wouldn't be too sure of that," he said.

The flight carrying Hopman, Gerulaitis, and the other players was delayed on the runway for half an hour. When it finally got off the ground and landed in Melbourne, the two girls were at the gate, waiting for Vitas.

"It all happened incredibly fast," Ruta Gerulaitis recalls. "For a long time Vitas wasn't that interested in tennis. Then, suddenly, he was a star. He really was an overnight sensation. One day we were living in Howard Beach and the next day we were all in this mansion in King's Point. We were like the Beverly Hillbillies." Gerulaitis took his family with him, moving everyone into a spacious contemporary house with a tennis court, a pool shaped like a racquet, and a three-car garage. Lined up inside were Gerulaitis's Porsche, his Ferrari, and his beloved yellow Rolls-Royce. It was the immigrant dream of conspicuous consumption come true.

Unlike the shy McEnroe and the silent Swede, Gerulaitis embraced his celebrity status. "When I walk out of Madison Square Garden," he said in 1975, "kids come up to me asking for my au-

tograph. I eat that up. Anyone who tells you that fame is a drag is talking out their racquet." According to many around him, though, Gerulaitis's relentless sociability made him hard to get to know, even something of a loner. "He always seemed to be with a crowd," Fleming says, "one step ahead of you. When you saw him out, he'd be with two women, but you weren't sure who was close to him."

"He was always moving, always laughing," adds journalist Peter Bodo, who became friends with Gerulaitis while covering him. "He didn't have any hang-ups; he didn't have an attitude. He made it cool to be from the boroughs. Drugs didn't hurt him in those days. He knew how to control his habit. But he never really had girlfriends. If a woman was looking for a guy to visit her parents over a weekend or go to a wedding with her, that wasn't going to be Vitas. Hanging out was his thing; he wasn't going to get pinned down by anything."

One friend who hung out with Gerulaitis regularly in those days recalls a typical evening with him. "He'd call to ask what you were doing that night, and see if you wanted to come out with him. Any plans you might have had were immediately canceled, of course. He'd pick you up at your place, in a limo, of course. There'd always be two or three models in the back with him, who he wasn't dating. We'd go to Studio 54, and with Vitas that meant you got ushered straight down to the VIP room, with the red velvet curtains and all kinds of ne'er-do-wells from around the world in there. The coke would be out on the table and Vitas was in his element, but it was never a heavy drug scene, nothing sinister about it. He loved music, loved to talk about music, liked to dance.

"At the end of the night we'd get back in the limo with the models and drop them off one by one at their apartments. He'd drop me off last, and I'd see him, his head of hair, in the back of the car going down the street, heading back out to his house on Long Island by himself."

But Gerulaitis couldn't stay a step ahead of the drug scene for-

ever. "He met all kinds of people," Ruta Gerulaitis says, "because he was open to everyone. But that meant he met a lot of bad people, too. It got to be more bad than good."

———————

So far 1981 had been a bust. And there were clouds on the horizon, clouds that would soon grow much darker. But Gerulaitis, who loved to play in his hometown even if they didn't love him back, would make the 1981 U.S. Open the site of his reclamation, and become the biggest surprise of the two weeks. He followed his win over Moor with two easy victories in his next two rounds, even as he stuck to his policy of blowing off the press and bolting the National Tennis Center as quickly as possible. In his straight-set third-round win over the tenacious Harold Solomon, Gerulaitis said he played well enough to "have a little confidence finally."

It appeared that his run would end in the next round, where he was scheduled to face the number three player in the world and the sport's stony new face of doom, a 21-year-old Czechoslovakian who had already been referred to by *Tennis* magazine as "the world's toughest player": Ivan Lendl. Few recognized it at the time, but their match on a jammed Grandstand court would pit tennis's past against its future. The 1981 U.S. Open had reached its middle weekend, and the sport had reached a turning point. Was it ready to make that turn?

IVAN THE POWERFUL

"Do you like a robot being number one?"
—JOHN MCENROE ON IVAN LENDL, 1987

In 2008, Georg Diez and Christopher Roth were playing tennis regularly in their hometown of Berlin. When the two artists and friends came to the net to gather the balls that inevitably landed there, they began to talk: about the past, about history, and about how and when the sport they were playing changed so drastically. Their conversations kept circling back to 1980 and 1981.

During those 24 months, Diez and Roth argued, the tensions that drive global politics today were established. The West, in the form of the Reagan and Thatcher administrations, was moving rightward, while radical Islamists were emboldened in the Middle East. Iranian students held American embassy employees hostage in Tehran, and Egyptian extremists assassinated President Anwar Sadat for negotiating peace with Israel. The Pope was shot by a Turkish terrorist, and Lech Walesa's Solidarity movement made world headlines for defying the Soviet-run Polish government.

There was also a new technological future opening up in those years, one that emphasized and reinforced the individual. In August 1981, IBM released the first personal computer. The year before, Sony had introduced the United States to the Walkman, a device that, according to more than one observer of the professional tours,

did more to destroy any remaining camaraderie among tennis players than anything else.

"In music, there was this inhuman element happening at that time, as if technology was going to run our lives," says Diez, who subsequently started a long-running multimedia art project called 80★81 with Roth. "The future was going to be robotic and techno, like the Human League and Kraftwerk. And that was starting to happen in tennis. You had McEnroe the artist and his rival the Ice Borg, but you also had Lendl, the technological player, coming up."

Bloodless German synthesizer drones did not overtake the pop charts, and 30 years later robots are still not doing our dishes. But tennis in the 1980s would indeed belong to the Technological Man, Ivan Lendl. He was the first top pro to make his debut inside the American tennis empire with no ties to its clubby past. "I never played at Forest Hills," Lendl says. "When I started at Flushing Meadows in 1978, some players were saying that 'this can't be the U.S. Open,' but it was always the U.S. Open for me. I never minded it."

In fact, Lendl would come to love the tournament, the same way he would come to be enamored of the United States, the country he would adopt as his own as a 20-year-old in 1980—unlike his fellow exile Borg, Lendl would not remain stateless. By the 1981 Open, he was living at the Greenwich, Connecticut, mansion of his mentor, Polish pro Wojtek Fibak. The following year, Lendl started making the short drive to Flushing each day from his own place in Greenwich.

Soon after, with vintage Lendl thoroughness, he would have his own backyard court laid down by the same crew who resurfaced the courts at the National Tennis Center. Each year, he would have the old court torn up and a new one put in to the Open's exact specifications. "I would have them come up the day after they did the courts at Flushing," Lendl says, "so they would remember how they made it. Even the slightest change in the amount of sand in the surface mix will change the way it plays. If you get that crew up there a

week later they would make it completely differently." Ivan Lendl, the professional's professional, would leave nothing to chance when it came to the U.S. Open. He would reach the final a record eight straight times.

Aside from Lendl's and the National Tennis Center's, a third important debut was made at the 1978 U.S. Open, one that would have an even more profound effect on the sport. That year, 16-year-old Pam Shriver became the first player to reach the final of a Grand Slam using an oversize racquet, the Prince Pro. The frame had first been manufactured two years earlier, but it had been widely derided among recreational players as a "cheater's racquet." Once Shriver legitimized it, the floodgates were open, and the wooden frame, after a century as the standard, was doomed. Soon players were hitting with power and spin that would have been unimaginable just 10 years earlier. The 1981 U.S. Open men's final between John McEnroe and Bjorn Borg would be the last one in which either player used a wooden racquet. It would also be the last one of the decade in which Ivan Lendl didn't play.

No player would symbolize or exploit this shift more than Lendl. He was an early adopter of the open-throated, midsize racquet, having been perhaps the only player in history who could handle the sledgehammer manufactured by Austrian racquet maker Kneissl and later by Lendl's sponsor Adidas. The game he played with that racquet, which was based around a heavy serve and powerful ground strokes, is the one played today by the vast majority of pros. Borg had become a champion by getting one more ball back into the court than his opponents. McEnroe won by attacking the net. Lendl broke down the divide between those two styles. He attacked, like McEnroe, but he did it from the back of the court, like Borg.

This subtle but ultimately monumental change was summed up in a conversation that Lendl had with his friend Bill Scanlon at a tournament in Tokyo at the end of 1980. Scanlon was scheduled to play Borg, whom Lendl had recently beaten for the first time. Rid-

ing from the stadium to the hotel, Scanlon asked Lendl for some advice on playing the great Swede. "Billy," Lendl said, "you just rally with him in the backcourt until you get a forehand you like. Then you crash it hard, crosscourt."

Scanlon, still thinking in terms of classic tennis strategy, finished the thought. "And then I can approach the net because his backhand is vulnerable?"

Lendl paused and gave Scanlon a quizzical look. Then he said, "No, he doesn't get the forehand back!" There was a new tactic in tennis, called power, and a new essential shot, the killer forehand, that could be blasted past an opponent even from the opposite baseline. It was a change that would eventually doom John McEnroe. While he switched to a midsize racquet in 1983 and used it to have the best year of his career the following season, his game had been built with wood, and it was too late for him to learn the monster forehand that would define the sport starting with the appearance of Andre Agassi in the second half of the decade.

The power baseline game wasn't the only innovation that Lendl brought to tennis. He explored fitness training and nutrition more thoroughly than anyone before him, and embraced anything that might make him even a slightly better player, whether it was aerobics at 6:00 AM or fad diets such as the one promoted by Dr. Robert Haas and touted by Martina Navratilova. (The Haas diet didn't last, but it did inspire a McEnroe one-liner: asked if he would ever consider going on it, he said he was trying the "Häagen-Dazs diet" instead.)

Lendl was also a trendsetter when it came to equipment. In the early 1980s, he became one of the first players to have all of his racquets customized to precisely the same specifications, something that was never possible with wood. Lendl even began to change his racquets every seven games, each time new balls were introduced into a match, because he felt that a racquet's playing characteristics changed as it was being used. It seemed bizarrely obsessive at the

time, and Lendl could take it too far. In the final of the 1986 Masters, he and Boris Becker played to a fifth set. Lendl broke Becker's serve at 5-5. His friends were stunned and appalled to see him, after winning that game, walk over and dutifully change his racquet, the way his schedule said he should. Lendl was subsequently broken and lost the match in a fifth-set tiebreaker. Still, like many of his seemingly strange innovations, almost all of the top pros change their racquets the same way today.

Tennis and discipline—punishment, even—went hand in hand in the clinical Czech's mind. His mother, Olga, had been a top national player. When Ivan was a toddler, she brought him to the court and kept him tethered to the net while she played. As he got older, he served as her ball boy, which wasn't an easy job. She liked to play with one lucky ball over and over, which meant that little Ivan was constantly racing all over the court to track it down. Olga was a taskmaster, too, and she and her son fought often when he was a teenager. But she also taught him to be resourceful, a trait that would make Lendl into perhaps tennis's greatest overachiever. "You had to do something great to get out of there," he says, referring to the Communist regime in his native country.

His dedication to success, and his desire to intimidate opponents by talking about that dedication, would make Lendl more respected than beloved. He was the anti-McEnroe in every sense. "I have more talent in my little finger than Lendl," McEnroe said, and it was, to a degree, true. Lendl was an earthbound, workmanlike, at times clunky player. McEnroe seemed to float; Lendl trudged. McEnroe caressed the ball with his racquet; Lendl hammered it without subtlety. McEnroe the artist berated himself as he played; Lendl the automaton methodically did what he thought he needed to do to improve, and rarely said a word on court.

Lendl, with an immigrant's appreciation for its freedoms, became more American than most of its natural-born citizens. He scolded the country's people for not properly appreciating what they

had, and was a law-and-order conservative who bred police dogs for fun. When guests came out to his Connecticut home, Lendl enjoyed showing off his dogs' self-control, as well as his control over them. He would put a plate of food in front of them and wait as they sat there salivating, before finally giving the signal that they were allowed to eat. Where McEnroe believed in his God-given talent, which is not so different from an aristocratic belief in inheritance, Lendl the self-made American put his faith in a Puritan's work ethic and self-improvement. As Scanlon says, he "embodied the maxim that hard training, self-discipline, and control of the on-court game will lead to certain victory."

Lendl would finish his career with eight Grand Slam titles to McEnroe's seven. But the love of his adopted country would always escape him. In 1986, at the height of his powers, *Sports Illustrated* dubbed him "The Champion That Nobody Cares About" (he would never speak to the magazine again). Lendl would become a U.S. citizen in 1992, but that was four years later than he had hoped. In 1987 he had applied for an expedited American citizenship in the hopes of playing for the 1988 U.S. Olympic and Davis Cup teams, but, when the Czechs refused to provide the necessary waivers, the U.S. Congress turned him down.

In 1981, Lendl's days and years of certain victory were still well ahead of him. His season had begun with a controversial loss, one that showcased what many thought was tennis's growing and debilitating obsession with money. At the Masters that January, Lendl was accused of giving up in a match against Jimmy Connors. In the eight-player round-robin event, the four top finishers qualified for the semifinals. Lendl and Connors had each made it in by the time they faced each other; whoever won their match would face Bjorn Borg in the semis, while the loser would get the decidedly less-

imposing figure of Gene Mayer. Lendl claimed that he gave it his all, but he went down to a conspicuously easy defeat in the second set, so conspicuous that an angry Connors called him a "chicken" afterward. Lendl beat Mayer in the semis, while Borg beat Connors. Borg then crushed Lendl in the finals, but the Czech's tank job had earned him $50,000 more than the enraged Jimbo in runner-up prize money. The American transplant was as meticulous about his finances as he was about everything else.

Nine months later, as Lendl walked onto a filled-to-beyond-capacity Grandstand court for his fourth-round match against Vitas Gerulaitis, talk had already begun about a possible semifinal match-up between McEnroe and the young Czech. Lendl had won their quarterfinal at the French Open, and many believed he would do it again here. But Gerulaitis was inspired: For the first time that he could remember, the crowd was on his side. "I was thinking, 'The boy is back,'" Gerulaitis said afterward about how he felt on court. "It was the first time they were behind me. Maybe it's because I'm ranked about 2,000 now."

The twitchy Gerulaitis and the grim Lendl couldn't have made a starker contrast. Over the years, Gerulaitis had become a ball of tics on court. Before every serve, he dipped his head, shook his locks, and peeked back over his right shoulder. "He looked like a rooster checking the henhouse for interlopers," sportswriter Michael Mewshaw wrote. At this point in his career, Lendl was emphasizing intimidation. He wore dark clothes when he could, and his facial expression never changed, even as he leveled one of his howitzer forehands straight at an opponent's head. While Gerulaitis used his bunny steps to sneak up to the net and angle off volleys, Lendl pounded the baseline with heavy-footed strides. The difference could even be heard in the sound of their shots. Gerulaitis's left his strings with a ping; Lendl's, with a resounding thud.

The match was an epic. By the middle of it, Gerulaitis was so worked up that he fired a ball at a lineswoman, only to hit a specta-

tor in the leg. He repeatedly told the chair umpire to "give someone else your seat; it's the best in the house." After losing the fourth set 6–3, Gerulaitis walked to the sidelines and saw his coach, Fred Stolle, stand up and lean out from the crowd. "He told me to stop bleeping around," Gerulaitis said later. He settled down, and the two players began the fifth set.

"Vitas was always a tough opponent for me," Lendl says. "He was quick and he rushed straight up the middle of the court, so it was hard to find an angle to pass him." That's how most of the points in this fifth set developed, with Gerulaitis chipping and coming forward and Lendl replying with a rifled passing shot. The two remained knotted at 1–1, 2–2, 3–3.

From the vantage point of 30 years, tennis can be seen to be moving in two directions in this set. Gerulaitis was going back in time, to the serve-and-volley, chip-and-charge Big Game of previous decades. Lendl the power-hitting baseliner was taking the sport forward all the way to the present day. A few months later, the two would face each other again, in the final of the 1982 Masters at Madison Square Garden, a match that Lendl would remember as one of the highlights of his career. Gerulaitis, his 1981 slump well behind him, came in on a high; this would be the biggest title of his career if he could win it. The same was true for Lendl. Gerulaitis outdueled Lendl for the better part of three sets and reached match point, but he couldn't close it. Lendl came all the way back to win in five. The tide began to turn with Gerulaitis ahead 2–0 in the third set and seemingly on his way to victory. He took a return of serve and rushed the net behind it. An angry Lendl took out his frustrations by drilling a forehand straight into Gerulaitis's forehead. Vitas was floored, literally and figuratively, even if he wasn't too worried for his health: "I have nothing in my head to really damage anyway," he joked afterward. But the momentum had shifted, and, symbolically, tennis had changed as well. In the future, the rifle-shot forehand would rule, and players

would come to the net at their peril. As for Gerulaitis, it would be the final what-if of his career.

———

At 3-3, 30-30 in the fifth set at the 1981 U.S. Open, Gerulaitis made the same move he would make at the Garden four months later. He took Lendl's serve and followed it in. Lendl did the same thing, slapping a forehand right at Gerulaitis. This time, though, the future was denied. Rather than taking it on the forehead, Gerulaitis deftly ducked to his left and knocked off a volley winner. "I decided at the beginning of the day that he was going to have to hit 2,000 passing shots," he said. "He made 1,999 of them."

Gerulaitis went on to break serve and, to the roar of the crowd, serve for the match in the fifth set. He walked back and saw a familiar face. Patrick McEnroe was a 15-year-old ball boy working his brother's friend's match. Before one point during that final game, Gerulaitis looked at his buddy's kid brother and said, "Give me a good one, Lenny," using the younger McEnroe's childhood nickname. Gerulaitis won that rally.

A minute later he reached match point. The two players hit back and forth from the baseline. Gerulaitis thought about coming to the net but stayed back instead. He didn't want to give Lendl a crack at that 2,000th passing shot. The safe play worked. A Lendl backhand caught the tape and fell backward. Gerulaitis lifted his arms; tears came to his eyes as he put his hands to his lips and blew kisses to his new supporters. "I love you, I love you," he said. The slump was over. Vitas had made it on Broadway at last.

Still, it wasn't enough to get him to call off his press boycott. Gerulaitis was last glimpsed on his day of triumph running from reporters in the parking lot. "The boy is back," he called out from the driver's seat of his Rolls. "Now I have to do some grocery shopping."

CHAPTER FIFTEEN

HEROES AND VILLAINS

"We're all part American now."

—JOHN NEWCOMBE

B y the start of the 1981 Open's second week, John McEnroe ap-
peared to be back to his old self. He was looking frazzled again.
His hair had grown long enough to curl, and as he pawed and
patted and scratched it through his quarterfinal match, it seemed
like it might even begin to stand on end.

Who had him on edge this time? A pudgy young mystery player
named Ramesh Krishnan. The 20-year-old Indian, despite being
ranked 101 in the world and owning a serve that McEnroe later
estimated to be traveling "like 10 miles an hour," had the number
one seed alternately doubled over his racquet in despair and scream-
ing at the sky. To the astonishment of the Flushing Meadows crowd
and McEnroe alike—"no one in the world expected me to lose this
match," he said afterward—Krishnan used crafty changes in speed
and uncannily accurate passing shots to win a long, lethargic first set
in a tiebreaker. Even more astonishing, an hour or so later he found
himself serving at 5-4 in the second, with a very good chance to
take a two-set lead.

As usual, the New York fans had warmed to the underdog and
the chance to witness the upset of the year. As usual, McEnroe
lashed back. According to *New York Times* columnist Dave Ander-

son, McEnroe snapped at one spectator, "Shut up or I'll stuff the ball down your throat."

It had been a typical McEnroe week, full of artistry, triumph, and if not outright chaos, then a satisfactory amount of disgruntlement and ill temper. The fine for his Wimbledon behavior had been followed by a controversy involving the shotgun microphones that CBS placed on the show courts. They were intended to pick up the sound of the ball—compared to the Open, Wimbledon seemed to be played with the Mute button on—but they also recorded McEnroe's voice as he uttered whatever choice words came to mind. "They make it sound like we're out there screaming, when we're not," he groused. He wasn't the only player to complain. Gerulaitis compared the situation to baseball, where no one heard what the players were saying. "When Reggie Jackson crashes into the wall in right field," Gerulaitis said, "do you think he says, 'Oh, I hurt my little heady-poo.'" In tennis, the behavior of its stars had become part of the game's story and one of its selling points.

Early in the event, CBS revealed that McEnroe and his father had told the network that they would refuse all interviews unless the microphones were removed. "We all know why they're there," Junior said. During his third-round match, he shouted sarcastically at the network employee whose job it was to hold one of the mikes, "Bring it closer, bring it closer," he said. "Let everyone hear." The microphones stayed. By tournament's end, McEnroe was swiping them with his racquet.

The problem was that everyone was listening to John McEnroe now. The kid who had thought of himself as a little brother to Borg, Connors, and Gerulaitis had surpassed them all. The hunter had become the hunted, and there was no one left to give him cover. That would soon be true of his personal life as well. While his girlfriend from Stanford, Stacy Margolin, was still in the stands for the tournament and still staying at his parents' house, their relationship was, as McEnroe would later say, "sputtering to a close." Matters weren't helped when the New York Post published an article during

the Open about a weekend McEnroe had reportedly spent with a model in Florida that summer.

McEnroe would ascend the mountain alone. The winds were icy at the top, he would say when he looked back on his career. And the phonies were coming out of the woodwork. "I just don't know who's looking out for my best interest, or who's just looking to use me," he said after winning Wimbledon. Whatever his talents, and as deep-seated as his belief in them was, the top of the tennis hill would never feel like home.

As he fumed his way through the first week at Flushing, McEnroe even began to sound an ominous note about his future. "Some of the fun has been taken out of it for me," the 22-year-old said. "That's why I can't go on like this."

For a moment, it looked like McEnroe wouldn't have to go on at all. Krishnan, the most unassuming of challengers, appeared ready to knock him out of the tournament. He served for the second set at 5-4 and reached 30-30. Krishnan, like McEnroe, was a touch artist who liked to caress the ball around the court before changing speeds and launching a surprise attack. On the next point he caressed a delicate drop shot, but this time he cut it a little too fine. The ball hit the tape and fell back on his side. "I missed it by an inch," Krishnan said afterward with a rueful smile. McEnroe would go on to win the set.

One reason the match was so difficult was that, like McEnroe, Krishnan played a softball style out of the game's past. Both men relied on finesse rather than power, which made the points tricky and delicate negotiations of slice and placement. Krishnan offered no pace for McEnroe to work with, yet he was still somehow controlling the points. "I had a lot of trouble with his serve," McEnroe said, "and all he does is get it in."

Krishnan's was a game that McEnroe knew well, one he had learned back in Port Washington. One afternoon back in 1970, Kay McEnroe had shown up with her 11-year-old eldest son. Tony Palafox, a former Davis Cup player for Mexico who was now teach-

ing at Hopman's, was impressed, but he thought the kid needed some polishing, and the competition was high class at the academy. So John McEnroe went into the intermediate, rather than the advanced, group. Intermediate wasn't going to cut it for his father. He made a call to an acquaintance, 1963 Wimbledon champion Chuck McKinley, who knew Palafox. McKinley got the coach to give Junior a second look. He moved up quickly after that.

"You could see that his touch was more advanced than anyone else's," Palafox says. "So we always worked on that and emphasized that."

The Latin players whom Connors learned from out west, former pros Pancho Segura and Pancho Gonzalez, were tough guys who hit with power and imposed their will on a match and an opponent. McEnroe's Latin influence, Palafox, like Harry Hopman, came from the amateur side. In both cases, the fit was right.

"I was a touch player," Palafox says. "Most people think you can't teach that or make your hands better, that you either have it or you don't have it. But we did drills all the time to improve his hands. We wanted him to be able to hit every shot from every part of the court. That was something not many people could do, and I think when John was at his best, no one did that better."

Palafox was also a guy who, lacking overwhelming power, had to think a couple of shots ahead and take the ball as early as he could. He saw that thought process in McEnroe as well. All those marathon chess games at Port Washington had helped. McEnroe transferred some of what he learned on the chessboard over to the tennis court. "John was constructing points and using angles even when he was young."

Palafox eventually left Port Washington and became the closest thing that McEnroe would have to a full-time coach. When, a few years later, McEnroe showed up with his new, elaborate service motion, Palafox knew exactly what to do. Instead of advising against it, he set about learning it himself so he could give McEnroe tips for hitting it better. ("It was hard to do," Palafox admits.) But, befitting

these two instinctive players and their instinctive rapport, Palafox understood his star pupil's game well enough that he didn't even have to travel with him to do his job. "We would fix things in his game by telephone," Palafox recalls. "I would ask 'Where are the balls going,' and he would tell me, and then I could tell him that he wasn't closing his shoulder enough, or whatever the problem was."

Now, on this blustery afternoon, Palafox sat in Louis Armstrong Stadium and watched his player begin to fret as Krishnan refused to go away. It has often been noted that McEnroe had an uncanny knack for losing his mind yet still being able to return to the baseline and play as well, if not better, than he did pre-meltdown. Part of the method behind his temporary madness may have been the tranquilizing effect Palafox had on him. "I was always calm," the coach says, "which was a good thing. John would go crazy and then look over at me and I would always be calm. Then he would be calm again and go back to playing."

Palafox chalked up McEnroe's antics to boredom as much as anything else. "It all came so easily for him," he says, "that he would get bored in practice. Then he'd miss a shot and he'd go nuts."

After the hair-pulling, the lethargy, the testy exchanges with fans, the disbelief at his opponent's shots, and, as Mike Lupica put it, "the icy brush with the upset," McEnroe did eventually settle down again. By the fourth and final set, which he won 6-2, he had taken control of the points from Krishnan and was, to the delight of Palafox, "hitting well from every part of the court."

Later, though, in his press conference, the dark clouds that had accompanied McEnroe at Flushing returned. "I'm beginning to feel the pressure," he admitted. One thing that hadn't changed about him was his head-on honesty. "There is a burden to being No. 1." He would carry that burden to the semifinals, where he would face old friend and new Cinderella story, Vitas Gerulaitis.

Bjorn Borg had carried the weight of number one on his shoulders for years, but on court at least, he had carried it alone. Once he reached the top, the Swede rarely played doubles; he and Connors had been the first players to make enough money in singles that they could focus solely on it. McEnroe was also wealthy enough to scrap his doubles career, but his partnership with Peter Fleming helped him in at least two ways: it gave him a way to stay sharp without having to slog through the drills that he still detested; and it allowed the team-sports lover his one chance of having someone on his side. McEnroe and Fleming were the number one team in the world in 1981, and it seemed that they would stay in that position for years. They were coming off a Wimbledon win and were trying for their third straight U.S. Open title.

Appearance-wise, they were a vintage odd couple. Fleming was a 6-foot-5, blond, blue-eyed WASP. They had met at Port Washington when Fleming was 16 and McEnroe was 12. Fleming had spotted the kid four games per set, then received an early glimpse of his talent and determination, as well as a humiliating beat down, when an angered McEnroe dispatched him in five straight sets. When they met again on tour in 1977, they became fast friends.

However different they may have looked, they had a lot in common. Fleming grew up in Chatham, New Jersey, a leafy suburb not unlike Douglaston. They shared a New York brashness, a love of New Wave music, and a tendency to blow up on a tennis court. But where McEnroe projected his rage onto his surroundings, Fleming directed his inward.

"We had great chemistry right from the start," Fleming says. "We really understood each other at the beginning. What I needed was the confidence that he always had."

Their styles meshed as well. One righty, one lefty, one finesse man and one grip-it-and-rip-it bomber. "My game is boom, boom, and more boom," Fleming once said. McEnroe brought the same blind self-belief that had propelled him up the singles ranks to their doubles matches, where it became contagious. In 1978, at their first

Wimbledon, he and Fleming faced the best team of the previous generation, Stan Smith and Bob Lutz. Fleming and McEnroe led two sets to one, before Smith and Lutz won the fourth to send it to a decider. While Fleming was filled with doubt, McEnroe was indignant. "These guys stink!" he yelled to his partner, referring to a team that had won eight Grand Slams. The pep talk, such as it was, worked, and the kids won the match in five. The doubles torch had been passed. Fleming says his sense of "self-belief" changed after that match. As with Borg, Connors, and Gerulaitis, McEnroe was the younger brother in his relationship with Fleming, but here, on the doubles court, he was the leader. His anger could be used for good.

It could also be used for intimidation, as Fleming found out later in 1978, when the two played another great, aging doubles team, 10-time Slam winners Bob Hewitt and Frew McMillan, in Cologne, Germany. Earlier in the season, the veterans had used their touch and placement to hand McEnroe and Fleming a straight-set loss in the Wimbledon final. The young Americans vowed that next time they were going use their superior power to ram the ball down their opponents' throats. They nearly made the vow come true in Cologne. Early in the match, McEnroe drilled a volley six inches from Hewitt's face. The Aussie, who had been the most temperamental player of his day—the man Harry Hopman suspended in the 1960s—stared at McEnroe and asked, "You want to die?"

If Hewitt thought he could scare McEnroe, he had the wrong teenager. "What?" McEnroe asked. "You want some more, old man? Next time I won't miss." The kids won that match and never lost to Hewitt and McMillan again. "It was all over for them," Fleming said, "and they knew it."

But there was a downside to playing alongside genius every day. "It could be hard to play with John," Fleming says, "because I judged myself by what he was doing, and sometimes that didn't give me any confidence at all. I would go into a shell out there. I couldn't move."

The low point came in the Davis Cup final in France in 1982. Fleming had hurt his foot two years earlier and was just finding his form again. He expected to play well against the French, but instead he reinjured the foot during the match and had to watch as McEnroe picked up the slack again and led them to a win anyway. In the press conference afterward, a morose Fleming was asked who the best doubles team in the world was. "John McEnroe and anyone," he muttered. McEnroe, who was sitting next to him, reacted with disbelief. "What are you saying?" he asked immediately and incredulously. "That's not true." No matter: The context of the quote was forgotten, but not the words themselves, which soon became gospel among tennis fans.

Their professional partnership flourished, but their friendship didn't. The rigors and pressures of the tour altered it, just as they altered McEnroe's friendship with another buddy from Port Washington, Gerulaitis, at virtually the same time.

The problems had begun two years earlier, when Fleming met a pretty, blond British woman named Jenny Hudson. McEnroe, whose own relationship with Margolin had begun to stagnate, was jealous, both of Fleming and of Jenny, who got to spend so much time with his friend. When Fleming confessed that he might be in love, the sensitive McEnroe responded, "Look, have you slept with her or not?"

Fleming said that he had not. "If you want to know my opinion," McEnroe concluded sagely, "if you haven't slept with her by tonight, just forget it." Three years later, McEnroe would be the best man at Fleming and Hudson's wedding. Nearly 20 years after the wedding, McEnroe picked up the phone one morning to hear Fleming on the line from London. "I'm just calling to say I forgive you for trying to ruin my marriage," he said.

At the same time, in 1979, McEnroe was having trouble accepting his partner's newfound success as a singles player. Fleming, who was traveling with Hudson, was flying high both personally and professionally, to the point where he even beat McEnroe in

a final in Los Angeles. A few weeks later, at a tournament in Hawaii, McEnroe lost to Bill Scanlon in the semifinals. Scanlon then faced Fleming in the final. Rather than watch the match, McEnroe sulked in his hotel room, unsure of how to feel. When Fleming later told him that he had lost, McEnroe was disgusted by the wave of relief that swept over him.

Two months later, they faced each other in an exhibition event in Jamaica. Fleming was tan, loose, and happy, which only made McEnroe more uptight than ever. His buddy had now become a threat. Fleming was in love, he was challenging him in singles, and he was joking with the crowd at their match, something McEnroe could never do. Was he going to take everything from him? It didn't take long for McEnroe to go ballistic over a line call. When Fleming refused to concede it, McEnroe sarcastically asked him, "So you're going to take that point?" Now it was the mild-mannered Fleming's turn to lose it. He walked toward McEnroe and yelled, "Just because we're friends, don't think I'm the Salvation Army!" McEnroe knew then that while he had a doubles partner, he was alone as a tennis player.

McEnroe and Fleming, the top seeds and overwhelming favorites, reached the semifinals at the 1981 Open. There they were scheduled to play a much-anticipated late-afternoon match against the least likely of opponents, John Newcombe, age 37, and Fred Stolle, age 43.

Newcombe and Stolle were fossils from the lawns brought back to life. They had won the last two amateur U.S. Championships held at Forest Hills, Stolle in 1966 and Newcombe in '67. Each was retired from singles and working as a television analyst during this tournament. They were Australians of the old Hopman school, and they'd been having the run of their lives at Flushing. Playing with joy and humor had always been the Aussie way, but now, like the TV personalities they had become, Newk and Stolle were hamming it up still further during their matches. Joking with the crowd, each pretending to be stunned by his partner's good shots, talking into

the cameras—they were a smash. As their unlikely act continued, they began to draw thousands of fans who yearned for the long gone days when tennis had been defined by the spirit of Aussie bonhomie.

"Their matches have taken on the aspects of celebrations," columnist Joe Gergen wrote in *Newsday*. "Fans drawn to the names as an exercise in nostalgia invariably stay to whoop, holler, and laugh at the best entertainment value on the grounds. Even at the height of their considerable talents, a decade or more ago, it was never life or death for them. They were of a breed that valued the experience as highly as the victories."

The old-timers' act was popular with spectators, but it wasn't universally appreciated by their fellow players. Over the years, Newcombe, who moved to Texas in the 1960s to start an academy, had turned his image as a charming rogue into a lucrative brand. A client of IMG, he hawked clothes and cameras, Dingo boots and Ralston-Purina pet foods. He set up tennis camps around the world, and registered his famous moustache as a trademark. *Tennis* magazine hailed him as the sport's "first tycoon" and a "miniature conglomerate." By the early 1980s, according to author Michael Mewshaw, the smiling self-promoter was "known as the 'Big Cute' behind his back."

On Thursday, September 10, 1981, 18,000 people jammed Armstrong Stadium to watch the clash of tennis generations. The amateur era was about to go head to head with the Open era; two products of Harry Hopman, the Australian Davis Cup dictator, would face two products of Harry Hopman, the player-friendly American academy director. There was little question which side the fans were on, and it wasn't that of the rich young pros. For two sets, the audience was silent as McEnroe and Fleming easily subdued Newcombe and Stolle, 6-2, 6-2.

"Were you trying in the first two sets?" Stolle was asked afterward. "We were very trying," he answered to a roar of laughter. The old-timers were a hit with the press as well. "I don't think

I've played in front of that many people, ever," Stolle went on. "It's a tough stadium to play in. I couldn't sight the ball well. I was so bloody nervous."

Gradually the nerves subsided as the sun began to descend and the crowd loosened up. Newk and Stolle won the next two sets. As they worked their way into the match, they worked themselves deeper under their opponents' skins. "We were annoyed that the fans were against us, that we were the villains," Fleming says, "and they were cracking jokes back and forth and to the TV."

Newcombe accidentally hit Stolle in the back with a shot. "It would have been a winner if Fred hadn't moved," Newk said. After another point, Newcombe pretended to criticize Stolle's court positioning; Stolle ran around the net and pretended to join his opponents against Newcombe. McEnroe and Fleming didn't play along.

Before the match, the four men had joked about what they were going to "do to each other out there." Stolle hadn't been so sure it was all a joke. "One of them said, 'If a ball floats, Newk's going to get it,'" Stolle remembers. Instead, it was Newcombe who, at the start of the third set, floated a ball into the middle of the court, and it was Stolle who got it. McEnroe drilled the ball straight into his neck, knocking him to the court. "I got really mad at Fred being hit," Newcombe said afterward. "A shot like that could put his eye out."

"I feel sorry for them both," continued Newcombe, who was paid $500 in expense money for winning at Forest Hills in 1967. "In our day, we never forgot it was a sport. They take it over the fringe, 'kill the opponent,' like it's a jungle. That's a load of crap. It seems like now, with so much more money, there ought to be more fun. But there isn't. They're missing all the pleasure in it."

McEnroe and Fleming took very little pleasure from this match. They barely spoke to each other on the sidelines, and as the games went on, McEnroe hung his head and swung his racquet back and forth at his feet. To the delight of the crowd, Newcombe and Stolle extended the top seeds to a fifth-set tiebreaker before finally suc-

cumbing. But you wouldn't have known it by their reactions. Stolle and Newk hugged, smiled, and interviewed each other on court, all to a rousing ovation. Later they basked in the attention and laughter of the press—"it felt like happy hour," one reporter wrote.

McEnroe and Fleming were clench-jawed in their moment of triumph. "Even in victory, men can be humiliated," wrote Thomas Boswell of the *Washington Post* when he saw them.

Hearing of Newcombe's criticism didn't help their moods. "As for us not enjoying the sport," Fleming said, "why can't they understand that it's a different world now?" Why couldn't they understand it was a job now?

McEnroe was even angrier. The Holden Caulfield of tennis had spotted a phony. "I was brought up to be serious on the court," he said. "John Newcombe is the perfect example of someone who will take advantage of everything and use it for himself, whether it's playing to the public or the press. I can't win either way."

He was right. No one sympathized, or took McEnroe's implied point that Newcombe's happy-go-lucky image had also, not coincidentally, made him a lot of money. The one thing McEnroe could never believe was that tennis was an act.

No match would encapsulate the sport's recent history like this improbable doubles semifinal. In the final paragraphs of his article on it for the *Washington Post*, Thomas Boswell summed up the trade-offs that a decade of tennis inside the American empire had forced on its pros:

As McEnroe and Fleming left tonight, the silent crowd gathered before them to get autographs. These men are rich celebrities. Their signatures have a value.

As Newcombe and Stolle left, the fans asked for no autographs from the has-beens. Instead, they applauded.

These men, you see, are heroes. And the smiles on their roguish faces are their signatures.

SUPER SATURDAY

"Human nature is not happy with staying the same. There must be changes."
—BJORN BORG

Had any new cracks developed in the Ice Borg? As much as anything else, that's what the world tuned into the 1981 U.S. Open to find out. If there were, it was hard for the spectators who packed Louis Armstrong Stadium for his early matches to find them. Borg may no longer have been ranked number one, he may have been without his traditional Wimbledon crown, he may even not have cared what happened to him out on the court anymore, but he remained at his metronomic best. Judging by the scores of his first three rounds—6-2, 6-2, 6-0 over Markus Gunthardt; 6-4, 6-4, 6-4 over Larry Stefanki; 6-2, 6-2, 6-2 over Stephen Carter— he was in even more serene control of his opponents than ever. No slow starts had to be weathered; no miraculous comebacks were needed. The whispers of his decline in the lobbies of the players' hotels had quieted, even if the talk of a U.S. Open curse continued in the media. After Borg's opening-round win, the first question he faced was "Do you think you're jinxed at the U.S. Open?" (Borg's answer: "No, I don't think so.") Even those who did believe that the Flushing fates were against him were starting to come around. "Borg Will Overcome the Hex to Net First U.S. Open Crown," predicted the *Daily News*.

While John McEnroe had struggled during the first week, with opponents, microphones, reporters, and fans, Borg reached the tournament's midpoint seemingly unperturbed. By that point, Stan Isaacs of *Newsday* thought he could hear, in the back of his head, a historical inevitability in the making. "Just as it began to feel as if all the histrionics by McEnroe which rocked Wimbledon were meant to set up a tumultuous upset victory by him over Borg," Isaacs wrote, "a small insistent voice here says the same kind of destiny to complete one of the greatest of all tennis sagas decrees that Borg now will win Flushing Meadow in a bust-out final over McEnroe. The voice says: 'History demands it.'"

But the doubters remained. In their eyes, Borg was not so much the Angelic Assassin as a ghost who appeared just long enough to win a tennis match before vanishing again. In an article titled "At Age 25, Can Borg Really Rest on His Laurels?," Mike Lupica joked that "he has become somewhat like your phone bill. Borg shows up about once a month" and he "appears in the U.S. as often as another Mark McCormack client: the Pope."

There was, naturally, an IMG connection to why Borg made so few appearances in the United States: It was one of the rare places where the player and agency couldn't do their work tax-free. As a married alien, 70 percent of Borg's earnings in America were due to the U.S. government, so he played in the country only when it was required, at the Open and at the Masters in Madison Square Garden. In this sense, Borg was once again a pro pioneer. The huge sums of money that had been meant to entice the top players to play more had, beginning with him, allowed them to play much less.

In the case of his opponents, absence didn't appear to make the heart grow fonder, just more awed. Lupica quoted one anonymous player talking about Borg's aura at the time: "He has become a mythic figure, and I think he likes that. A guy gets across the net from him and thinks: 'Oh my God, it's him. It's *Borg.*' You get to play him once a year, maybe."

Lupica also noted that Borg now seemed old for his age, worn by

pressure. "Only in tennis do you grow frown lines worrying about your place in history at the age of 25, but for Borg it's either that or count the money again."

As for Borg, he was giving out even fewer signals than usual about his state of mind. And when he did, he was liable to contradict himself from one sentence to the next. "I feel very eager and fresh," he claimed after his first-round match in 1981. "My biggest ambition now is to win the U.S. Open." Asked in the same interview if he missed playing more tournaments, he said with placid honesty, "I don't miss tournament tennis, no." Asked if he minded being ranked number two behind McEnroe, he said, even more dully, "It's all right with me."

Was Borg rusty, loose, geared up, or resigned? Was he playing better or worse than the previous year? From his opponents to the media to Borg himself, no one had a clue. One day he said, "I'm missing more passing shots than normal." The next day he noted that he was "getting better with every match." On a third day he volunteered that he was developing some "outside interests," though he wouldn't share what they were. "Just a few things I'll keep to myself."

The one thing that Borg repeated after each match, question, and press conference was that he was "feeling no pressure" this time around. But was that really a good sign? As Bud Collins wrote midway through the tournament, "There must be some pressure from the man himself." Or was Borg no longer feeling even that?

The first test of Borg's will came in the quarterfinals, where he faced, as he had the previous two years, Roscoe Tanner. Now, in 1981, Tanner's rocket serves had been flying even faster than normal. That year the U.S. Open, not satisfied that the hard courts suited the best American players, had begun using lighter balls that would help the country's big hitters. To win the title, Borg would probably have to face down three of them, Tanner, Connors, and McEnroe, yet again.

"It makes a good serve like Tanner's and McEnroe's even harder

to return," said Lennart Bergelin, sounding the paranoid note again. "Big servers have an even bigger advantage here than they do at Wimbledon on the grass."

But the balls didn't fly quite fast enough for Tanner. His quarterfinal with Borg was played on another gusty second-week afternoon, and the American later complained that Borg's returns, which floated back high over the net, were twisting in the wind like knuckleballs. Still, Tanner pushed the fourth set to a tiebreaker. There the two players went back and forth until, at 8-7, match point for Borg, the Swede fired a crosscourt backhand winner to seal the victory and a trip to the semifinals.

Borg had cleared a major obstacle, and he had even added a little to his mystique in the process. Serving at 5-5, 15-0 in the fourth set, he hit a backhand that landed well inside the baseline. The linesman put his hands down in the "safe" sign—the ball was good. Borg turned away, but chair umpire Herb Lewis announced "15-all." Borg silently looked at the umpire and then at Tanner. He stood still and waited. Then he began to walk toward Lewis. The audience roared; Borg was going to argue! Unfortunately, no one got to hear what he said. As Larry Brooks of *Newsday* wrote, "The fellow at courtside with the CBS microphone was caught unaware, and was unable to train that infamous electronic eavesdropper on the player. And so the world did not experience the Borg tantrum, which consisted of a quizzical expression and a question. In a matter of moments, Borg returned to the service line. Lewis had an amended score to announce. 'Thirty-love,' he said. The fans loved it."

One American, one lefty, one nemesis, one man who had beaten him at the Open in the past, was down. Now it was on to another. Jimmy Connors, Borg's conqueror at this tournament in 1975, '76, and '78, awaited.

The semifinal between John McEnroe and Vitas Gerulaitis had a little bit of everything. At the same time, as one sideline observer said, "It was hard to watch."

That observer was Tony Palafox. He was McEnroe's coach, but he had worked with both men at Port Washington. "It was hard for me to watch, and hard for them to play."

On Saturday 12, 1981, the tournament drew 18,892 spectators, the most that had ever sat in Louis Armstrong Stadium, or any U.S Open stadium, at one time. They were there for what in future years would come to be known as "Super Saturday." This made-for-CBS blockbuster day, which had been introduced when the tournament moved to Flushing Meadows, began at 11:00 AM with one men's semifinal, progressed to the women's final, and closed under the lights with the second men's semifinal. It was a bonanza for spectators, who, this year, had a chance to see six of the most famous athletes in the world: McEnroe, Gerulaitis, Borg, and Connors, as well as Martina Navratilova and Tracy Austin, who fought each other in a thrilling women's final.

On the other hand, the schedule made life difficult for the winners of the men's semifinals, particularly the second match, which could last late into Saturday evening. After getting a day off in between matches for two weeks, each had to come back to play the final the following afternoon. Of the four Grand Slams, only the U.S. Open required its finalists to make this turnaround. The schedule had been agreed to by the USTA after the costs for building the National Tennis Center had proven higher than expected; television, which ultimately held the purse strings, had its way, even if it came at the expense of the players and the quality of the Open. It's not coincidental that over the years, dramatic, high-quality men's finals at Flushing have been rare.

If Palafox found the first semifinal in 1981 to be stomach churning, many of the other 18,891 people in the stadium thought it would never end. McEnroe versus Gerulaitis lasted an epic 3 hours

and 47 minutes, but on this warm, gusty, extremely bright day, it felt even longer. The American flags at the top of the stadium blew out straight, but the wind swirled in different directions at the bottom of the stadium. Cups flew across the court and were chased by ball kids, and Gerulaitis's blond mane was blown up over his head.

While there were flashes of brilliance from both players, they came at different times. The two men never threw their best at each other at the same moment, the way Borg and McEnroe routinely did. It was not an elegant match; to combat the wind, each man was forced to shorten his stroke and poke at the ball to make sure it didn't get away from him. While the fifth set was intense—McEnroe said afterward that he had gotten "lucky"—it ended in a fizzle of anger and frustration. McEnroe berated himself after missing first serves and threw his racquet at changeovers. Gerulaitis mimicked McEnroe and tried to intimidate line judges. The impatient, pro-Gerulaitis fans screamed at McEnroe, who played at a very deliberate pace throughout, to "hurry up and serve the ball!" When he went into his service motion, they yelled, "Balk!" It was a testy afternoon.

McEnroe seemed more tentative than normal, particularly around the net. This was in part because of the wind, but as Palafox said, this wasn't just any opponent. During the tournament, McEnroe said that he was happy to see Gerulaitis make a comeback and not continue to waste his talent. Now he was charged with ending his old friend's run.

Much as he had with Borg, Gerulaitis had helped McEnroe come out of his shell in his early years as a celebrity. When he still lived in his parents' house on Manor Road, where nights were spent sharing beers and Black Sabbath records with neighborhood cronies, McEnroe would occasionally jump into his orange Pinto with a buddy from Douglaston and follow Gerulaitis's yellow Rolls through Queens. Coming out on the other side, they entered a pulsating, super-size foreign world, the glass canyons of Manhattan and blaring disco at Studio 54 and Xenon. "It felt like a field trip to

us," McEnroe said. In those days, Gerulaitis stayed, as always, in the lead. To the Douglaston kids, he seemed to own every place they went. While they hovered shyly at the edges of the crowd, Gerulaitis was at the center of the room, with women draped over him.

"Vitas was the big brother I never had," McEnroe said of his friendship with Gerulaitis. "He loved to play guitar, and he introduced me to that. He introduced me to just about everything I did. When I look back, I see he had an influence on all parts of my life."

Gerulaitis also introduced McEnroe to New York celebrity culture. He brought him to parties at the East Side duplex of Richard Weisman, an investment banker and art collector, who, in the words of McEnroe, "really collected people." There McEnroe began to move for the first time with the rich and famous, in the intertwining worlds of New York and Hollywood. At first, McEnroe struggled to hold his own. "He doesn't talk," the women there said of him. Even after defeating Gerulaitis in the 1979 U.S. Open final, he needed his "big brother's" help through the door at Studio 54.

Two years later, it was hard to find any signs of friendship, or enjoyment, in their semifinal. McEnroe, appearing skinnier than ever in a tight Sergio Tacchini shirt, prowled the court with a look of heroically sustained petulance. Gerulaitis's usual energy had turned to agitation. At the start of the fourth set, McEnroe fell backward while scrambling for a ball and came up stepping gingerly on his left ankle. He began to walk in circles, touching and fiddling with his left shoe. Finally chair umpire Leon Lipp barked, "Mr. McEnroe, do you want to take an injury timeout?"

McEnroe abruptly readied to play. He was down break point. He rocketed a first serve, charged into the net, and sent a sizzling backhand volley into the opposite corner to bring the game back to deuce. He was no longer walking tentatively, or even checking on his ankle. On the other side of the net, Gerulaitis began to imitate McEnroe's injury walk. After the match, Gerulaitis's compliments were grudging. "He had all the good luck," McEnroe's old buddy said of him. "He guessed right every time."

Gerulaitis had 15 break points over the course of the afternoon, but could convert only two. Time after time, McEnroe, pushed to the brink, generated just enough brilliance—a wide serve, a stab volley, an improbable forehand passing shot an inch out of Gerulaitis's reach—to stay alive. Facing break point late in the fifth set, McEnroe served and stumbled coming to the net. He put his racquet up in desperation and hit the ball into the tape, where it bounced up, bounced again, and dribbled over to Gerulaitis's side.

What finally sank Gerulaitis was another McEnroe specialty: an argument with a chair umpire. Serving at 1-2, 15-0 in the fifth set, Gerulaitis, who had the momentum with him at that point, was distracted by a ball that a fan tossed back onto the court. McEnroe won the point, but Lipp called a let after Gerulaitis complained that the fan's ball had distracted him. Then it was McEnroe's turn to speak up, at length. In the middle of his rant, he spotted a CBS mike in front of him and gave it a quick bash. It was enough to break a string in his racquet, which required a long walk to the other side of the net to get another one.

Finally, McEnroe was ready. While all of his anxiety had been released in the argument, Gerulaitis, bouncing a ball as he waited impatiently at the back of the court, had let his build up. His rhythm was broken, and a few minutes later, McEnroe was ahead 4-1. There was just one more rant to go, and this time it would come from Gerulaitis.

McEnroe served at 5-3, 40-15, double match point. He hit a forehand volley that landed either on or just beyond the sideline. Gerulaitis waited for a call, but none came. "Game, set, and match, McEnroe," Lipp announced, but Gerulaitis wasn't having any of it. He turned around to confront the line judge who'd called the ball good, except that there was no one there. Then he remembered that the call had been made, or not made, by someone standing all the way across the court, on the other side of the net.

If Wimbledon in 1981 was famous for the blinkered pompos-

ity of its officials, the Open was famous for something simpler: not having enough of them. The tournament had reduced the number of line judges it used for each match to five. (Wimbledon used 12.) They were required to rove from line to line during points and to call balls from the other side of the net. The person who called the middle service line would, once the serve had been hit, immediately jump over to call the sideline. Complaints were rampant, from players and press. "We didn't do it to save money," said USTA official Randy Gregson in defense of the system. "Ours is the only sport that uses officials in chairs. If we can get them running around, at least we know they aren't asleep."

Now, as Gerulaitis reluctantly accepted the inevitable and trudged toward the sideline in defeat, he pointed at the line judge at the other end of the court and let out one final protest that was picked up by CBS's microphone and beamed around the world: "It's a foot over the fucking line!"

McEnroe, his victory forgotten in the moment, stood and watched, unsure of what to do, while his friend packed up his stuff and stalked off the court. As a seething Broadway Vitas finally shook McEnroe's hand and disappeared into the tunnel on the other side of the court, Lipp tried to get in the final, sarcastic word: "Goodbye, Mr. Gerulaitis," he called out dismissively. It was too late; Gerulaitis was gone. Even in defeat, Vitas was a step ahead.

McEnroe had, like the champion he was in the process of becoming, found his best when he needed it most. He had released his nervous energy and reached another level of intensity in the process. But as always in New York, the fans hadn't cared. When McEnroe got up from his fall in the fourth set and walked slowly around the court, the crowd had briefly cheered. Asked afterward if they had wanted him to win this time, McEnroe shook his head.

"No," he said, "they just didn't want me to default. They wanted to see me lose fair and square."

Among the many thousands of people sitting through the McEnroe-Gerulaitis semifinal was Jimmy Connors. He had begun the day hanging out with friends in the locker room, joking and feeling good. Once again, he had taken the U.S. Open and grabbed it by the scruff of the neck. A few days earlier, in front of a raucous Labor Day weekend crowd, he reenacted his famous high-wire win over Adriano Panatta in 1978. This time the victim was 20-year-old Andrés Gómez, a wild-haired, free-swinging lefty from Ecuador who would eventually win a French Open title. Connors had taken an injury—he had a cramp in a finger—and milked it for all it was worth. On the sideline, he kept his hand dunked in an ice bucket. He sat there like a boxer, jiggling his left leg, sucking on a Coke, and dousing his head with water until it was time to meet the bell. The audience ate it up.

The match wound through five thrilling sets. Gómez kept aiming for the lines and hitting them, until he found himself serving for the match at 6-5. Just then, a moment in tennis history flashed through his mind. "I was here in the juniors in 1978," Gómez said, "and I watched Jimmy beat Panatta in the same kind of match. It was the only time in my life that I sat through five sets. It was that good."

Connors broke serve. Running off the court between points to ice his cramping hand, he reached match point at 6-5 in the tiebreaker. He tossed to serve, his left hand shaking on his racquet handle, and hit his first and only ace of the match.

Jimbo was alive, in full screaming glory, and so was the Open. But afterward, he knew he had been lucky. "You know," he said later with a laugh, "I'm really in trouble when this finger lets me down," referring to his famous middle digit. The year's worth of training, of jumping rope, had paid off; compared to 1980, his leg muscles were well defined. The morning of his semifinal, he had moved well and seen the ball well in practice.

The last time he had played Bjorn Borg under the lights in Louis

Armstrong Stadium, in 1978, he had done everything but rip the Swede's head off. But he hadn't matched that performance since. In the ensuing years, Connors had struggled to balance career and family life, to take love on the rise. Doug Henderson had watched that struggle firsthand. "With a professional tennis player," Henderson says, "everything is always sacrificed for their career, everything revolves around what's good for their game. When they get married and have kids, suddenly they have to do some sacrificing themselves. That's not easy."

Connors's once intensely focused mind could now be distracted; during matches, he might find it flashing back to an afternoon when his young son, Brett, fell off the couch. But while there had been no big titles up to that point, there had been signs of life from Connors that season. Most prominent was the titanic five-set Wimbledon semifinal two months before with Borg.

Now he would get another shot at the Swede. But when was it going to begin? After the McEnroe-Gerulaitis marathon, the women's final between Navratilova and Austin had also gone the distance, to a third-set tiebreaker. At some point during the afternoon, it was decided that Connors should be taken to an undisclosed location, away from all possible distractions. Only his longtime crony, Las Vegas teaching pro Lornie Kuhle, was there to keep him company. Henderson wondered whether the directive had come "from Belleville"—meaning Gloria Connors herself. Sequestering Connors had been a success three years earlier. To keep him from learning of Borg's infected thumb, which might have changed his mind-set in unpredictable ways, he had been cut off from all outside communication. While Connors somehow still found out about the injury, by the time he got to the court he was like a lion released from his cage.

This time the plan backfired. With the Super Saturday matches dragging on into the early evening, Connors was stuck for hours with nothing to think about but the monumental match ahead. All

of his work hung in the balance. It was enough to drive a man, particularly an athlete as volatile as Connors, over the edge. "Jimmy emerged from behind a closed door," Henderson recalls, "and his skin color was awful, as if someone had drained all the blood from his face. His ghostly complexion and inability to stand still were bad omens. He seemed like a combination of Casper the Friendly Ghost and Don Knotts." Connors wasn't a caged lion; walking onto the court, he looked like a man with the shakes.

Three times Connors had stood between Borg and his quest for the U.S. Open. Twice the Swede's losses had come in finals, under the lights that Borg believed threw off his machinelike timing. The loss to Connors in the 1976 final, on clay, had been the bitterest of his career. Now Jimbo, who had been so close to defeating Borg at Wimbledon that summer, appeared to be gaining momentum through the second week. He hadn't beaten Borg since that Flushing final in '78, but was he destined to shatter Borg's New York dream again?

One shot made the difference. Borg came out under the lights and found that he had no trouble sighting, and hitting, his serve. He finished with 15 aces, and shot down whatever Connors threw at him. The Assassin picked Jimbo apart in straight sets. It was the best he had ever served, and one of the finest matches of his career. Even Connors, never effusive with his praise, bowed to the Borg serve afterward. "It was extra special tonight."

Otherwise, Jimbo was crushed. By the middle of the first set, the edginess he had brought to the court had boiled over. After one point, he began to scream at Ilie Nastase, who was seated in the front row. Afterward, Connors faced the inevitable press questions about his inability to win the big one, about his Grand Slam slump, even about whether he should consider retiring. He met them all with a stony silence.

By his standards, Borg was ecstatic in his own press conference: "I played very well," he said. Two big-serving American lefties,

Tanner and Connors, had been vanquished. One more remained. Was this the year? Borg, for the first time in the tournament, sounded cautiously optimistic. "If I can just serve like that tomorrow," he said, as if he were trying to convince himself that it was possible. "I really hope I can serve like that tomorrow."

REQUIEM FOR
AN ASSASSIN

*"Borg's still a pretty young guy. This thing could turn out to be
pretty interesting. I just don't want him to have a bad half-year
sometime and decide to bag it."*

—JOHN MCENROE, 1980

Head down but quietly pleased, Bjorn Borg walked out of a
breezy Louis Armstrong Stadium a winner in the 1981 U.S.
Open semifinals. He had, at long last, put the wood to Jimmy
Connors, a man he had never previously beaten at the U.S. Open
and who, over the last six years at this tournament, had handed him
three of the most disappointing defeats of his life. But not on this
night. Borg's win had been one of the finest matches of his 10-year
career and, he would later claim, the best he ever served.

Soon after, Borg was informed that a threat had been made on
his life before the match began. Calling into the switchboard at the
Open, an unidentified male voice had said, "I'm going to shoot him
when he walks on court."

In one sense, this was little more than a sign of the times. By
1981, social protest had curdled into an obsession with assassination.
President Reagan and the Pope were shot that year, and John Len-

non was killed the previous December. Death threats were a part of life for all public figures. Borg had been threatened multiple times after appearing in Israeli army gear a few years earlier, and even a New York favorite like Jimmy Connors had received threats in the city. "It casts a weird feeling over everything when you're out in public," Connors's friend Doug Henderson says. "Even if you don't believe it's real, you feel different when you're in front of people."

Mary Carillo, who was working as a press liaison for the USTA at the Open in 1981, has a slightly more skeptical view. "If you're really going to shoot someone," she asks, "why would you call in and tell everyone about it first?"

Even without the specter of would-be assassins in the stands, the men's final at the U.S. Open is a moment of high tension. The 4:00 PM start time is widely ridiculed as one more sop by the tournament to CBS; the network typically airs a 1:00 football game that day, and tennis follows. The players never know exactly when they'll have to be ready, because the match can't begin until the football game's final whistle has been blown. But the schedule has an underappreciated upside. The long wait through the day, the massive, mingling audience in the stadium, and the orange sun that has just begun its afternoon descent all combine to create a shootout-at-dusk atmosphere. On the grass inside the theater of Centre Court at Wimbledon, tennis players could be actors on a stage. The performances of each are duly appreciated. On the cement at Flushing Meadows, they're in tennis's version of a rumble. As day turns to night and the lights go on, the drama turns to spectacle.

The Wimbledon final begins with a traditional walk from the locker room and into a cramped waiting area, tennis's green room, where the players sit virtually knee to knee in uncomfortable silence—"you can almost smell your opponent," Ilie Nastase has said. They're assigned this position in co-purgatory so that the denizens

of the Royal Box, once they've finished luncheon and are settled in their seats, won't be forced to wait long for the players to arrive on court. The occasion has its solemn majesty, as it had when Borg and McEnroe first met there as number one and number two the year before.

Now, 14 months later, the same two players prepared to take the court against each other at Flushing Meadows. The scene this time could hardly have been called majestic. Borg and McEnroe made their way down the tunnel to the court with stony faces and shoulders stiffly squared. The Swede toted his customary pile of Donnay racquets; McEnroe had turned up the collar of his red-white-and-blue Davis Cup jacket in the preppy style of the day. Unlike at Wimbledon, they didn't walk alone. In New York a buzzing circle of security guards, friends, relatives, and hangers-on surrounded the two celebrities. Running interference for McEnroe was his younger brother Mark, who, according to Jane Gross of the *New York Times*, looked "like a punk star's bodyguard in a turquoise T-shirt and dark glasses." As the players reached the court, very few in the record audience of close to 20,000 were even close to settled. Rather than greeting the actors in this drama with a round of applause, as is the custom on Centre Court, the fans at Flushing stood, drank, chatted, and climbed over each other to get to their seats while Borg and McEnroe went through their pre-match rituals.

One of those fans was Mariana Borg. As her husband briskly tapped the strings of his racquets together, she nervously took a piece of gum out of her mouth and replaced it with a cigarette. On this evening her blond hair was hidden under a hat. Next to her, as always, sat Lennart Bergelin. His manner was more tentative and subdued than it once had been. One row in front of them were Kay and John McEnroe Sr. The four supporters had become the extended first family of tennis over the past year, and they were gathered in uncomfortable proximity once again. "They were as used to one another's company," Gross wrote, "as Borg and McEn-

roe were used to each other's game, yet the tension appeared not to have diminished with time."

The players had begun to feel that tension in the last year. They had been friends, they had partied together on the exhibition circuit, and Borg had helped a young McEnroe find his way on tour when few others wanted to accept the new hothead. As the '81 Open approached, though, McEnroe said of his relationship with Borg, "We're not close. We used to be closer, but that's what happens when a thing like this gets big." There was room for only one number one, one Wimbledon champion, one U.S. Open champion. Until this moment, they had split those honors between them.

As he had at the start of their Wimbledon final the year before, McEnroe opened the match by lining his light-blue Nikes up along the baseline and winding his way through his now familiar herky-jerky service motion. The audience went silent while 87 photographers, who were fighting for prime positions along both sidelines, trained their cameras on McEnroe as he arched his back and sent his first service toss skyward.

The tournament's early money had been on McEnroe to win the title, but after Borg's serving renaissance the previous evening, the match was now generally considered a toss-up. Victory for McEnroe would cement his number one status and establish his dominance over Borg. But it would also mean something more: The kid from down the road would become the first player to win his national championship three straight times since Bill Tilden did it in the 1920s. Having his name mentioned in the same sentence as Tilden's was something the 22-year-old McEnroe couldn't begin to contemplate. Before the tournament, when a reporter asked him about the prospect of tying Tilden's feat, he put his hand up and cut the question off. "I don't even want to hear about it," he said.

McEnroe, like the college kid he once was—he would have graduated from Stanford in May of '81—slept late at his parents' house the morning of the final. But as comfortable as he was in that familiar setting, playing in Queens presented its own set of challenges.

"He put pressure on himself to win here," Peter Fleming says. "More stuff happens when you're at home. You have to deal with all the things you can leave behind on the road. Family, friends, people asking for tickets. You can't just go up into your hotel room and forget it."

Still, nothing during this period could sink McEnroe's buoyant burgeoning ambition. The artist in him had always striven for perfection as much as victory, and the past year, with its triumphs over Borg and his own worst self at Wimbledon, had finally brought him within touching distance of the perfect match, the one whose pursuit had driven him to so much frustration. The tennis court continued to be his refuge and his canvas.

"Sometimes I'm out there and I get this feeling there that I'm just starting to touch the game," McEnroe said in the summer of 1981, with more than a touch of his musical hero, Bruce Springsteen, echoing through his words. "There's so much more to bring out and test, I've never played even close to a perfect match, one in which I've felt OK, I'm at the limit. That's what makes you want to go out there and put it all on the line, to risk everything and take all the consequences, just 'cause it's worth finding." There may have been more pressure, but the upside of reaching number one was that you could get away with a little self-mythologizing.

Whatever hassles he had endured over the two weeks, at home or on the court, and whatever hopes for artistic perfection he harbored, by 4:00 PM on Sunday, McEnroe was bristling with a fierce, street-walking, rock star energy. He sported a sleek glow of health that would be rare over the course of his career. The hours in the sun had lightened his curly hair and even given the pasty American a tan. A gold chain, something typically associated with the vulgarly

aggressive Connors, glinted from his neck. The look of petulant annoyance that he had carried through five sets with Gerulaitis the day before had vanished. John McEnroe was back where he wanted to be, in the only place where he could find peace and satisfaction. In his mind, he was on the tennis mountaintop, with the only guy who deserved to be there with him.

At 4:10 PM, with the orange sun shining above his right shoulder, McEnroe lifted his right arm high and held it there with elegant nonchalance. The ball reached the peak of its toss. As it did, he snapped the left side of his body upward and sent a skidding ace past Borg's forehand side. The audience close to the court clapped politely but tepidly. Someone high in the stands bellowed, "That's it, Johnny!"

The audience that had roared for Jimmy Connors's comeback the week before had a punchy, populist energy. For the premium-ticket final a week later, the style had turned distinctly upper crust. That afternoon the New York Jets played the second game of their season at Shea Stadium, just across the subway tracks from the National Tennis Center. In the Shea parking lot, bare-chested Jets faithful spent the day drinking beer, grilling hamburgers, and heckling the sweater-over-the-shoulders Manhattan tennis fans who were slumming it in the boroughs. "The tennis elite came out of rented limousines," reported the *New York Times*, "and lunched on crabmeat-stuffed croissants and imported mineral water." While heavy metal blared in the Shea lot, a Dixieland band played outside Armstrong Stadium. Autograph hounds milled around, waiting for the players. A few teenage girls sported T-shirts that read, "I'm for Borg. Nobody Does It Better." They snickered as McEnroe walked past them. As aggressively as tennis had remade itself for the masses, it would never cross that subway track in Queens.

Whatever they thought of the credibility of the death threat against Borg, the New York City Police Department wasn't leaving anything to chance. Six plainclothes officers were stationed at various spots in the stands. "They had a sniper up on the roof," says

photographer Russ Adams. Before the match, another photographer said to Adams that he was heading up to the top of the stadium to take some atmosphere photos. "I told him, 'Don't even think about it. If you pop your head up there, you'll get it shot off.'" Borg himself came into the match under police guard.

Tension flooded the stadium from top to bottom, and the wind whipped from the south end of the court toward the north. In the CBS commentary booth, former U.S National champion Tony Trabert noted that the strong gusts would give the players an opportunity to lob from that end of the court. But Borg appeared to be oblivious to his surroundings at the start. As he had prayed, he was serving as well as he had against Connors and dictating points by hitting heavy forehands to McEnroe's backhand. The rallies lasted longer on Flushing's true-bouncing hard courts than they did at Wimbledon, a fact that favored the steadier Borg.

"We knew that Bjorn liked to hit to John's backhand," Tony Palafox says, "so we worked on that beforehand. John hit backhands from everywhere. We wanted him not to have any weaknesses, to be able to execute every shot from every part of the court."

It was the Angelic Assassin who was executing early. Up a break at 4–3, he was relaxed enough to hit a backhand pass as if he felt no extra pressure on the shot at all. Like another icy athlete of the era, Joe Montana, Borg could reproduce the form he had honed in practice whatever the situation; his mind never seemed to get in the way of his muscle memory. The shot gave Borg a 5–3 lead, and McEnroe's anger flashed for the first time. "Shut up!" he yelled at a woman in the stands. It didn't help. He immediately went down 0–40; triple set point. Borg dug in. His Diadoras loudly scraped the court, and his feet danced faster than ever. He was going in for the kill.

The problem was that Borg was trying to launch his attack from farther away than ever. For this match, he had backed up as much as possible to return McEnroe's serve. The CBS cameras couldn't even keep him in the picture with their normal back-of-the-court shot. They had to go to a lower angle to find him at times.

"Borg sometimes had trouble getting his returns down on this court," Palafox says of the bouncy DecoTurf II at Flushing. "When he played so far back, that gave John confidence that he could control the court and helped him relax on his serve."

Just as he had the day before against Gerulaitis, McEnroe bent but didn't break. Adversity was now second nature. He slowed down, gathered himself, blocked out his surroundings, and served his way out of the game. He had his first jolt of confidence.

When Borg served out the first set, it was the audience that was jolted with excitement. Johnny Carson and Henry Kissinger sat up and raised their hands in applause. If anything, the support for Borg only made McEnroe calmer to start the second set, just as his underdog status the year before had helped him through the fifth. There was a part of McEnroe that reveled in beating the master of the Houdini act at his own game. Two months before, when he won Wimbledon after dropping the first set to the Swede, McEnroe said that he "wanted to prove that it wasn't just Borg who could come back."

This comeback began with a lucky shot. Borg, as Palafox had known he would, approached the net to McEnroe's backhand. McEnroe hit a ball off the frame that sailed over Borg's head and dropped inside the baseline for a winner. From there, the Swede's serve began to falter. It wasn't bailing him out the way it had against Connors. McEnroe broke by moving around a Borg second serve and knifing a forehand up the line for a winning return. It was an ambush right out of the Assassin's handbook, and a vintage piece of magical McEnroe unorthodoxy. Standing straight up and down, he backpedaled around the ball, stuck his racquet straight out from his left side, leaned in and poked the ball with maximum simplicity to a spot where his opponent could never get it. He was up 2-0.

From there, McEnroe's grunts grew louder as his serve got better. Borg's shots began to float, inexplicably, over the baseline and past the sidelines. The Swede looked worn. There were lines around his eyes. He swung wildly, without purpose, as the second set went

on. The CBS commentators noted that he wasn't his usual oppor-
tunistic self. "McEnroe's right on top of the net," Trabert declared,
"Borg should send up a lob there." None came.

"It seemed like he let up," McEnroe said. "He got careless after
the first set. I don't think he was sure what he wanted to do. He was
coming in, but he wasn't sure if he should or not." McEnroe's work
with Palafox on his backhand was paying off. The holes in his game
were closing up. There was nowhere for the Swede to go.

In the stands, Mariana Borg continued to chew gum and drag
on one cigarette after another. At Wimbledon, she and Bergelin
had leaned forward in the players' box as far as they could; they
looked like they were going to jump onto the court at any moment.
Now they sat back in their chairs, with their legs crossed in front of
them. They appeared more resigned than anxious. McEnroe ended
the set emphatically, with another surprise forehand return winner
down the line. If he had learned one thing from Borg, it was when
to strike.

"Stinky, stinky," McEnroe said quietly as he walked back to the
baseline after missing a first serve early in the third set. But that was
as much of his famous irritability as he would show all afternoon.
He had a confident strut now. The crowd had been neutralized. But
McEnroe knew better than to ease up. "When he lets up, I have a
tendency to do so, too," he said before the tournament began, put-
ting his finger on a phenomenon that had helped prolong both of
their five-set finals in 1980 and turn them into classics. "I have to
learn to deal with that."

"Borg kind of lulls you to sleep," John Newcombe said in the
CBS booth, "and then suddenly he's playing well again."

Borg sprang his own ambush at 2-2, when he broke McEnroe
with a backhand pass that woke the crowd up. At 3-2, the quality of

the match reached its peak as the two traded ground-stroke blows and ran each other through a series of long, highly varied rallies. The pace had quickened. When Borg finally held serve for 4–2, the crowd again erupted. The sun was setting, and the rivals were throwing off sparks. They appeared ready to lift each other skyward one more time.

McEnroe held serve for 4–3. Borg began his service game by approaching the net, again to McEnroe's backhand side. McEnroe bent slightly at the waist, took an even shorter backswing than normal, and snapped the ball crosscourt, past a startled Borg. The shot sounded like a gun crack. It was the hardest hit ball of the match thus far, and it briefly silenced the stadium. Newcombe was as startled as Borg. "It looks so easy, doesn't it?" Newk asked in awe.

McEnroe's assault continued. Borg approached the net again on the next point, but this time he stayed away from the backhand. McEnroe took a big cut at a forehand and missed the pass by inches.

"Suddenly I felt like I could hit, or attempt, any shot I wanted," McEnroe said. "I was going for it."

"That's when it came together for him," Palafox says. "John showed everything he could do, everything he did all the time in practice and when he was a kid. We wanted him to be able to hit the ball anywhere, that would be his advantage—and he did."

"I learned watching Jimmy [play Borg the night before]," McEnroe said. "I had to mix it up. If you hit hard at Borg, it comes back even harder."

McEnroe had trumped Borg's consistency with the totality of his game. In the process, he had revived several traditional aspects of the sport—the slice, the volley, the chip and charge, touch shots around the net—that had seemed close to extinction during the Open era.

But there was one shot that McEnroe and Palafox hadn't used to much effect in his previous matches with Borg: the lob.

"When Bjorn comes in," McEnroe said after the match, "he

stands close to the net, and if you hit the lob right, there's a good chance you'll get the point."

At 15-15, Borg approached the net to McEnroe's forehand. This time, rather than try to drill the ball past or through him, the way Borg's previous opponents, Tanner and Connors, invariably had, McEnroe slowed his swing in the Palafox style and lofted a delicate forehand topspin lob over Borg's head. It landed well inside the baseline, but it so surprised the Swede that he didn't bother trying to track it down. By the time it landed, Borg already had his head down and was putting his hand in his pocket to retrieve the ball for the next serve.

"It broke him," Palafox said.

If that was the point that cracked the Ice Borg, the next two would shatter him into a million pieces. At 15-30, stubborn to the end, Borg came to the net again, this time returning to McEnroe's backhand side. McEnroe was ready again with another stinging back-hand crosscourt pass that was as perfectly struck as the last—15-40.

Borg was one point from giving back the service break that had pumped so much life into the afternoon, and seemingly into him. A rally began. McEnroe hit short and softly. Borg, for the fifth time in the game, moved into the net. McEnroe scrambled across the baseline, jumped, and whipped his racquet straight upward so that his forehand swing finished behind his head. The ball soared high, higher than his previous lob. The ball dropped like a stone in the far corner of the court and Borg watched in futility as it kicked away from him.

The jump, the whip, the arc, the landing, the placement, the moment—McEnroe's second lob was a glorious capstone to one of the most spectacular games ever played in an important match. It was a game that had begun 14 months earlier at Wimbledon, when he had broken Borg's serve to stay in the final with four similarly brilliant shots. Those points had shown McEnroe that he belonged in the same conversation with Borg. This game elevated him above his rival for good. He had touched a part of the sport that had previously been out of his reach, or anyone else's.

Kay and John McEnroe Sr. were sitting in the front row, a few feet from where their son's lob landed. As the ball fell out of the sky, they leaned forward and put their arms over the railing in front of them. Mom shook her head in disbelief. Dad just nodded.

"That's when he showed everything he had," McEnroe Sr. says. "I don't think anyone had seen a game like that before. It was the best game he ever played. Bjorn never recovered."

As the second lob in that fateful eighth game touched down, Borg's shoulders visibly slumped. It didn't appear that he even raised his head to see where it landed. By the next game, he was flailing. He dumped easy returns of second serves into the net and walked disconsolately to the sideline, down 4–5 and nearly out of the match. The next game went to deuce, but McEnroe came up with another masterpiece when he needed it. With an unpredictable mix of pace and finesse, he maneuvered Borg from one part of the court to another before cracking a backhand winner. It was insult to injury. He was beating the Swede at his own baseline game.

"He did everything in that point," Newcombe said. "Chops, slices, balls hit long, balls hit short. That's a clinic in how to construct a rally." McEnroe broke to win the third set 6–4. The crowd was silent. They must have felt like witnesses at an execution.

The end may have seemed inevitable, but the way it happened was stunning. McEnroe hit yet another brilliant pass to go up 3–1 in the fourth set, but Borg rallied to break back for 3–2. CBS's Pat Summerall, hoping against hope, wondered, "Does Houdini in a headband have one more great escape in him?"

Instead, Borg played a game that was as shockingly bad as McEnroe's eighth game of the third set had been impossibly good. He pushed two easy backhands over the baseline to make the score 15–40.

"He's failing where he's usually rock solid," a disbelieving Newcombe said.

On the next point, McEnroe moved Borg forward with a short, low slice. Borg ran toward the net, took his usual backhand swing,

and sent the ball over the baseline for a third time. He put his head down and walked back to the baseline as he had countless times before. But for the first time in a decade, what happened on the next point didn't matter.

"That was the crisis moment," Thomas Boswell wrote in the *Washington Post*, "when, for the last five years, Borg would probably have held service to draw even, and then finally pull away. Instead, Borg broke himself. His margin of error for beating McEnroe had finally become too minuscule to endure. The demand for continuously flawless, deep ground strokes was too great."

Ten minutes later, McEnroe served at 5-3, 40-15, double championship point. He missed his first serve. The audience, fighting him until the bitter end, cheered wildly. Sometimes when this happened to him, and it did wherever he played, McEnroe would stop and clap along sarcastically. This time he wasn't stopping for anything. Like Borg when he had first reached match point at Wimbledon in the fourth set in 1980, McEnroe was working quickly.

He sped through his delivery and sent a second serve down the middle. Borg, who was still returning serve from somewhere near LaGuardia Airport, reached up to hit an uncomfortable backhand. He floated a slow, sluggish, knuckling return down the middle of the court. McEnroe could have swatted it away with ease, but he chose to let it fly. It kept floating through the New York dusk—this match hadn't gone on long enough or been dramatic enough to be worthy of the Louis Armstrong lights. The ball finally floated, softly, harmlessly, over the baseline.

In victory, McEnroe didn't drop to his knees, as Borg did. He didn't lean back and drink in the moment of triumph, the way he had at Wimbledon. This time he punched the air, and in one rapid motion turned toward the net to shake Borg's hand. There was little triumph in the air for him to drink in. Instead, the afternoon smelled of failure, Borg's failure yet again to win the U.S. Open. The Swede had been gutted in the process, and McEnroe and everyone in the stadium could see it.

"At the end," Fleming says, "we were like, 'Hey, great. Junior's gonna win this thing!' But when it was over, and you saw Borg, it was a little deflating. He had lost heart in the fourth set. His heart was broken; you could see it clearly. I'm sure John could sense it."

After his brief celebration, McEnroe kept moving. With a look of grim determination rather than anything approaching joy, he walked quickly toward the net and put his hand toward a shell-shocked Borg. At Wimbledon the previous year, the two had stood close during the handshake and exchanged congratulations. There were no words this time. They shook hands from a distance, their arms extended in front of them as far as possible. McEnroe, after briefly meeting Borg's eyes, looked to the ground and moved off toward the sideline in a hurry.

It had all come too easily. There was no drama in the end. A Borg-McEnroe match could never be this routine. It hadn't even lasted as long as the women's final between Tracy Austin and Martina Navratilova the previous day. McEnroe wasn't sure how to react, after his rival had refused to fight. "I didn't know what to do, exactly," he said afterward. "I think, I guess, I was a little confused."

McEnroe could always read Borg's expression in their Grand Slam finals. At Wimbledon in 1980, he could see that the Swede, even after the devastation of the fourth-set tiebreaker, was "always there, always there; he never went away." When McEnroe defeated him the following year on Centre Court, he saw relief in the smirk that Borg gave him as they shook hands. It seemed to hold a message: now you'll see what it's like.

This time, at the 1981 Open, "it looked like he'd quit," McEnroe said.

The new three-time champion, conqueror of Borg, and undisputed number one kept walking quickly, past the umpire and toward his chair on the sideline. McEnroe hadn't lost his rock star strut. Even now that the match was over, his body was still wired for the battle. He got to his chair and put his racquet down. He stood still. ATP trainer Bill Norris, standing next to him, put out

his hand. McEnroe, without meeting his eye, gave it a perfunctory shake. He was on the sideline inside Louis Armstrong Stadium, but he was also on the mountaintop alone. What was he supposed to do now?

Five minutes later, a stage had been dragged onto the court, and most of the audience had exited in grumbling disappointment. It was time for the trophy ceremony, something that the Open, as one tennis official put it, "always makes a hash of." The presentation at the All England Club is a model of restrained pageantry. At that time, the players didn't make speeches. (Now, following American TV's lead, they do.) Any mention of prize money is considered bad form. Every action is strictly choreographed. By comparison, the Open's ceremony is a slapdash, commercialized, made-for-TV production.

Today, CBS commentators present the trophies. In 1981, green-jacketed, white-haired USTA officials—Old Goats who had gotten into the game in the amateur days—still had that honor. The ceremony began with a brief announcement saying, essentially, that Bjorn Borg had left the building. "We are sorry that he is unable to be here to accept his award." There was silence, then a loud burst of boos, perhaps the first the Swede had ever received.

An unsmiling McEnroe was handed the winner's trophy by a USTA official. He kissed it uncomfortably for the cameras. The applause was muted. He was then handed a sweater. The champion leaned away from it as if it were infested with something.

The official continued to ramble, until McEnroe walked up behind him and swept his hands across his body in a gesture that said, "Get this old man outta here!"

Finally, McEnroe was handed the mike. "I want to thank all my friends who came out here," he said with a sarcastic smile while

gazing around at the ragged remains of the audience that had rooted so vociferously for him to lose.

"I want to single out my coach, Tony Palafox. If it wasn't for him, I wouldn't be here. I wouldn't have won three straight U.S. Opens." (Thirty years later, Palafox could quote McEnroe's tribute word for word.) But that was as fulsome as he would get. "And also thanks to my parents and all that stuff," McEnroe said with a dismissive wave and a scornful laugh. Even on the victory stand, he couldn't bring himself to play the prescribed role of the gracious winner. It would have been phony.

McEnroe had one more person to acknowledge. He stepped back and said, with honesty in his voice again, "I want to join in commiseration for Bjorn, because he's a great champion. Hopefully someday he's going to win this damn tournament, but hopefully not as long as I'm around."

Borg was very much not around. "I just couldn't stand up in front of those people again and make a nice speech," he said later. "I guess I was a bad boy." When disaster struck, he had been unable to meet it.

Instead, he had briefly waved his racquet at the chair umpire, picked up his stack of Donnays, and started walking. The six policemen, walkie-talkies in hand, surrounded him as he entered a darkened tunnel. There the phalanx was joined by Bergelin. The men made their way out of the stadium and across a small plaza, where fans were stunned at the sight of Borg walking away with the police. The group went up a set of stairs and into the players' locker room. Behind them, in the tunnel off the court, a green-jacketed USTA official gestured frantically. "Where did he go?" he asked.

Borg showered as McEnroe made his speech. Four of the policemen guarded the locker room door. One of them yelled, "Bring the car around." From there, Borg was surrounded again as he headed down a set of back stairs. His hair still wet, he was led through a

kitchen—he paused for a moment to warn Bergelin not to slip on one of the greasy puddles on the floor. Outside, while being chased by reporters, he was escorted at top speed toward a waiting car.

"Are you leaving because of the death threat or because you lost?" a journalist yelled. Borg didn't answer, or acknowledge that he had even heard the question. Bergelin, who was hurrying with Mariana to keep up, mumbled that everything would "be all right."

Borg laid his racquets in the backseat. This time, rather than letting Bergelin drive, as he had for so long at Wimbledon, Borg grabbed the wheel himself; there would be no more need for superstition. Flashbulbs popped in his face as he started the car. His damp, stringy hair was pulled over his left ear. He stared straight ahead, seemingly a thousand miles into the distance. Just before he hit the accelerator, a tiny, inscrutable smirk appeared on his lips. Then the car roared off into the night. There would be no more comebacks for Bjorn Borg. He would never play another Grand Slam match.

With the story of Borg's exit making front pages around the world, there was a consensus among sportswriters the next day that the rivalry that had seemed destined to last for years, as well as the golden era of tennis that inspired it, was in fact over:

"Super Mac Batters Borg"
"McEnroe Ends Fabled Rivalry"
"The Iceman Goeth as the Curtain Drops on a Sporting Era"
"Borg: Prisoner of Queens"
"Now Only McEnroe Stands on Top"
"Did an Era End at Flushing Meadows?"

Gene Scott, in *Tennis Week*, articulated one version of why McEnroe had triumphed. "Like a knife fight," he wrote of the

match, "it was full of confrontation and short, deadly strokes. A street brawl is ragged and wild and there is no place to hide. McEnroe won because he is a superior fighter. He likes the clinches, the brawl of it all. Borg, on the other hand, had no appetite for the gore of this particular battle. If there's a chain fight on my block, I would want Johnny Mac on my side."

Another, much older tennis writer also sang McEnroe's praises, but in very different terms. Like Frank Deford at Wimbledon the year before, Allison Danzig sat in the southeast corner of Louis Armstrong Stadium and kept a close eye on the winner. Danzig, sports correspondent for the *New York Times* from the 1920s to 1968 (his career ended with the amateur era) had watched every tennis champion of the century, and he saw various bits and pieces of the greatest of them brought back to life and unified in the singular figure of John McEnroe. "There has never been a player like him," Danzig said when it was over. "Tilden was an artist but didn't attack like McEnroe. Henri Cochet, the Frenchman who ended Tilden's run, had gorgeous touch much like McEnroe's, but not the wonderful serve."

All of those players did have one thing in common: They created their artistry with wooden racquets. In the future, the distinction between the amateur and professional games may fade, and historians may talk of a greater span of time: the wood-racquet era. In the U.S., it lasted for exactly 100 years, from the first U.S. Nationals, in 1881, to the 1981 U.S. Open, when John McEnroe became the last man to win the tournament with a wood racquet. There couldn't have been a more fitting winner: McEnroe was the apotheosis of the wood era. He played the serve and volley game that had been its dominant style and added his own patina of genius to it. And he finished the 1981 Open by showcasing that genius as he never had before.

While Borg made his escape, McEnroe walked through Louis Armstrong Stadium and into the USTA's most exclusive haunt, a lounge called Slew's Place. This was the province of former USTA president and Flushing Meadows master builder Slew Hester. Like Hester, McEnroe had just presented the tennis fans of New York with a little beauty and had received ashes in return. The two men, who stood at the top of the American tennis empire, drank a toast to each other. Hester took his stogie out of his mouth, congratulated McEnroe, and told him how much, whatever anyone else thought, the old guard organization appreciated the young punk. McEnroe smiled and thanked Hester for building him a great court.

As McEnroe and Hester enjoyed their moment of triumph, Bjorn Borg was tearing across Long Island, heading east on the Grand Central Parkway. Borg drove past Douglaston; past the Gerulaitises' compound in King's Point; past the Port Washington Academy, where his nemesis had learned to play tennis so well; and out of the American empire. He walked into his "castle by the water" in Sands Point, put on his bathing suit, and jumped in his pool. Popping his head above water, he looked up. The clear night sky seemed to go on forever.

Bjorn Borg swept his long hair out of his eyes and thought, for the first time in his life: "I'm free."

EPILOGUE

T his is new," Bill Scanlon thought as he walked to the net before a packed house at the Cow Palace in San Francisco in late September 1981. Waiting for him there was John McEnroe, the man who two weeks earlier had won his third consecutive U.S. Open. Scanlon and McEnroe were rivals who had never made a secret of their mutual disdain. Scanlon was the far less accomplished player, but he typically rose to the occasion against McEnroe. He had beaten Mac once, and two other times held match points before losing. Scanlon was putting up a good fight again on this night. The match was in a third set and he was up a break. It was as much as McEnroe could take.

He and Scanlon had had their arguments before, but now McEnroe was taking it a step further. He had stopped in the middle of his service motion and walked forward to address his opponent directly. The audience, aware of the players' history, grew silent. Was a brawl about to ensue? Instead, they listened, along with Scanlon, as McEnroe patiently and logically lectured him on exactly why he shouldn't be winning.

"Don't you know who I am?" McEnroe asked, according to Scanlon. "You don't deserve to be on the same court with me. Do you think these people in the crowd really want to see you tomorrow instead of me?"

The fans, however, would have no choice. Scanlon, once the impromptu lecture had concluded, walked back to the baseline and went on to win the match.

Four weeks later Scanlon and McEnroe met again, in Tokyo. This time McEnroe was determined to teach him a lesson. Late in the first set, Scanlon, as he often did when playing McEnroe, began to speak in hushed tones to the chair umpire about how best to handle the temperamental star's antics and stalling tactics. When Scanlon was finished, McEnroe yelled across the net, "You're lower than dirt!" Scanlon scurried back to the umpire, who issued a warning to McEnroe for "abuse of an opponent."

This time it was Scanlon who was unnerved. He double-faulted at key moments, and McEnroe won in straight sets. After the final point, McEnroe marched straight to the sideline, picked up his gear, and walked off the court. Scanlon was left standing at the net by himself, holding his hand out. The Japanese crowd gave him a standing ovation. Being number one was doing funny things to John McEnroe.

"I hadn't realized what it entailed," he would later say, looking back on that season. "It was far more than I'd expected. The weight of everyone's expectations felt huge."

The various threads of McEnroe's 1981, the triumphant and the disastrous, the past and the future, were tied together in a series of events at year's end.

In early October, McEnroe traveled with the U.S. Davis Cup team, including his doubles partner Peter Fleming, to Portland, Oregon, for a semifinal tie against Australia. The team event was one of the few in the sport that was still the property of the old amateur federations. The formal obligations that went with it—the

dinners and cocktails and various outdated ceremonies—always put the young pros, who were used to doing their own thing on their own time, on edge. "It was the most stressful time of our career," Fleming says. "All that outside stuff, the dinners and crap, really put a strain on us."

Trouble came, as it often did, in the doubles. Against the Aussies, McEnroe and Fleming got into a five-minute screaming fight with an official. The Americans won the match, but even their captain, Arthur Ashe, called their behavior "disgraceful."

"It was pretty strained with Arthur, too," Fleming says of their relationship with the game's dignified elder statesman. "He would say, 'You need to do this,' and our reaction was automatically, 'Fuck that. I'm not going to do that.'"

In December, in the season's final event, the U.S. team went to Cincinnati to play the Davis Cup final. Their opponent was Argentina, the team that had eliminated America the previous year in a raucous match in Buenos Aires. This time McEnroe played brilliantly in leading the United States to a messy and dramatic 3-2 victory. It was one of the most contentious weekends the sport had ever seen. "Bad calls, bad blood, bad behavior" was how McEnroe later described what should have been a glorious season-capping achievement. "Everything that could happen in a tennis match did happen."

Ashe was barely speaking to his players, while the two Argentine stars and doubles partners, Guillermo Vilas and José Luis Clerc, were barely speaking to each other. On one heated changeover, Clerc said to McEnroe, in an effeminate voice, "You're so nice, John." McEnroe threw his racquet down and confronted Clerc. Even the court surface fell apart during the doubles and had to be repaired. McEnroe went through the weekend complaining about everything and fighting with everyone, but in the end he won the fifth and deciding match in five sets over Clerc. A season of unprecedented brilliance ended with one final ace and a leap of joy.

McEnroe jumped the net, hugged all of his teammates, and gave Ashe an enthusiastic embrace. In that moment at least, all was forgiven between the tennis generations, between the amateur and pro eras. McEnroe was part of a scene that could have come out of the Harry Hopman days of old.

———————

At the same time, the first flickers of a new and surprising dawn in McEnroe's career were showing. He couldn't foresee it then, but that fall, his first great rival was exiting the tennis stage at the same time as his next one was stepping onto it.

As the year ended, McEnroe, Gerulaitis, and Borg went on an exhibition tour of Australia. The three friends were lounging and drinking a beer together before a press conference when Borg, out of the blue, said, "I'm quitting tennis." McEnroe and Gerulaitis were blindsided. They told him he couldn't be serious. He was young, just 25; they were all young. What was he going to do?

"I told Bjorn, 'Tennis is all we know,' McEnroe said. Borg shook his head and said that the decision was final. Then he walked into the press conference and informed reporters, without missing a beat, of how much he was looking forward to the 1982 season.

Meanwhile, that same fall, Ivan Lendl began a 44-match winning streak. As 1981 wound down, McEnroe and Lendl played an exhibition in Milan. McEnroe won the first set. In the second, Lendl got a couple of bad calls; his shoulders slumped and he appeared ready to call it a night. McEnroe wasn't having any of it. At the next changeover, he told the Czech he was "acting like a pussy." An angered Lendl came back to win the match. Years later, McEnroe wondered if he hadn't sparked a competitive edge in Lendl that night, one that would alter the course of both of their careers.

It wasn't only Lendl who was stalking the new number one.

Jimmy Connors vowed again that whether it killed him or not, he was going to win another major. He had put in the work in 1981, and he hadn't lost his bedrock sense of belief, even as Wimbledon and the Open came and went, and he came and went titleless. As Connors was leaving Flushing Meadows in 1981, a reporter had asked whether he was "haunted" by the man who had just beaten him for the 10th straight time, Bjorn Borg. "What is he, a ghost?" Connors, forever defiant, had shot back.

By November, though, when Connors made his way to London to play in a tournament at Wembley Arena, the specters of Borg and McEnroe, who had taken his place atop the rankings, were indeed beginning to haunt him. It was increasingly difficult to argue with the consensus that they had passed Jimbo for good.

But Connors was sharp at Wembley, and he went into the final against McEnroe with all of his old eagerness. To the surprise of no one, the match quickly turned into a circus. McEnroe, despite taunts from the crowd and an umpire who was bent on ruling against him, won the first two sets easily. Then chaos slowly took hold. McEnroe fired a ball into the ceiling. Connors climbed into the stands during a long McEnroe dispute. The two met at the net to have it out. "It was the most incredible spectacle I've ever seen," Doug Henderson says.

It would be one of the few times when McEnroe couldn't summon the energy to fight off a hostile crowd. He lost the last three sets to Connors. Again, tennis was front-page news. The match was widely decried as a betrayal of all sporting ideals.

That's not how the winner saw it. Hours after the spectacle had concluded, Connors sat in the back of a Rolls-Royce as it coasted to his London hotel and said, with a quiet honesty that he rarely showed in public, "I was starting to doubt whether I could win those types of matches anymore."

There was about to be a new New Jimmy Connors.

After their icy handshake at Flushing Meadows, Bjorn Borg and John McEnroe met for the first time in Tokyo a month later. They were entered in the richest tournament in the world at the time, the Seiko World Tennis Event. (The name was as generic as "The Lawn Tennis Championships" at Wimbledon, except that "event" made it clear there was nothing at stake.) The two players were coaxed into shaking hands again, this time for a photo-op in front of a gigantic keg of sake. Was there a new Japanese tennis empire in the making? It looked possible in the early 1980s, when the country was booming, but it would fizzle along with the country's economy at the end of the decade.

At a party to kick off the tournament, a dozen or so photographers snapped away as Borg walked into a large convention hall. A few minutes later, McEnroe arrived. Three times as many flashbulbs popped, and the entire room seemed to surge in his direction. A British tennis player stood to the side and watched the scene. "It's amazing how quickly things change," he said. "There's Borg, a guy who has won five Wimbledons, and he's practically being ignored here tonight."

As he entered a new phase of his career, many were asking what was at the core of the Ice Borg? From the evidence of his final significant tennis act, it was pride that drove him to victory, and pride that drove him away when the victories ended. The man whose entire life had been about winning—that was all he did—simply couldn't make another concession speech at the U.S. Open.

Borg yearned for freedom. A few months after the Open, he tried to find it on a tennis court in Geneva. There, he played Manuel Orantes of Spain, the same man he had defeated at the 1973 French Open to win the first of his 11 Grand Slam titles. Borg won the first set. In the second, he began to serve and volley, attempting to play the type of game he had never been able to, a style that he had seen McEnroe use so successfully against him. Orantes couldn't believe his luck. He gleefully picked Borg apart to win

the second set, before the Swede put his head down and dutifully traipsed back to the safety of the baseline. Borg won the third set the way he knew how. Tennis freedom was not his destiny. He had lived by the grind, and he would die by it.

At the start of 1982, Borg asked the men's tour if he could enter fewer than the minimum 10 tournaments required. The tour refused. If he didn't meet the minimum, the five-time champion would have to qualify for Wimbledon.

Instead, Borg announced that he would begin 1982 by taking a sabbatical from the sport. He played his first event in May, in his adopted hometown of Monte Carlo. A media frenzy ensued when he showed up and reached the quarterfinals in his usual silent fashion. There he lost to Yannick Noah. During the match, the Frenchman could hear someone whistling as the two players changed sides. He realized, to his shock, that it was Borg. Later, as he exited his post-match press conference, Borg whistled loudly while walking out the door.

It was his last match of the year.

———

Nobody took the disappearance of Bjorn Borg harder than John McEnroe. His early idol and protector, his rival on tennis's Olympus, had left him alone at the top. But Borg's fall would bring them both down.

There was no one else whom McEnroe respected as much, and no one who could motivate him the way Borg had. Not Connors, who beat McEnroe at the first Borg-less Wimbledon in a decade, in a heartbreaking final. Not Lendl, who handed McEnroe his first defeat at the U.S. Open in four years. "I thought we'd pull each other to these unreal heights," McEnroe said of Borg. "And then he up and quit just like that."

It took two years for McEnroe to make his way back up the

mountain. In 1984, at age 25, he finished with the best single-season record of any man in the Open era, at 82-3. He also avenged himself with a straight-set win over Connors at Wimbledon and another straight-setter over Lendl at the U.S. Open. Still, his missing rival haunted him.

In Stockholm in the fall of '84, McEnroe found himself losing to a young blond Swede named Anders Jarryd. The location and the opponent reminded him of someone. "Where's Borg?" he found himself wondering. In the second set he engaged in one of his most notorious meltdowns. McEnroe barked at the chair umpire, "Answer the question, jerk!" He hit a ball into the stands. He took a swipe at a water glass next to him on the sidelines. The liquid flew into the air and landed in the lap of the king of Sweden, who was sitting in the front row. McEnroe virtually begged the umpire to default him, but he was allowed to play on, and eventually won the match. He couldn't be disqualified even if he wanted to be; by then McEnroe was bigger than the sport. And like Borg, he found there was no escape.

John McEnroe wouldn't win another Grand Slam after 1984; that year he was 25, the same age Borg had been when he'd played the 1981 U.S. Open. By then, McEnroe had been ranked number one in the world for four straight seasons. Starting in 1985, Ivan Lendl took over that spot and started his own four-year reign. But the death knell for McEnroe's finessed, wood-racquet-based game would come with the rise of two younger players in the middle of the decade, Boris Becker and Andre Agassi. In 1985, Becker, who outweighed McEnroe by 30 pounds, won Wimbledon at 17 with a diving, headlong, all-court game that was more physical than anything tennis had seen before.

Agassi made his debut the following year. The most talented product of the Nick Bollettieri Tennis Academy to that point, he could dominate a match with his forehand alone. "Nobody has ever hit the ball that hard at me," McEnroe said after beating a

16-year-old Agassi in his debut tournament in Vermont that year. Becker and Agassi had grown up in the post-wood era; they were the first players to fully exploit the possibilities of the more powerful, larger-framed racquets. McEnroe, the master of touch, of wood, would struggle to survive in the new world they created.

By the middle of the decade, McEnroe had begun to spend more time in Hollywood. He took his own sabbatical from tennis, and in 1986 was introduced to actress Tatum O'Neal at a party in Los Angeles. "Tantrum and McBrat" were married that August. They would have three children and a famously tempestuous relationship that ended in divorce in 1994.

For the rest of the 1980s, McEnroe vacillated in his commitment to tennis, while also taking care of a family. (When O'Neal told him she was pregnant one New Year's Day, he sat back and said, "Well, there goes 1987!") His battles with Borg were already the stuff of legend, and nothing he could do now would match them, no opponent would command the respect that he had had for the Swede. McEnroe lost motivation at times; other times he came back more eager than ever. Out-trained by Lendl at the start of the decade, he tried to catch up by hiring a string of coaches, trainers, and gurus. He later regretted trying to beef up his game to match his younger rivals'. He had more moments of genius, but he could never get back to the perfect world of his youth, the now-mythic world of Viking gods and wooden racquets. The power of Lendl, Agassi, Becker, and Pete Sampras, who ended McEnroe's last run to the semifinals at the U.S. Open in 1990, made his old-fashioned tennis magic obsolete.

———————

If the 1980s was a decade of disappointment for McEnroe, they were largely lost years for his friend Vitas Gerulaitis. He remained a top-10 player through 1983 and won his last tournament a year

later. Two years after holding off the game's future with his win over Lendl on the Grandstand at Flushing Meadows, Gerulaitis helped usher it in by losing on the same court to 16-year-old Aaron Krickstein, a baseline-hugging product of the Bollettieri academy. Gerulaitis looked liked a shadow of the man who had made the U.S. Open semifinals 24 months earlier.

The ensuing decline and the black hole of retirement in his early 30s proved to be crushing. "I started to believe my own press and tried to live up to my image," Gerulaitis said. "I stayed out later and partied harder. But it wasn't the drugs and booze or whatever. I was down, I had the blues." Gerulaitis worked overtime to replace the rush of tennis, of performing, of applause, of the fame that he had always loved. He ended up whiling away many nights playing the guitar alone.

"He was in therapy and rehab a lot," Mary Carillo says of her friend. "He tried. Once he was there for a month and they made him write letters to the people he had disappointed."

A long-running engagement to actress Janet Jones ended when it became clear that he couldn't kick his habit. According to Gerulaitis's sister, drugs changed him. "His downfall was really heartbreaking," Ruta Gerulaitis said. "In the dark days, he wasn't the same anymore. He had terrible guilt about disappointing his parents. He got caught in the spiral of addiction."

Jimmy Connors and Jones staged an intervention at a Florida resort, and by the end of the decade, Gerulaitis had gotten himself clean. In 1989, USA Network hired him to commentate at the U.S. Open. "I know you come with baggage," USA executive producer Gordon Beck told him, "but we'll give you a shot." He was a hit in the booth. Vitas Gerulaitis had surfaced. He had survived his lost decade.

———

"I'm two people," Bjorn Borg once told John McEnroe. Two extremely different people, it would turn out. As rigidly self-controlled as Borg had been for the 10 years of his career, that's how much he let himself go over the next 10. As famous as he had made himself during his playing days, he would become nearly as infamous as a cautionary tale in his post-career.

The Teen Angel stepped down from the clouds in search of a normal life. In 1983 he appeared again at a tournament in Monte Carlo, and again created a media frenzy. That same year, though, he called IMG to tell them that he was officially retiring from tennis. The time away had made the idea of trying to return to the tour, and putting in all the old work again—of hitting the thousands of balls that he would need to hit to play his old game again—seem like an impossible hill to climb.

Borg, with Sweden's taxes still prohibitively high, tried to start over in Monaco. He took a stab at rally car racing. He tried TV commentary, but didn't have the knack for it. He started a clothing company and folded it.

He concentrated primarily on his private life. As his biographer, Gene Scott, noted, Borg was a child of the light who harbored a curiosity about the darkness on the other side. According to McEnroe, whichever direction Borg went, whichever self he chose to be, he always took it to extremes. He went into the night with all he had.

Much like the Beatles he had always resembled, Borg spent his post-career severing all ties with a past that he could never possibly live up to. First to go was the two-person tennis family that had catered to him for so long. He divorced Mariana. He cut ties with Bergelin; they would run into each other years later by accident, seeing each other from separate boats on a lake.

Back in Sweden for a visit, Borg fell in love with 17-year-old Jannike Bjorling and had a son with her. After he and Bjorling broke up, he married lusty Italian actress Loredana Berte; they

were divorced in 1993. A decade that began with his glorious 1980 Wimbledon win over McEnroe ended in Milan in 1989, when he was rushed to a hospital to have his stomach pumped after taking too many sleeping pills.

Sociologist and tennis historian E. Digby Baltzell believed that the years 1989 to 1991 marked a transition in tennis, from the "roughneck era" of the game's first group of pros, to the businesslike manner of its second professional generation. The pioneers of the Open era had been wild men on the range, carving out a life with no predecessors to guide them. The next group, led by Americans Pete Sampras, Michael Chang, and Jim Courier, had learned from the excesses and early burnout of their elders. They were, for the most part, gentlemanly and cautious—professionals in all ways. A 17-year-old Chang won the French Open in 1989, Sampras won his first U.S. Open at 19 in 1990, and Courier won his first French the following year. They were successful, but they failed to capture the public's imagination the way their predecessors had. The biggest headlines during that period still belonged to the roughnecks. Borg, McEnroe, and Connors staged a series of final, sometimes pathetic, sometimes exhilarating hurrahs.

In 1990, McEnroe was playing superb tennis at the Australian Open, so good that many people believed the 30-year-old had a chance to taste Grand Slam glory one last time. As always, the chance of success put McEnroe on edge. In the fourth round, he faced Mikael Pernfors on a hot day in Melbourne. With the score one set all, McEnroe glared at a lineswoman and was given a warning by chair umpire Gerry Armstrong. Later, he threw his racquet to the ground and was hit with a point penalty. McEnroe demanded to see tournament supervisor Ken Farrar, who walked on court and confirmed that McEnroe's action had indeed warranted

the penalty. McEnroe didn't agree, and as Farrar was walking away he let him know it by advising him to "fuck your mother." The crowd gasped. Farrar stopped in his tracks, turned around, and walked to the umpire, who, after a very brief consultation, announced, "Verbal abuse, audible obscenity, Mr. McEnroe. Default. Game, set, and match, Mr. Pernfors." After nearly 15 years, it had finally happened. McEnroe became the first player of the Open era to be defaulted from a Grand Slam match.

After a decade spent traveling as far from his tennis career as he could, Bjorn Borg decided to pick up a racquet again in 1991. It turned out it was virtually the same racquet that had made him a champion: a black wooden stick that he had had constructed especially for the occasion, even though no one had used anything made of wood for nearly a decade. Borg began his comeback at age 35 in his usual spot, the Monte Carlo Country Club, inspiring the usual mayhem. This time he was accompanied not by Lennart Bergelin, but by a freakish entourage led by "doctor" and martial arts master Tia Honsai, whom Borg referred to as "the Professor." Honsai claimed that he had returned Borg's body to its 22-year-old self, and that "he should go all the way; there's nothing to stop him."

On the surface, it appeared that nothing had changed about Borg. The hair was long, the fingers were wrapped in white tape, the strokes and mannerisms were the same. It was enough to give the overflow crowds hope that he was still the same player, that he still had the old quiet magic.

He didn't. Borg lost his first-round match to a journeyman pro. Honsai was asleep for most of it. With Borg serving at 3-4 in the third set, Honsai awoke, stood up, and yelled, "Do it now, Bjorn!" Borg double-faulted. His comeback would continue for 11 more

tournaments before he would hang up his new wooden racquet again. He didn't win a match.

The anarchic final at Wembley in late 1981 proved to be the turning point that Jimmy Connors believed it would be. The following season, with Borg gone and McEnroe wondering where he was, Connors stepped into the void. He made good on his vow to win another Grand Slam, at Wimbledon, then followed it up with titles at the next two U.S. Opens.

Borg and Gerulaitis were swallowed by the night. McEnroe vacillated and agonized through the decade. Connors kept bashing. The Grand Slam titles and the number one ranking may have belonged to a new generation—Lendl, Becker, and Stefan Edberg—but Jimbo never lost that eagerness for the next ball that he had shown as a boy with his mother back in Belleville. He never wanted to be anywhere but "in the arena," as he said.

Four months after Borg's bizarre return in 1991, Connors made his own improbable comeback at Flushing Meadows. He had been injured during his favorite tournament the previous year, but he still believed he could get the place rocking one more time. He was right. In the most famous run in tennis history, a 39-year-old Jimbo pumped and thrusted and cursed and bullied his way to the semifinals. No player has ever wrapped a crowd around his index finger the way Connors did in New York that year. It was the last ride of the roughnecks, a brief, sentimental return to the early professional era, to tennis's colorfully vulgar golden age.

It had been 10 years since the demise of that era, 10 years since Borg made his somber exit on the same court, and 20 years since Connors himself first skidded across the lawns at Forest Hills as Pancho Gonzalez's tagalong. Now the man who had gotten so

many of these fans at Flushing Meadows into the game in the first place reminded them of why they had fallen in love with tennis, and of the possibilities it had once held out as a popular spectator sport.

In the fourth round, Connors faced Aaron Krickstein, the young Bollettieri product who had signaled the beginning of the end for the older generation when he beat Gerulaitis at the Open eight years earlier. This time Connors turned the tables, and turned back the clock for one afternoon, by beating Krickstein in a five-set thriller.

During the tournament, Connors had periodically looked into the camera and shouted to his friend Gerulaitis, who was in the commentary booth. Late in the match, an exhausted Connors sat down next to a camera at one end of the court. The chain around his neck glinted in the sun. Waves of energy from the crowd washed over him. Connors nodded and said to the TV audience, "This is what they paid for. This is what they want."

Of the original pros, none had understood the professional era, its demands and opportunities and rewards, as well as Jimmy Connors. None had thrived in America's tennis empire for as long. He hadn't treated triumph and disaster just the same, but that wasn't the American way. He had faced up, more fully than his peers, to the reality at the bottom of the sport: It was a war out there, and the people who coughed up money to sit in the stands wanted to see you put yourself on the line and show that you cared.

Connors turned away from the camera and stood up with theatrical weariness. The roar of the Louis Armstrong Stadium faithful was deafening. He walked slowly forward to the baseline, milking the moment for all it was worth. He was going into the arena one more time. He was going to give them what they paid for.

In the middle of September 1994, Vitas Gerulaitis, Jimmy Connors, and Bjorn Borg played an exhibition in Seattle. They had a great time; Gerulaitis was on his game as player and entertainer. John Lloyd, the fourth player on the court, said to Connors, "We might as well not even be here. This is Vitas's room."

"Aren't they all?" Connors quipped.

Gerulaitis flew back east the next day for a charity tennis event in the Hamptons. The following afternoon he was found dead in the bedroom of a friend's house in Southampton. He had died in his sleep, poisoned by carbon monoxide from a malfunctioning swimming pool heater.

Borg refused to believe the news when he heard it. He called Gerulaitis's mother to confirm it. When Connors was told, he grabbed onto the nearest chair to keep himself from falling over. McEnroe found out just before he went out to play an exhibition match. He went through with it, beating Michael Chang, and then called a woman he had been dating, the singer Patty Smyth. He told her he needed to be with her that night. They were married in 1997.

Gerulaitis's funeral was held at St. Dominic's Church in Oyster Bay, Long Island. Five hundred people attended. For those who couldn't squeeze inside, the service was piped through speakers outside the building. Among the pallbearers were Gerulaitis's friends and fellow semifinalists at the 1981 U.S. Open, Bjorn Borg, John McEnroe, and Jimmy Connors. The three rivals were united in their love of the fourth, Gerulaitis.

"It was a beautiful service, but so sad," Ruta Gerulaitis says, "he was too young, and his spirit was so strong. Nobody could believe we wouldn't see him again."

Mary Carillo spoke, as did Connors. "Vitas would give you the shirt off his back," he said.

"Vitas's casket was carried by the numbers one, two, and three players in the world," Carillo says. "How do you pull that off? Vitas knew no strangers."

The youngest of the four, McEnroe, listened to the words and wept. He couldn't bring himself to speak. At the graveside, he and Connors faced each other. Lefty and lefty, old pro and old pro, champion and champion, each mourning the same friend, they stood and embraced.

ACKNOWLEDGMENTS

Writing a book seems to be half typing and half asking people for favors, people whom you often don't know and will never be able to pay back. I couldn't have written a word without their help.

Thank you, for help with this book and for talking to me about this era during my 12 years at *Tennis* magazine, to Patrick, Mark, and John McEnroe Sr.; Ivan Lendl, Bjorn Borg, Peter Fleming, Fred Stolle, Mary Carillo, Ruta Gerulaitis, Mel Purcell, Juan Nuñez, Doug Henderson, Tony Palafox, Russ Adams, Eliot Teltscher, Cliff Drysdale, Tracy Austin, Nick Bollettieri, Butch Buchholz, Richard Evans, Peter Bodo, Bud Collins, Allen Fox, Matt Cronin, Steve Flink, Tom Tebbutt, Neil Amdur, Cindy Shmerler, Chris Clarey, Georg Diez, Christopher Roth, and the late Gene Scott. Thank you also to Anita Aguilar at the New York Public Library, Joanie Agler at the International Tennis Hall of Fame, Brad Kallet, Jackie Roe, David Rosenberg, Nick Trautwein, and Amy Rennert. Special thanks to my family, to Julie and Nula Kapustka, and to my editor,

David Hirshey. When the prospects of finishing on time looked bleak, I remembered his words of inspiration: "Suck it up and power through." They worked.

Among the many books that I read covering this period, particularly helpful were *Borg vs. McEnroe*, by Malcolm Folley; *Total Tennis* and *My Life With the Pros* by Bud Collins; *A Rage for Perfection* and *Open Tennis* by Richard Evans; *Love Match* by Mariana Borg; *On Being John McEnroe* by Tim Adams; *Jimmy Connors Saved My Life* by Joel Drucker; *Endeavor to Persevere* by Doug Henderson; and *The Tennis Bubble* by Rich Koster.

Very special thanks to Joel Drucker. During a difficult period in his life, Joel took time to help me decide on the most likely spelling of Two-Mom, as well as discussing the literary merits of Dumbo Cooper. That's above and beyond.

ABOUT THE AUTHOR

Stephen Tignor is a Senior Writer and former Executive Editor at *Tennis* magazine and a columnist at Tennis.com and ESPN.com. He lives in Brooklyn, New York.